THE
OBELISK
AND THE
ENGLISHMAN

THE

OBELISK

AND THE

ENGLISHMAN

THE PIONEERING DISCOVERIES OF EGYPTOLOGIST
WILLIAM BANKES

Dorothy U. Seyler

 Prometheus Books

59 John Glenn Drive
Amherst, New York 14228

Published 2015 by Prometheus Books

Cover image of Temple Luxor © Bridgeman Images
Cover image of William Bankes by George Sandars, National Trust Images
Cover design by Nicole Sommer-Lecht

Inquiries should be addressed to
Prometheus Books
59 John Glenn Drive
Amherst, New York 14228
VOICE: 716–691–0133
FAX: 716–691–0137
WWW.PROMETHEUSBOOKS.COM

19 18 17 16 15 5 4 3 2 1

Library of Congress Cataloging-in-Publication Data Pending

ISBN 978-1-63388-036-8 (cloth)
ISBN 978-1-63388-037-5 (ebook)

Printed in the United States of America

CONTENTS

PREFACE

I am delighted to welcome you to the world of William John Bankes, the second son of a prominent land-owning family in Dorset, England. William grew up during the Regency Period and lived to see Victoria become England's queen. His life was shaped by both country living and city politics, by the Napoleonic Wars in Europe and ongoing conflicts with the new United States, by family tradition and rather different personal interests. On this stage he found his way and accomplished much that was out of step with his father's hopes and expectations—but not with the times, a time of wider travel and exciting discoveries.

When I first became interested in William I would not have predicted the journeys I have taken and discoveries I have made, but I now thank William for the rich years of travel and research that have led to this book. I invite you to become engaged with William's story. I hope that William and I together will inspire you to seek new lands and explore new worlds.

Acknowledgments

No book of value is written alone. I am happy to have this opportunity to thank the wonderful folks who have helped me along the way. First thanks should go to both the National Trust and the Dorset History Centre for letting me use many of William's Egyptian and Syrian drawings as well as family portraits and images of Kingston Lacy at a significantly reduced rate. Special thanks to Jenny Liddle, Sam Johnston, and Jo Hearton. I want to acknowledge as well the Kingston Lacy staff who allowed me to visit William's home when it was not open to the public, a visit that just

happened to include an early viewing of the restored Guido Reni painting just returned to the library ceiling. Thanks especially to Rob Gray, who found Bankes's drawing of his plan for hanging his Spanish paintings, took a photocopy, and made it possible for me to include this significant image in the book.

It goes without saying that I am also in debt to both Anne Sebba and Dr. Patricia Usick, two British authors who were the first to write about Bankes. Patricia was especially kind during my period of study at the British Museum, at that time the location of William's Nile Albums and most of his site plans and temple drawings. I am also indebted to the John Murray Archive for the chance to read its collection of letters from Bankes to Byron and Bankes to Murray. A special thanks to the current John Murray for his gracious permission to use the Byron portrait from his collection.

I must also thank Northern Virginia Community College for the award of their Presidential Sabbatical; winning this semester sabbatical allowed me to do the necessary research both at the British Museum and the Dorset Record Office (now the Dorset History Centre). In addition, colleagues and friends have given of their time to read parts of the book during its various incarnations: Solveig Eggerz (with her repeated emphasis on the need for a narrative arc), Ruth Stewart (for her careful attention to sentences that did not work), Marian Delmore (who read early and late and helped me locate sources at the Library of Congress), Janet Taliaferro (for her close reading of early chapters), Barbara Simon and Erik Neilson (for their helpful comments and unerring enthusiasm), Stephen Black (for his good advice on presenting Bankes's role in decoding hieroglyphs), and Ryan Winfield (for his careful scanning of images and help with Facebook). All have remained a steady chorus of support during my years of research, travel, and writing. Added to this list of supporters are my tennis, golf, and bridge friends who have listened—with patience and good grace—to my endless chatter about Bankes.

I want to thank as well Serena and Luigi Terziotti for their translation of an Italian document for me, and Tony Rodriguez for his help with

the letters in French between Thomas Young and both Champollion and Sylvestre de Sacy.

With pleasure I acknowledge my debt to my agent Gary Heidt, who significantly improved my proposal, that key document for getting this book placed with a publisher, and to Steven L. Mitchell, editor-in-chief at Prometheus Books, for giving me this opportunity to tell William's story. My thanks to all of the Prometheus staff, notably Julia DeGraf, Melissa Raé Shofner, Cate Roberts-Abel, and Lisa Michalski.

But the top prize for both patience and good advice goes to my daughter Ruth: reader, photographer, travel companion, and generally smart cookie! Thank you.

PROLOGUE

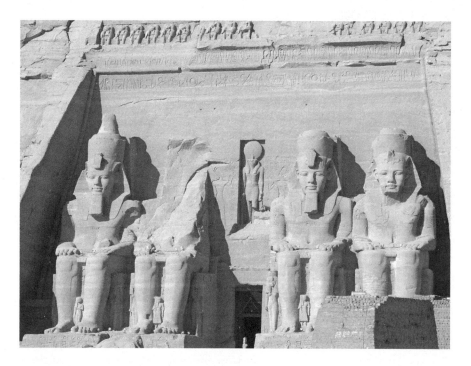

1. Entrance to the Great Temple at Abu Simbel.

B raving suffocating heat, William John Bankes stood, nearly naked, on his handmade ladder and squinted in the dim light provided by 20 to 50 small wax candles fastened to clusters of palm branches so that he could copy wall drawings in the great temple at Abu Simbel. The land of the Pharaohs offered many riches, but sturdy oak trees were not among them. And so, in 1819, William, now 32 and on his second journey up the Nile, experimented with ropes and branches to craft flimsy ladders so that

he and the artists he brought with him could be the first to copy all of the wall reliefs in this recently opened magnificent New Kingdom temple. The task was a challenge; how could they get enough light and something firm enough to hold them as they copied the highest registers atop the imposing walls of the temple? At first the walls won the battle, but William kept thinking about solutions as he traveled farther into Nubia. He successfully applied his ideas when they stopped again at Abu Simbel on their voyage north to Cairo. William's artists completed over one hundred drawings of the grandest temple built by Ramesses II.[1]

The rather plump-looking, fair-skinned young man of 26, sitting for his portrait in London, had disappeared during six years of travel around the Mediterranean. Now lean and perpetually tanned, William found himself red-faced again, though, burning with fever during much of his stay at Abu Simbel. But, unwilling to give up control of the copying and excavations, William could probably be found directing his group while stretched out in what little shade he could find near the temple.

His crew and hired workmen together removed tons of sand from the colossal statues of Ramesses II fronting the rock-cut temple. Finding that they could not carry all that sand far enough away to reveal all four figures at once, they had to settle for excavating and studying one statue at a time. Their work was rewarded: One statue contained a Greek inscription from which William could date Ramesses's rock-cut marvel.

William gaped at the colossal images of Ramesses II and wondered again about the row of baboons carved above them. These he had seen and drawn when he first gazed at Abu Simbel in 1815, on his first journey into southern Egypt and Nubia. His second sketch of the temple, then mostly covered with sand, shows his speculation that the four figures were standing, not sitting. That William was incorrect in 1815 is less important than the shift in focus that these first two drawings represent. No longer writing in his journal about the heat and flies—the endless plague of flies—he started sketching the temples and contemplating their forms and possible dates. This moment in 1815 marked the start of his love affair with ancient sites,

his shift from eager traveler to archaeologist. Now, with Christmas over, the new year of 1819 had come. It was time to move on.

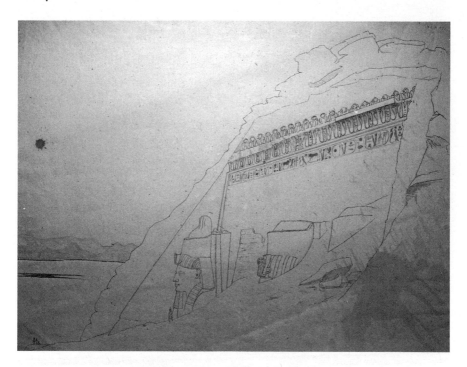

2. The Great Temple at Abu Simbel in 1815, showing most of the front covered in sand. Drawing by Bankes.

After several weeks of hauling sand and copying, William pushed farther south. They camped at Wadi Halfa to explore some ruins only partly visible in the sand. Their digging revealed part of a temple first built by Hatshepsut, Egypt's female king. While directing the dig, William also spent days negotiating with local leaders to obtain supplies for a land journey deep into Nubia (modern Sudan). Ignoring the Arabs' reluctance to help, William beguiled them with arguments—and gifts—eventually winning approval to hire a few guides from a fierce tribe of local troublemakers. William's Portuguese servant Antonio Da Costa was left in charge of the dig at Wadi Halfa while the rest continued their travel south toward Amarra with their new guides and ten camels.

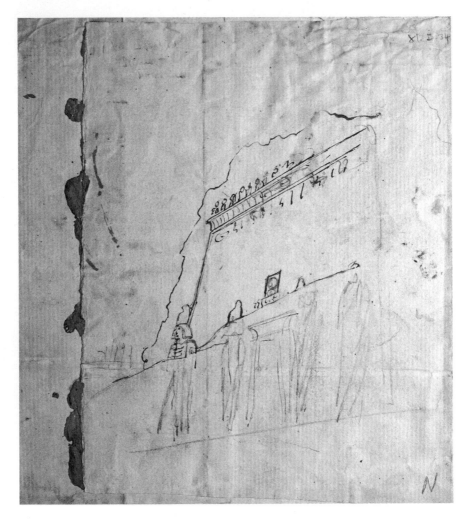

3. The Great Temple at Abu Simbel in 1815, showing Bankes's speculation about the figures.

Almost overcome by the more than 100-degree heat, the artists stopped to bathe in the Nile and rest. This proved a fatal mistake, as one by one their Arab guides moved toward the resting camels and then, on a signal, leapt aboard and trotted off with much of the group's provisions and transport.

After a fruitless chase by the naked bathers, William began the long

trudge through burning sand to Amarra, hoping to purchase replacements to continue their journey. Unfortunately, William learned that all of his considerable money from the family estate in England could not buy safe passage farther south. The son of the Casheff of Wadi Halfa, "ruling" in the Amarra region, told them that if they insisted on going forward, they would find their "graves were already dug" for them.[2]

Disposing of all but the most important remaining baggage, William and his band of artists began the slow trek back to Wadi Halfa. Blistered and burned by sun, pounded by sand sent in swirls by the hot wind from the Sahara, they were forced to beg or steal what food and donkeys they could find. William dug deep into his resources of determination and humor, convincing his weary band that they would survive to tell great tales of their travels at future London dinners. Leading the way, his back to the others, William must have quietly contemplated what his father would think of this adventure. Would Henry be proud of my achievements, William pondered—or disappointed that his heir was still traipsing around foreign lands rather than doing his duty in Parliament. How often did William wonder if he would even see his family again, as he struggled to find food and transport in this dismal desert beyond the reach of the Pasha's control?

Although frustrated by his inability to travel all the way to Dongola in Nubia, William knew that his second journey up the Nile was anything but a failure. The excavation work on partially buried temples and his large basket of drawings would be important contributions to the budding field of Egyptology. His passion for the achievements of the ancient Egyptians and his accurate copying of Greek inscriptions would surely interest his father, for after all Henry Bankes had written a book on Greek government.

Finally back to their ships at Wadi Halfa and setting sail north to complete their study of Abu Simbel surely left William next wondering: Why am I standing on flimsy scaffolding, wiping sweat from my eyes, struggling not to gag on the smell of bat droppings? But then he could smile to himself, thinking, "If only Byron and my other mates from Trinity could see me now."

While William traveled, his close friend from college lived and loved

and wrote in exile in Venice. Byron also followed the news of William's amazing journeys, describing him to another Trinity friend as a "stupendous traveller." Byron admired William's daring and discoveries, continuing his praise by writing: "Bankes *has* done *miracles* of research and enterprize—salute him."[3] William Turner, a British traveler William met in Cairo, was equally effusive, telling readers that William "goes everywhere, fearing neither danger nor fatigue, collecting more information than any other man could obtain, and never forgetting what he collects."[4] These are gracious words from Turner, but Byron's admiration mattered more to William. When William finally headed home, he stopped first in Venice to see Byron, to reminisce about their Cambridge years.

William and Byron: Two restless young romantics coming of age during Napoleonic times, each gifted in his way, each shaped by dramatically different family experiences, both at the center of London life as the nineteenth century begins. Both were drawn to ancient worlds and shaped by their love of the past. If William was less driven than Byron to seek fame, he was just as driven to escape London's social restrictions and family expectations. His need for daring escapades led first to great adventures and then—after his pivotal 1815 journey up the Nile—to significant research around the Mediterranean world. But, back in staid England, his need for continued risk taking, as well as his loneliness, resulted in not one but two charges of "unnatural behavior." What did William do? Did he, like Byron, raise the curtain on a final act of creativity and achievement? What we can say is that William John Bankes's life journey, as well as that of his college friend, was never dull.

1

THE SECOND SON

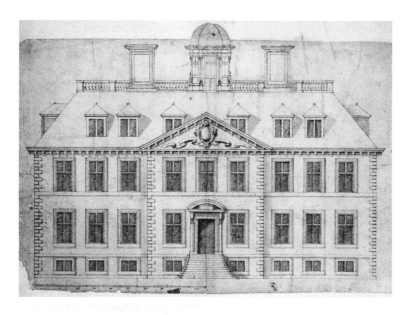

4. Kingston Hall. Built by Roger Pratt, 1663.

Henry Bankes and Frances Woodley Bankes received an early Christmas present in 1786: William John Bankes, their second child and second son, was born on December 11 at their Dorset County estate Kingston Lacy. This robust baby was first marked for originality in the Bankes family by his parents' choice of names. John was a common Bankes family name, but William was not. William John was named for both sides of his family, specifically after his grandfather William Woodley (William was a name given to all first sons in the Woodley family, dating back to

1620), but perhaps also for his great-uncle William Wynne, from whom he would inherit an estate in Wales.

Because of the common practice in William John's time of using last rather than first names in the salutations of letters, we do not know for sure how William introduced himself to others. Letters from his friend Lord Byron begin "My dear Bankes." William signed his letters with both names, usually "Wm. J. Bankes" or "Wm. John Bankes." Harriet Arbuthnot, confidant of the Duke of Wellington, refers to William in her journals either as Mr. Bankes or William Bankes, so probably he introduced himself as William but used his full name in more formal situations.

During William's childhood, the Bankes home was filled with the shrieks and laughter of active children. In addition to Henry (1785–1806), William's older brother by seventeen months, the family included George (1787–1856), Anne (1789–1864), Maria (1791–1821), Edward (1794–1867), and finally Frederick, who died in infancy. Only a portion of the home's third floor—behind the green baize door—was devoted to rooms for the female servants. The rest of the top floor contained additional bedrooms and a large nursery whose windows faced the south lawn.

Even with the aid of Nurse and Mrs. Hills, a nanny or governess, William's mother was busy watching over the early education of her rapidly growing family. Frances was delivering at a time of new interest in the health management and education of children. She was modern in her choice to inoculate the children against smallpox even though the vaccine used at that time was risky—and killed her youngest son Frederick. In spite of their inoculation, the children did have smallpox—along with mumps and chicken pox and most of the other childhood diseases—their survival a mark of good care and sturdy constitutions. Frances carefully recorded these details in a journal she kept for many years.[1]

William and his brothers and sisters played with blocks and dolls and rocking horses in the nursery under Mrs. Hills's watchful eyes, ran through the large house in spite of repeated warnings not to, roamed the gardens and grounds, and learned to ride on a favorite pony. Frances saw to their instruction in reading, writing, and simple math. Anne and Maria were edu-

cated entirely at home, but the boys also received their earliest education at Kingston Lacy. At the time there were not a lot of children's books, but more were getting published, and there were nursery rhymes to learn and Aesop's fables to read. There was also the home's library, filled with books of history, biographies, and essays as well as maps for the study of geography. Although a music master was hired, we have no knowledge that William could play an instrument or sing; later a dancing master prepared the children for the balls of their adult years.

Most important, as it turned out, was the drawing master. In the collection of papers from Kingston Lacy now in the Dorset archives is a folder filled with various sketches and drawings, unsigned, some of them surely early exercises by William. The drawing master's influence was reinforced by Frances's own interest in art, as shown in her pastel copies of other works. Perhaps William acquired his talent from his mother. Developing his drawing skills would also be one way to stand out from his brother Henry and to get his mother's attention.

If we had only the drawings William made of Petra and other sites in the Middle East and of Egypt's temples and tombs—and none by the more polished artists he later employed—we would still have a great gift to our knowledge of these ancient sites. He paid attention to the most minute details of carvings, worked to produce exact measurements of large temples, and used his knowledge of perspective to render the many now invaluable drawings that he prepared during his travels. If his early tutor was alive in 1820 to hear of William's travels, he could feel a just pride as one who developed the boy's talent for sketching and fostered his love of art.

The young William became his mother's favorite. Maybe Frances, having produced a male heir in her first son, wanted a daughter and treated her second son with indulgence. Certainly more was demanded of Henry early on, as part of his preparation to succeed his father. And William, so close in age to Henry on the one side and George on the other, pressed by sibling rivalry, worked hard to distinguish himself from his brothers. He sought—and settled for—his mother's attention, if not his father's.

Described repeatedly by adult acquaintances as a great conversationalist, William was highly verbal at an early age and quick to learn to read. Although never described as mean or bad-tempered, he was determined to be different, to do it his way. When William was nine and involved in some conflict with Henry, Frances wrote to Henry, less than two years older but still the oldest, asking him to have patience with William: "William, to please me, will I am sure break himself entirely of his fondness for singularity. We are few of us exempt from faults but I am very desirous you should all of you have as few as possible."[2] William would do no such thing, preferring to preserve his "singularity."

Turning just five in December 1791, William was too young yet for the dancing master, but he—and his brothers and sister—were "invited" to a ball, a glamorous night of dancing and eating hosted by their parents to celebrate the completion of renovations to Kingston Lacy and show off their new home. This busy mother's first big entertainment, Frances clearly felt that it was important for her to succeed, to have the evening run smoothly, thereby impressing both neighbors and the members of Parliament included in the 140 guests.

As a toddler and young boy, William watched the major changes taking place around him in his Dorset home. Frances retreated at times—with her young brood—to her mother-in-law's London home to avoid some of the most disruptive renovations, including the removal of walls and redesign of stairways. But she also needed to be in Dorset to select wall fabrics and paint colors, to approve ceiling designs and the placing of new furniture. Knowing the talent for drawing and fascination with art and architecture that William will develop, we can imagine that more than once he was found underfoot, watching as the ballroom ceiling was painted and the drapes hung to create a stunning new space in his seventeenth-century home.

William's father Henry (1758–1834) inherited the large Dorset estate when his father Henry died in 1776. The Bankeses first settled in Dorset County in 1635 when Sir John Bankes purchased Corfe Castle, initially an imposing fortress on the county's southern tip that juts into the English

Channel. John Bankes lost the castle during the Revolution, but when Charles II was restored to the English throne, John's second son, Ralph, now his heir, was knighted by Charles and restored to the family lands. Deciding that the castle was too damaged by Cromwell's forces to warrant repair, Ralph hired Roger Pratt in 1663 to begin work on a new home on a more inland part of the estate near the town of Wimborne. Kingston Hall (as it was called until William renamed it Kingston Lacy when he became its heir) had a basement level, two full floors, and an attic level with a dormered roof, balustrade, and cupola. The north-side entrance presented sweeping stairs leading to the main floor. Pratt's home was completed for Ralph Bankes in 1665.[3]

During Ralph's continental travels, he started one of the finest surviving collections of paintings for a nonaristocratic family. Although his purchases for the house left him in debt, his will provided for his sons' education and travel abroad and specified that his collection of books and art not be sold by trustees to pay his debts but pass on to his eldest son. (The house was leased by Ralph's son until the debts were covered.) William seems most closely related—in spirit at least—to his great-great-grandfather Ralph, this second son of the previous century. Their portraits show both with strawberry-blond curls and a flair for dramatic dressing—William in his collegiate robe. William, like Ralph, will travel extensively, add to the family's art collection, and treasure the family estate (see color plates C1 and C2).

Ralph built the house and his son made the family solvent, but it was William's grandfather Henry (1698–1776) who significantly enhanced the family's fortunes. First, he closed down a smuggling operation that cut into the family's income from a half share in a Cumberland lead mine—the primary source of graphite for pencils until 1815—and then he used the courts—or bribery—as necessary to get full control of the business. Next, Grandfather Henry purchased the estate next to Kingston Lacy (raising the cash by selling most of the family's government stock) and organized tenants and stewards into a profitable business. Finally, to prepare for enclosure, he hired William Woodward to survey the estate, both the enlarged Kingston Lacy estate and the Corfe Castle lands as well.

William's father inherited the now 60-thousand-acre estate while he was still at Cambridge, but his new responsibilities did not alter the family tradition of European travel after university, a plan perceived by parents as an ideal finishing school for young men—and embraced by the young men as a wonderful chance to feast on some pleasures more readily available on the Continent. Henry traveled twice to France and Italy, the second time requesting that the young architect Furze Brettingham, whom he saw in Rome, draw up plans for remodeling Kingston Lacy.

Upon Henry's return to England in 1784, he married the beautiful and wealthy Frances Woodley, continued the process of enclosing the estate, and

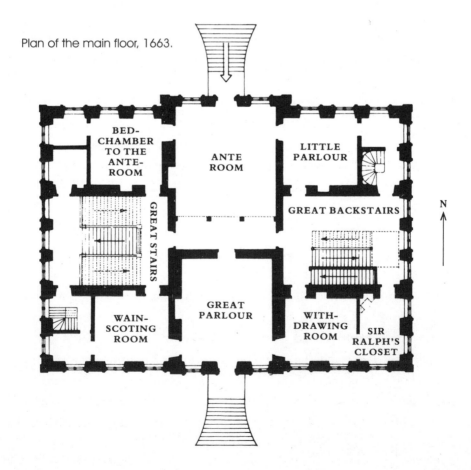

Plan of the main floor, 1663.

commissioned Brettingham's changes to his home. The extensive renovations were accomplished during the first six years of their marriage. A comparison of floor plans reveals that, in general, the changes created more living area by reducing the space given to stairs and enlarging three of the corner rooms. The former north-side entrance was glazed over to make a more comfortable ball-room, and a new main entrance was placed on the east side, at the lower level, covered by a new porch. On the second floor, another bedroom was added over the stone stairs, a wise plan considering the steady arrival of babies.

When the new library was finished, William could run into it—escaping Mrs. Hills for a few moments—to look at his father's Grand Tour portrait, painted

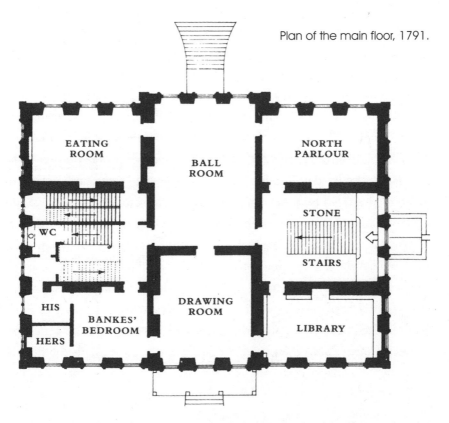

Plan of the main floor, 1791.

5. Floor plans show changes made to Kingston Lacy by Henry Bankes, William's father.

by Pompeo Batoni in Rome (see color plate C3). Henry did not like the work, this typical souvenir of a young man's European travel. He wrote in 1779 to his mother: "It is certainly like me, but without any sort of Taste or good painting." In another letter to Margaret Bankes, he observed: "I think it but a melancholy, cold picture whose only merit is being simple and having nothing offensive."[4]

The young William may well have preferred to gaze at the portrait of his mother, robed in Grecian splendor, hanging dramatically in the new drawing room. If we did not know the dates of Henry's comments to his mother, we might be tempted to conclude that he felt the lack of drama in his portrait when compared with Frances's more arresting, sensuous portrayal. Henry poses in a dark-brown suit against a dark background, and his left arm, placed on his hip in an attempt at a jaunty, self-confident look, seems more awkward than rakish. William's mother, by contrast, wears a low-necked dress, its body-hugging drapes clearly shown by her jutting right leg as she gracefully leans on her right elbow (see color plate C4). Henry found in the fair and charming Frances a balance to his more serious, introverted temperament. William seems to have inherited his flair for the dramatic from both his great-great-grandfather Ralph and his mother Frances.

Frances described her grand ball of 1791 in detail for her mother-in-law Margaret, who lived in London.[5] The invitation read eight, and most of the guests had arrived by nine. They entered under the new porch, ascended the new stairs, and turned left into the library to be greeted by Frances and Henry. Henry's writing table had been removed so that there was just one card table in the library. Guests moved into the drawing room "which is by much the most gay and indeed the prettiest room I ever saw." Apparently concerned to keep the new furniture from experiencing any mishaps, Frances had removed drawing room furniture as well, setting up three card tables instead. Guests could then enter the ballroom or go through the drawing room to the Bankes's bedroom where a long, cloth-covered table had been set up to serve tea, lemonade, hot sweetened wine, and Orgeat, a drink of barley or almonds and orange flower water.

Pleased with her planning, Frances continues:

Mr. Bankes's Dressing Room and the side of my Bed room where the Fire place is, was occupied by the Tea-makers, who by that means could go in and out [using the back stairs] for everything they wanted without disturbing the Company, and people in general must have been better off than usual from having a place to go to where they were sure to find a constant supply of Cakes etc. during the whole evening.

Upon Mr. Bankes's Dressing Room Fire we kept a Quantity of Water constantly boiling, so that I flatter myself there never was so large a Company better supplied with hot Tea and Negus. I likewise saved my new Carpets very much by having nothing of that sort handed about.

The ten ladies' maids who served the tea were attractive in pink and white, and Frances proudly reports that she included powder puffs and Lavender water on her dressing table, pleasing her guests "more than many articles attended with greater expense."

A band from Salisbury provided for the night's dancing in this beautiful room with its coved ceiling recently painted by Cornelius Dixon in complex circle designs. Frances provides further details of the room's décor: The new curtains "are very large White and Gold with painted Medallions in them, the Curtains themselves are pink with a most elegant border, you may guess it is gay and striking when the first person who went into the room called out that it looked like the Palace of Alladin."

The dancing lasted until one, at which time supper was served on long tables set up in both the dining room and the north parlor to accommodate all the guests. These rooms were magnificently lit with candles, guaranteed, Frances hoped, to impress everyone. To serve the supper, Frances employed additional male servants so that none of her guests "had occasion to call twice for any one thing, which is a great deal to say in so large a company." Frances did economize by not serving dessert—but of course there were those cakes on the tea table available all night.

After supper, the dancing began again and continued until morning, at which time breakfast was served until about eight-thirty, when the guests left, except for those staying at Kingston Lacy who retired upstairs. At this

point, Frances demanded that her servants not go to bed until they had picked up and put the entire house back to order, so that when the family and house guests came down to a second breakfast about noon, all would be "as if nothing had happened." After writing this, Frances admitted to her mother-in-law that she was demanding in the managing of her house but that everyone was in good humor. Good humor among the house guests surely, but perhaps not so much among the exhausted servants.

Frances also recounts how William and his siblings spent the evening:

> We were obliged to Dine at four in their sitting room up stairs, when I advised Mrs. Hills to put them all four to Bed. They slept comfortably near two hours, and then got up to Supper. They were then dressed and I ordered that they should not come down stairs till I rung the up stairs bell, which I did not do till enough of the Company were assembled to propose going into the Ball Room. I contrived to give the summons just in time enough to have the five Children [the baby Maria has now been added to the group] all ranged in a row with Mrs. Hills and Nurse to attend them in the great Room so that every body saw them as they came in, and it was a very pretty sight, they all enjoyed it more than I should have imagined.

Who enjoyed it? The guests asked to fuss over the youngsters, or the children at the sight of the grown-up party? Presumably both—except for the baby Maria, who, frightened by so many people, was taken to bed rather quickly. Anne and George were given some food in the tea room around midnight and then put to bed.

Although Frances observes that William also appeared tired late in the evening, she then writes that "Wm. and Henry sat up till near one, the latter was not in the least tired, but ate a very hearty supper and they all slept till near ten the next day, and did not even *look* the worse for it." William, tired as George, was determined to last as long as his older brother rather than be trotted off to bed with "the babies." Never to be outdone by Henry, William must also have been dazzled by "the Palace of Alladin," as he would later be dazzled by the temple wall drawings and magnificent columns of the ancient Egyptians.

Frances assures her mother-in-law that she was pleased with Mrs. Hills's conduct, as she was successful in keeping the children from "running about" or "being rude, or doing anything wrong." Mrs. Hills retired with Henry and William and seemed pleased to have been part of the party. Frances was happy to write that nothing was damaged or broken except for a few ordinary plates—but not the "French China Dinner and Tea Set."

This young mother of five and mistress of a comfortable and newly redecorated home did not take her pleasant life for granted. She was determined to run the house properly, and carefully planned for her first large party so that the guests would be impressed while the new furniture and good china remained undamaged. The children grew up in comfort, certainly, but they learned from an early age the value of the comfort and beauty that surrounded them. Frances taught William the proper care of a family's heritage, although William and his conservative brother George might have disputed the meaning of "proper care" when, after their father's death, William initiated an extensive remodeling of Kingston Lacy.

Frances concluded her letter to Margaret Bankes by expressing a desire to see her in a few weeks when she will bring all five children to London as "it is so long since they have been in Town that every thing will be new to them and a matter of wonder." Although Frances spent most of her time at Kingston Lacy when her children were young, she also wanted the children to experience the wonder of the big city.

The pleasures of Kingston Lacy and comfort of schooling there with his siblings ended for William at the age of nine, when he started at Westminster School, a renowned private school in London, just a short walk from the family's new city home at No. 5 Old Palace Yard, located directly across from Westminster Palace. William's brothers Henry, George, and later Edmund also attended Westminster, the school of their father.

While many have heard of England's most famous private boarding school, Eton, and perhaps even Eton's rival, Harrow—Bryon's school—surprisingly few have heard of Westminster. And yet Westminster has had a long and illustrious history and was considered one of the finest schools throughout the

seventeenth and eighteenth centuries. It was school to the philosopher John Locke, to many MPs, and to many of Wellington's officers. William and his brothers would have had as classmates the children of many of London's best families. Fortunately for the Bankes boys they did not have to board. They lived with their grandmother Margaret and their father when Parliament was in session. In September 1799, ten-year-old Anne wrote to her grandmother that "we miss our poor brothers sadly and long already for the Christmas holidays. You must be very happy to have them with you."

Three active schoolboys—Henry, William, and then George—must have exhausted their grandmother at times, but the boys were able to avoid some of the challenges of public-school life at the end of the eighteenth century. Hazing and fighting were common, privacy nonexistent. Even the non-boarders were toughened by the experience and learned to form loyalties and protect their friends, or their survival would likely include some psychological damage. This was a "pull up your socks, man, and don't be a cry-baby" world, but if you made it through you would carry into adulthood an easy self-assurance, even cockiness bordering on arrogance, which describes William as well as the Duke of Wellington, a Bankes family friend.

Byron, boarding at Harrow, hated the place and absolutely refused to return for his second term. Finally persuaded to go back the next year, he made some friends, took some younger boys under his wing, and eventually learned to be happy there, even to the point of not wanting to leave for Cambridge when the time came.

What William thought of Westminster we do not know. If he ever wrote about his years there, those letters have not survived. But, he certainly learned his Latin and Greek, the school's primary focus, and he surely participated in Westminster's yearly performances of Latin plays. He also studied math and science and probably other languages as well. Although there is nothing to suggest that William excelled at Westminster, no saved letters bragging about notable performances academic or theatrical, he polished his sketching skills—and prepared for his college role as the "father of all mischiefs."[6]

2

COLLEGE CONNECTIONS

A BRAVE NEW WORLD!

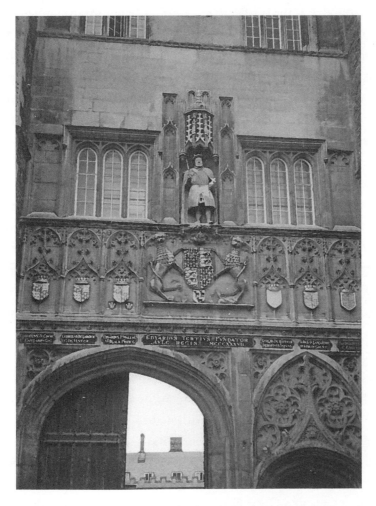

6. The Great Gate. Trinity College, Cambridge.

Willliam hopped out of the carriage, stretching his stiff legs and gazing up at the Great Gate of Trinity College, Cambridge. Not quite 17, he was eager to settle into his new rooms and begin his first experience of living away from home.

William was not entirely on his own though; his brother Henry was already studying at the smaller Trinity Hall, where the boys' great-uncle Sir William Wynne was Master. And soon George would also study at Trinity Hall, the college of their father. During William's first year at Cambridge, he and Henry saw much of each other, often breakfasting together. Probably Frances charged Henry with keeping an eye on his younger brother; possibly some of the conflicts of their boyhood years had been outgrown. Still, William had been singled out, the only one to attend Cambridge's largest and one of its most prestigious colleges, home to Francis Bacon and Sir Isaac Newton, to name only two famous alums.

Did Henry and Frances send William to Trinity College to keep him apart from his older brother—or to give Henry some breathing room from William? The family member who remains a mystery, Henry might have been less self-assured, less imposing than William. When he left Trinity Hall, Henry did not take the family's traditional Grand Tour, or join his father in Parliament, or settle in at Kingston Lacy to learn the details of running the estate. Henry seems not to have shared an interest in the classics or in art and architecture, William's passions.

Trinity College looks much the same today as it did when William arrived, fronting on Trinity Street, backing onto the River Cam, and composed essentially of three quads. Although founded as early as 1546 by Henry VIII through the combination of several small colleges, its Great Court design was created by Thomas Nevile, Master of the College from 1593 to 1615. Just as students do today, William entered the Great Court through the wooden Great Gate with its sculpture of Henry VIII looking down—except that thanks to college pranks he now holds a chair leg instead of the original scepter.

From his rooms facing the Great Court, William could see the Gothic chapel, completed in 1567, and Master's Lodge bordering the north side with the Clock Tower between them. He ate in the dining hall on the west side and visited other students' rooms that completed the square along the south side and the east side up to the Great Gate. He crossed the center of this beautiful green space on paths circulating around the college's famous fountain, rebuilt in 1715–16 according to its original 1601–1602 design. To get to Byron's rooms, William strode past the dining hall to Nevile's Court, a smaller square encircled by cloisters and eventually completed on its west side by Sir Christopher Wren's stunning 1695 library. The college insists that the bear Byron brought to Trinity was not housed in his rooms but elsewhere in Cambridge. Byron, always a lover of animals, usually possessed several dogs in addition to more exotic pets. Annoyed by college regulations specifying no dogs, he rather quickly displayed his attitude toward rules by bringing the bear instead.

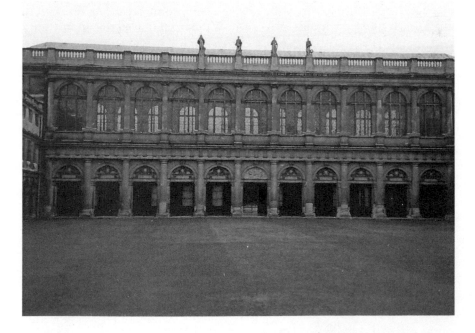

7. The Wren Library, Trinity College, Cambridge.

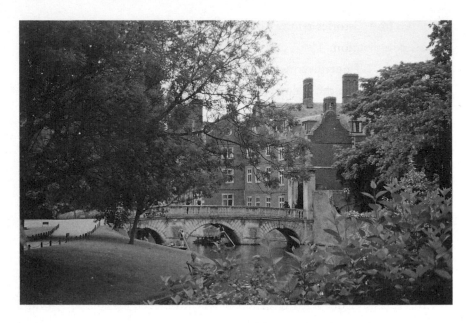

8. The River Cam, seen from Trinity College, Cambridge.

Clearly pleased with his own space, William embraced the opportunity to complete his first decorating scheme. In November 1803 he wrote to his grandmother Margaret Bankes describing his rooms, beginning with his large drawing room, which was

> uncommonly neatly, though not expensively, furnished, and my bedroom is very suitable to it with all its accoutrements. I also have a third room which has no fireplace and I use it rather as a light closet than a dwelling room. Three of my windows look into the quadrangle and one looks backward with a view of Caius College, Trinity Hall and King's Chapel. . . . My library is a very great and very useful ornament to my rooms, which are now as well furnished as any in college.[1]

The teenaged William was proud of his rooms, his taste, and—his tutors would be pleased to note—his books. Among William's many papers are receipts for books and lists of books, books in Latin and Greek and Italian,

grammars and histories and famous authors, some certainly purchases for his college collection.

William did not give a full account of his decorating to his grand-mother, but he gave those details to his great uncle, or, more likely, invited Sir William to visit his rooms, for Sir William sent him prints of the Gothic Exeter and Durham cathedrals. The Trinity Hall Head Master commented in an 1804 letter that he knew what William already had and that he would send along "as many Gothick ornaments as can well be employed in the intended improvements of your rooms."[2] William's choice of a romantic Gothic style did not go unnoticed at Trinity. One contemporary wrote that Bankes "fitted up some of his rooms in imitation of a Catholic Chapel and used to have the Singing Boys in dress suitable to the occasion, come and sing there for him."[3]

The extensive decorating, probably not entirely in line with College rules, included an altar at which William regularly burned incense. Some have assumed that Byron first met John Edleston—the fifteen-year-old cho-rister and subject of an early poem "The Cornelian"—in the college chapel, but Byron could just as easily have seen Edleston first in William's rooms. Byron wrote that he was initially attracted to Edleston's voice, then to his appearance—fair-skinned with dark eyes—then to his personality.[4]

When Byron arrived at Trinity in October 1805, he was seven-teen, unhappy that his mother and guardian John Hanson had sent him to Cambridge instead of Oxford, and on an allowance that could not be stretched to cover the cost of the lavish lifestyle to which he aspired. Never a good student at Harrow because he balked at rules and requirements, Byron was nonetheless brilliant, widely read, and competent enough in Latin and Greek to handle college work had he desired to perform. But initially, at least, he seemed more interested in style than substance and was quite pre-pared to enjoy all of the riotous dissipation readily available at Trinity. He wrote to Hanson: "Yesterday my appearance in the Hall [dining room] in my State Robes was *Superb*, but uncomfortable to my *Diffidence*" (see color plate C5).[5]

Byron was immensely proud of his title and the Newstead Abbey estate that he inherited—especially after an early life of tight finances and conflicts with a mother who had no understanding of the boy's sensitive, reflective nature. But at seventeen he was unpolished, at times withdrawn and melancholy, known for his "tumultuous passions." Embarrassed by a limp caused by his club foot, he was not yet the gorgeous and famous young man he would become. He eased into his new world at Trinity by strengthening a friendship with Edward Long, whom he had known at Harrow. They read and swam in the Cam together.

New experiences and friendships awaited both Byron and William at Cambridge. Byron met William and, probably through him, the brilliant if not entirely career-focused Charles Skinner Matthews, who became a close friend. William also knew John Cam Hobhouse, but it was Byron's tutor who made that introduction. Hobhouse would advance to an illustrious career in Parliament as a Whig reformer in the House of Commons. In spite of his public position, he remained one of Byron's closest lifelong friends. As a young man at Cambridge, his strong feelings for Byron would lead to a jealous interest in keeping Byron away from William.

Another figure in this group of friends was Scrope Berdmore Davies, the quintessential Regency Dandy, a great wit and womanizer and, unfortunately, a serious gambler who lived on "dining out" until he was required to flee from his debts to spend the rest of his rather wasted life in Belgium.[6] When Byron returned to Cambridge in 1807 to pack up his rooms before deciding to stay another term, he, Matthews, Hobhouse, and Davies became a close-knit group that did not include William. This regrouping developed at least in part because William was at home for some of the year. Earlier in Byron's years at Trinity, William and Bryon forged a friendship that, while testy at times—as one would expect between two proud young men with quite different personalities—endured until Byron's death.

What were the elements of this friendship? Given Byron's almost compulsive letter writing, William must have received more letters from Byron than have survived. Either William destroyed sensitive letters or the Bankes

family destroyed them at some point after his death. That there must be missing letters in itself tells a story.

For good and bad, Byron was precocious in every way. He later wrote in his journal that his "passions were developed *very* early—so early—that few would believe me—if I were to state the period—and the facts which accompanied it."[7] These lines may refer to either one or both of the two people who used him sexually. The first was a nurse, May Gray, with whom he lived in 1799 while obtaining some treatment for his club foot. She beat him, drank heavily and entertained male friends, but she also "used to come to bed with him and play tricks with his person," in the words of John Hanson writing to Byron's mother to advise her to fire the servant.[8] The second was Lord Grey, to whom the family estate Newstead Abbey was leased for five years until Byron reached his majority. During one term when Byron refused to return to Harrow, he spent much time at Newstead Abbey. His later intense dislike of Grey and refusal to see him again invites the inference that Grey seduced Byron.

Byron also had several summertime loves of girls in the neighborhood, experiences that found their way into some of his earliest poems. And he developed friendships with several younger boys during his last year at Harrow, the time he remembers in letters with much pleasure. Although some early poems addressed to these boys seem to extol an idealized friendship only, a poem to the Earl of Delawarr uses language more typically associated with passion. Even allowing for the overstatement of youthful, romantic poetry, readers are unlikely to accept that a heart *palpitates*[9] for a friend only.

As a youth Byron had the kind of beautiful, tender looks—including naturally curly hair and a full mouth—that he also found attractive in others. Even so, we could not expect him as a teenager to have anticipated Lord Grey's motives. He spent time at Newstead Abbey because it was his inheritance, it kept him apart from his mother with whom he was in constant conflict, and it seemed to offer a much-needed substitute father figure in Lord Grey.

Byron's strong reaction to Grey points to a troubled teen not at all certain of his sexual identity. When Hobhouse read Thomas Moore's 1830 biography of Byron, in which Moore fudges and dodges the issues of Byron's homosexuality, Hobhouse wrote in his journal that Byron "had nothing to learn in the way of depravity either of mind or body when he came from Harrow" to Cambridge.[10] If anyone knew of Byron's homosexual experiences it would have been either William or Hobhouse.

Byron may have first allowed a relationship with Grey and then broke it off in dismay. "Friendships" with boys at school can be perceived as innocent; Byron's relationship with the adult Grey could only be defined as, in Byron's later words, the "nameless crime." Homophobia in Regency England is almost beyond our imagining today. Men were hanged for sodomy. A man could be tried on the intent to commit sodomy and placed in the stocks to be abused with such violence by enraged citizens as often to die.

Although there were some calls for ending the death penalty in the early nineteenth century, and the number of hangings in general declined, the number for sodomy did not show the same decline. Neither fortune nor rank—nor marriage or holy orders—could protect one from exile, a scandalous trial, or death. One celebrated case was that of the fabulously wealthy William Beckford, author of the romantic novel *Vathek*, who was forced in 1784 to retreat to the Continent for ten years as a result of an accusation of sex with a teenaged boy.

The message from the British culture in the early nineteenth century to young men such as Byron and Bankes and Matthews was absolutely clear. Schoolboys fumbling under the sheets in cold dorm rooms, or forming idealized friendships with boys in the lower forms, was unfortunate but understandable—and best forgotten. To seek the subculture of sodomy at university was to risk one's future power and social standing. To pursue homoerotic desires beyond the college years was summed up later by Hobhouse—now a cautious, image-conscious politician—as "monstrous madness."[11]

Because William was part of a large, stable family and did not board at Westminster, opportunities for early sexual encounters would have been

more limited than Byron's, but of course they could have been found. Still, Byron probably arrived at Trinity more grown up sexually, if not socially, than William. Nonetheless, Byron looked up to the slightly older and much more polished William, describing him as his "collegiate pastor, and master, and patron."

Looking back on these years, Byron wrote that William "ruled the roast—or rather the roasting—and was father of all mischiefs."[12] These mischiefs included—in addition to the traditional wild parties and foolish pranks around campus and town—the harsh repartee and cynical criticism captured in the term *roasting*. Lounging in William's fanciful drawing room, these young men searched for the most compelling rhetoric, argued with their most profound logic, and sought the most damning classical quotation.

William and his new friend Byron would also have been schooled in the ridicule of society's institutions and human follies by Charles Skinner Matthews, known for his unorthodox religious views. When, in 1811, Matthews drowned in the Cam, Byron expressed great sorrow in a letter to Hobhouse. He was also curious about the apparent loss of Matthews's papers. When Hobhouse replied that it was best to forget the past, Byron responded that he could "hardly agree with . . . a wish to forget" and that it was odd that not "a scrap of paper has been found, at Cambridge."[13] Although Byron never doubted that the drowning was an accident, we have to wonder. And we should not be surprised that Matthews's papers were entirely missing. Either he chose to destroy his work or his family did the same censoring that took place in William's family. Among the best and brightest of their generation, these young men formed—within Cambridge's hallowed halls—their private gay community.

In response to an 1820 query from publisher John Murray regarding the possibility of a Matthews memoir, Byron wrote that both Hobhouse and Bankes were close to Matthews and that when he was first at college he met Matthews often in Bankes's rooms. In 1807 he became a closer friend, after he had left Trinity and saw Matthews mostly in London. Offering his assessment of Matthews, Byron asserted that Charles, who became a Fellow at the

university in 1808, was intellectually superior to all of them, even though his competition included such top-notch men as Bankes and Hobhouse. Byron also informed Murray that his letters from Charles would "hardly do for the public—for our lives were not over strict—& our letters somewhat lax upon most subjects."[14] "Somewhat lax"? Byron's understatement could not have said it better.

Byron, not William, was the letter writer; from him we see into William's world at Trinity. While waiting to sail to Lisbon in June 1809, Byron and Hobhouse wrote letters revealing the expectations that both men shared of the homoerotic adventures awaiting them in Greece and the Near East. Byron writes to Matthews to "express a vain wish that you were with us in this delectable region." He declares that they are "surrounded by Hyancinths & other flowers of the most fragrant [na]ture" and that he intends to cull "a handsome Bouquet to compare with the exotics I hope to meet in Asia."[15] Matthews, of course, knew his Greek mythology: A boy loved by Apollo was accidentally killed while playing quoits (pronounced "coits" in William's day) and turned into the hyacinth flower.

Matthews's response reveals that these young men were part of a gay community. He congratulates Byron on his success in writing a letter in a style "in which more is meant than meets the Eye." He observes that Hobhouse has also written in this style but recommends that "he do not in future put a *dash* under his mysterious significances" because doing so will reveal his true meaning should the mail carrier choose to "peep." Matthews continues:

> I do positively decree that every one who professes *ma methode* do spell the term wch [*sic*] designates his calling with an e at the end of it—*method-iste*, not Method*ist*, and pronounce the word in the French fashion. Every one's taste must revolt at confounding ourselves with that sect of horrible, sniveling, fanatics. . . . Adieu my dear Lord; . . . as grand founder and arch-Patriarch of the Methode I give your undertaking my benediction, and wish you, Byron of Byzantium, and you, Cam of Constantinople, jointly and severally, all the success which in your most methodistical fantasies, you can wish yourselves.[16]

One surprise in this letter is that Matthews includes Hobhouse in the fantasizing about "Greek love" awaiting them abroad. If this is correct, then Hobhouse seems to have started his "forgetting about the past" at the time of Matthews's death and to have committed himself to a private life above reproach so as not to endanger his public one. Possibly, under Bryon's influence, Hobhouse engaged in some youthful experimenting and then decided that he was heterosexual. When he left Byron in Greece in 1810 to return to England and work, Byron was happy to be alone for his tour of the Greek Morea. Knowing exactly what Byron intended to include in his tour—Byron took a Greek lad with him—Hobhouse had probably had enough and did not want to travel with conflict between them.

As Byron continued his travels, he sent letters to both Hobhouse and Matthews, regaling them with his sexual exploits during the final stage of his Mediterranean trip. If he also wrote to William, these letters—somewhat lax!—have not survived.

While at Trinity were Byron and Hobhouse and Matthews and William happy to bond in recognition of a shared sexual identity, or were they also, in some combination, intimate? The existing letters reveal their connectedness without spelling out precise relationships. However, it is quite possible that Matthews was William's first lover and that William was also intimate with Byron.

In an 1822 letter to Byron, William reminisces about his chapel, calling it "an architectural folly" that "must recall to both our minds some singular, some pleasant, some bitter associations."[17] In William Byron found an important friend, someone he trusted, someone who was "good-naturedly tolerant" of his "ferocities."[18] The young poet was in awe of the sophisticated and self-confident Bankes and appreciated William's acceptance of him in spite of his mood swings and lack of polish. Known for his own "singularity," in his mother's words, William had no problem with other odd chaps if they were bright and interesting—and if they were ready to take risks and ignore rules. Some sexual encounters may have strengthened this bond.

William also connected to Byron the poet in advance of others. Byron

first read the poetry of Sir Walter Scott in William's rooms and remained grateful for that awakening. From their reading and discussions together, William knew of Byron's own writing, but perhaps not of his plans to publish privately first his *Fugitive Pieces* (1806) and then *Poems on Various Occasions* just a few months later. But, William had been preoccupied. After finishing his studies at Trinity Hall, William's brother Henry asked his father to purchase an army officer's commission for him. In October 1806, Henry died in a shipwreck on the way to join his regiment in Sicily. Many who took to the lifeboats survived the wreck, but Henry refused to join them, perhaps because he thought the ship would not sink, or perhaps, like William, he could not swim and was terrified of the small boats. He was last seen struggling to reach a piece of the wreckage.

Young Henry's unexpected death saddened all of the family, but William's father in particular was deeply wounded by the loss of his first-born. William left Cambridge to join the family, an act of love or duty or both, but surely a difficult time for William too.

He wondered if his father's grief would have been as great over his death, and he now weighed the burden of becoming his father's heir. The stress shows in a March 1807 letter to Byron. He congratulates Byron on a successful lawsuit regarding his family estate but continues: "Your wealth is not chased by affliction, nor made a mockery of grief by pretending compensation—you have no brother to mourn for and to succeed." Feeling a bit sorry for himself, William asked his friend to destroy this melancholy letter.[19]

When William first returned to Trinity, he stayed for a time with his great-uncle, Master of Trinity Hall. In a letter from Hobhouse to Byron, who had left Trinity for good in December 1807, Hobhouse writes movingly of their separation—rather surprising because all of these young men will be in and out of London where they will see each other frequently. Hobhouse then comments on William:

> William Bankes is here at the Master's Lodge, Trinity Hall, living in state so he tells me—he told us yesterday that he wanted to buy a

horse for hunting—we asked him, "Why?" "Oh," said he, "you know in Dorsetshire I must hunt for popularity's sake!!!" Is not this complete Corfe Castle all over?[20]

Hobhouse's need to ridicule William to Byron led him to misread William altogether. Blinded by his competition with William for Byron's affection, Hobhouse is forgetting William's situation. It is possible that William gave up his rooms when he left at the time of Henry's death and must now wait to find new rooms. More likely, he kept his rooms but chose not to be alone when he first returned to Cambridge. The remark that he was living in state was meant as a joke, the Master's Lodge being far more commodious than the student rooms. William is not with the Master as a special privilege but because Sir William is family. Buying a horse can be joked about by the twenty-one-year-old William because hunting in Dorset will be much the easiest—if not the most appealing—activity of the future head of the Bankes family. This second son, until now marching to his own drummer, felt unwelcome pressures of responsibility and duty.

Back at Trinity, William wrote to the newly published poet: "Nothing is more difficult than to address an Author, more especially a young one, and this has deterred me from writing more immediately after the perusal of your poems." Clearly a "but" is coming, and William does offer his views along with a request for his own copy of the newly published poems.[21] Byron obliged by return post but not without misgivings.

In a letter to his Harrow friend Long, Byron writes that he is sorry to learn that Long has sent his "poor effusions to the perusal of Bankes." Believing that Williams's critical talents will outmatch his poetic skills, Byron writes that he "would have rather passed the *Ordeal* of an Edinburgh *Review*, than offered . . . [his] *Juvenilia* to his [William's] Inspection." William, in Byron's view, "has too much of the *Man*, ever to approve the *flights* of a Boy" so he waits "in trembling Suspense . . . [his] *Crucifixion* from his *Decree*." Byron includes a verse from William Cowper's satirical poem on friendship ("He'll plant a dagger in your Breast, / And tell you 'twas a *special Jest*, / By way

of *Balm*, for *Healing.*") as a comment on William's sharp wit and verbal sparring.[22]

In this letter to Long, Byron reveals as much of himself as he does of William, for William is not the only clever young man at Trinity ready to dissect and ridicule. For Byron, Long is the friend from his early teens who will be supportive regardless of his actual views of Byron's poetry. Bankes represents the adult world to Byron, a world that can praise or destroy him before he ever matures as man and poet. And Byron wants to be successful. William's judgment will hardly be worse than a negative review in the *Edinburgh Review*, but if William's judgment is too harsh, Byron knew his confidence will be shaken. However, he will not go down without a fight. In his response to William's letter, Byron shows his own mastery of satire:

> Your Critique is valuable for many Reasons, in the first place, it is the only one, in which Flattery has borne so slight a part, in the *next*, I am *cloyed* with insipid Compliments & have a better opinion of your Judgement & Ability, than your *Feelings*.—Accept, my most sincere thanks for your kind decision, not less welcome, because totally unexpected.[23]

Here are several clever zingers from Byron. There will be no flattery from his dear Bankes, no judgment softened by feeling. After taking his shots at William, Byron then turns to a more measured discussion of poetry, observing that since not even the best poems can withstand too close scrutiny one could not expect "the effusions of a Boy" to be beyond revision. Not only were the poems the work of a boy; they were written "under great Depression of Spirits," which accounts for their "gloomy Turn."[24]

Byron notes that he has more poems in manuscript that may be published, but at the moment he lacks the time or inclination to prepare them, and he published the first volumes "merely at the Request of my Friends." But he then announces that a new collection will appear in a couple of months, giving the lie to his studied denial of time or inclination for recognition and acclaim. At any rate, they will not quarrel on the

subject, Byron concludes, because "poetic fame is by no means the *'acme'* of my Wishes."[25]

Although it is easy to see through these excessive protestations, Byron's need to take a stance of disengagement is not caused by William alone. Both young men spent time in the company of fellows quick to ridicule just about everything, including taking oneself too seriously. In an 1806 letter, Henry Temple (the young Lord Palmerston and future prime minister) wrote of Hobhouse that he "possesses a good turn for sarcasm."[26] William will show the same attitude of disengagement in his letter to Byron announcing that he was busy preparing to sit for his BA exams—proclaiming that getting the degree is of no great value. Both have developed the stance of the casual amateur, the mark of the gentleman of that time.

When William returned to Trinity in 1808 to take his exams, he needed, finally, to engage in some serious preparation. He had not been a focused student during his first years in college. He found some science lectures interesting but was cocky enough to find the classics lectures boring—and they might have been, given his preparation at Westminster. But now his great uncle was encouraging diligence and offered the following advice for studying: "Scarce any book should be read without taking notes of it," and the notes should be studied again the following week. William should pause over striking passages and "lay aside the Book, and endeavour to express the substance of it aloud, in as correct Language as you can." Still good advice for learning, and apparently William took it. He passed his BA exams in 1808 and was awarded an MA in 1811. William's uncle also stressed that "Chronology and Geography must accompany History to make it at all intelligible,"[27] an important guide for the future student of Egypt's ancient ruins.

In her family history, Viola Bankes comments on William's most important relationship from his college years:

William John and Byron, both keenly alive to beauty and both privileged by fate to indulge their pursuit of it, whether in art, literature or

life, profited by each other's company. Broadminded, even eccentric himself, William John respected the peculiarities of others. He went his way, through stately halls and continents, enveloped in the smiling and unruffled cloak of his own good breeding and good sense.[28]

Good breeding certainly; good sense, not always.

LONDON

POLITICS AND PARTIES

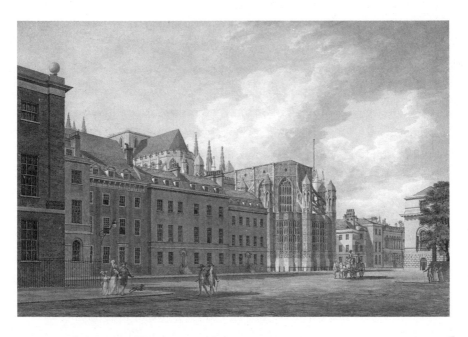

9. Old Palace Yard, with Westminster Abbey in the background. Watercolor by Thomas Malton.

W illiam buttoned his waistcoat, slipped on his jacket, and once again tried to smooth his wayward curls. He smiled in anticipation of tonight's dinner, contemplating the amusing conversation awaiting him. Although Byron would not be there that evening, he looked forward to the event, preferring dinner parties to another ball given by Lady

Jersey. Thinking about Byron gave William pause, but he brightened as he headed out to his carriage and reflected on an upcoming trip to the north of England.

This likely snapshot of William now in London makes clear that he is no longer at the center of Byron's world. A summer trip to Brighton with Hobhouse and Davies did not include William. And in April 1809, when Byron entertained Hobhouse, Charles Matthews, and others at Newstead Abbey—with much drinking and buffoonery in monks' robes—William was not among the group. It seems that they confined their joint activities to London, meeting at the same parties or dining together on occasion. We have a note to William from Byron, written in March 1809, that suggests they may have been in the habit of getting together alone or in small groups. On the evening in question, Byron had already headed out before William left him a message:

> I have just received your note [on his return home at midnight]; believe me I regret most sincerely that I was not fortunate enough to see it before, as I need not repeat to you, that your conversation for half an hour would have been much more agreeable to me than gambling or drinking, or any other fashionable mode of passing an evening abroad or at home.—I really am very sorry that I went out previous to the arrival of your dispatch; in future pray let me hear from you before six, and whatever my engagements may be, I will always postpone them.—Believe me, with that deference which I have always from my childhood paid to your *talents*, and with somewhat a better opinion of your heart than I have hitherto entertained,
> Yours ever &c.[1]

Byron is still noting a difference between William's talents and feelings, but giving more credit to his feelings than during their exchange over Byron's poetry.

Byron often wrote—both letters and poetry—late into the night and then slept until noon. When he left Cambridge in December 1807, he began a wild life in London, partying, drinking, and borrowing heavily

from usurers. Reaching his majority, he also took his seat in the House of Lords in 1809. At 21 he had published two volumes of poems, established some close friends from college, and assailed the London scene with drop-dead looks, a title, and no money.

Differences in politics and finances as well as temperament—more easily accepted by the two as young university men—caused more friction in London. Byron joined a Whig Club at Cambridge, and his lifelong attachment to Hobhouse—who would become a leader of the radical Whig group in the Commons—kept him at odds with the more conservative politics of William and his father Henry. Byron, by the time he leaves for Lisbon with Hobhouse, is so heavily in debt that he must seek a mortgage on Newstead, the first step to the agonizing realization that he will have to part with this visible mark of his aristocratic status. William, now heir to Kingston Lacy and its substantial grounds and farms, already draws an income of £8,000 a year (about £500,000 today)[2] from the estate. In addition he knows he will inherit Soughton Hall and other farms and estates in Wales from his great-uncle Sir William Wynne.

While Byron is the topic of endless gossip, William does not appear in the letters of London's powerful women, those ladies controlling society and quick to note where a young man's calling cards are left. When Byron strode into drawing rooms, heads turned and ladies quickly surrounded him. William, an extremely eligible young man, caused much less stir, suggesting that he was not chasing skirts, either those of young ladies looking for a suitable marriage or those of the already married looking for something on the side.

William and his friend are not in Cambridge anymore; the balance of power has shifted with Byron's London success. And yet William clearly wants to remain in Byron's orbit and will seek more of his attention upon Byron's return from his journeys through Spain and the Mediterranean.

Meanwhile William did what he was supposed to do: He took a seat in the House of Commons. For his first seat, from 1810–12, William did not campaign. He was given the representation of Truro, in Cornwall, by

his friend Edward Boscawen, 4th Viscount of Falmouth. Edward married William's sister Anne in 1810 and later became the 1st Earl of Falmouth.

These "pocket boroughs," as they were called, existed throughout England and were used by many men who would become important figures in government. Some were purchased; others given, presumably in exchange for support of either the government or the opposition. There is no record of money changing hands for William's seat, but we know that Henry Temple—who as Lord Palmerston would become a prime minister under Queen Victoria—purchased his first seat in 1807, a borough on the Isle of Wight that he apparently never visited.

In 1806 the young Arthur Wellesley, not yet the famous Duke of Wellington, campaigned for his seat, but he campaigned in Rye, not where he lived. Wellington, a good friend of the Bankeses, apparently succeeded in Rye by purchasing many rounds of ale for the voters. In 1807 he, too, purchased a seat from the Isle of Wight. There were many roads into the House of Commons. With William, the expectation was that he would support the administration, that is, the prime minister and his government, and thus help his brother-in-law Edward obtain his earldom.

Edward's Cornwall home, Truro, has castle ruins dating to the twelfth century. Well situated as an inland port also controlling the busy port of Falmouth, the town thrived by combining shipping with tin mining and other industries that effectively used the area's rivers. The Boscawen shipping family could trace its family tree back to the thirteenth century. Their estate, Tregothnan, was a three-day journey for William. Since Edward was not at Cambridge, William probably first met him in London. Did they meet at a party of mutual friends, or did William's mother develop the connection, seeing Edward as a good match for her daughter? Or, did William's father first meet Edward through the previous representative from Truro and seek to obtain the seat for his son? All are possible explanations, for the world of England's landed gentry early in the nineteenth century was really quite small.

What is certain is Frances Bankes's coup in securing a wealthy, titled

young man for Anne—at least in the eyes of society. But after their wedding in August 1810, Edward refused to ride in the carriage with Anne to the Bankes's town home for the reception, an odd decision at best. The following summer Anne gave birth to their only child, the requisite son and heir, an uncommonly small family for the times. Edward probably shared William's sexual preference, which he chose to hide by marrying. William was quite close to his sister Anne and held Edward in high esteem; he certainly wanted both of them to be happy. When he reflected on Anne and Edward, on his own future, on life, how honest were his thoughts? How much denial and repression were necessary to carry on? William might have denied to himself the significance of sexual passion in a happy marriage.

William coped at least in part by keeping busy. Both before and during his first term in Parliament, he traveled extensively throughout England. He made sketches and took notes of architectural features that attracted him and also noted some furniture and carved wood that he found for sale. He visited Newstead when Byron was not there and later wrote to Byron to suggest that he plant some trees, as William was doing at Kingston Lacy. Byron of course had no money for improvements to Newstead. William had money but not really the authority to redecorate while his father lived. But William, developing his keen eye for design, assumed the authority, and his father, for the most part, indulged his son's decisions.

Although Henry himself did not make major changes to Kingston Lacy after his extensive remodeling early in his marriage, he took his role as estate owner seriously and was always active in local issues. But, considering the time he spent in London and the need to educate his young sons, in 1794 Henry chose to lease (and later purchase) No. 5 Old Palace Yard, a large five-story home directly across from Westminster Palace and next to his friend, the social reformer William Wilberforce.

The houses in this area are gone now, although Edward III's jewel tower (erected in 1365 and located just behind Old Palace Yard) remains standing, as of course does Westminster Abbey. After Henry's death many years later, when William's brother George suggested selling No. 5, William objected

strongly, arguing that it was the family's only town home and in so convenient a location. Convenient to Parliament, yes, but never the most fashionable address, and certainly not when George was keen to sell. William understood, though, how much it represented his father and was unwilling to let it leave the family.

Henry, like previous Bankeses, took his seat in the House of Commons. He represented Corfe Castle and then Dorset for a total of fifty years—before losing his seat in 1831 as a result of the strong Whig reform movement. All William needed to do was calculate the total number of years spent in Parliament by all of the Bankeses who preceded him to feel the powerful weight of such a legacy—and the duty it now imposed on him.

Throughout Henry's fifty busy years in the Commons he was determinedly independent, occupying a seat on the cross benches, never sitting with either the Administration or the Opposition. The cross bench became known as "Bankes's bench." In a speech in 1817 George Canning referred to Henry by saying:

> My honorable friend is well known for the independent manner in which his speeches and his votes are directed, sometimes to this, and sometimes to that side of the House; a manner the most conformable to the theory of a perfect Member of Parliament.[3]

Although many of his votes place Henry in support of the Administration—that is, the Prime Minister and hence the Crown—Henry's close friendship with both William Wilberforce and William Pitt support the image of an independent voice. Henry voted with Wilberforce to end the slave trade and was, much of the time, a supporter of William Pitt, prime minister at the age of 31 for most of 19 years until his untimely death in 1806. Henry, William Wilberforce, and William Pitt all started their careers in the Commons fresh out of Cambridge in 1781, in their early 20s, a young age even for the eighteenth century—though less remarkable for that time than for ours. As Pitt enlarged his power in the Commons, he

gathered around him a number of young men from Cambridge, including Wilberforce and Henry. Frequently after a session, the Cambridge group would join Pitt for supper at 10 Downing Street and talk and drink late into the night. When Parliament was not in session and members had retired to their country homes, Henry exchanged letters with both Pitt and Wilberforce as they continued to debate issues facing the House and the country.[4]

One House member, observing that at times Henry voted against Pitt, asked if this affected their relationship. Henry's response was "not at all." Henry spoke on just about every critical issue during his years in the House, beginning by opposing Lord North and the war with America. Always a voice for the control of spending, Henry became an expert on parliamentary procedure and was instrumental in developing the system of House committees to oversee the administration. While serving on the finance committee, he frequently criticized military spending.

Henry's close connection to the major power brokers from the 1790s on can be seen when, on February 1, 1793, Pitt stopped Wilberforce from speaking against going to war with France by sending Henry to get Wilberforce to yield the floor and sit down. Henry conveyed Pitt's promise that Wilberforce would have a chance to speak at a later time. Unfortunately Pitt could not deliver on that promise; later that same day France declared war on England.[5]

By the beginning of the new parliamentary session at the end of December 1794, Wilberforce knew that he would have to break with his dear friend Pitt over the war. Earlier he had explained his views in detail in a letter to Henry. He sought strength and support for his speech in opposition by gathering a group around him for dinner at No. 4 Old Palace Yard instead of joining Pitt at 10 Downing Street. Henry was one of Wilberforce's supporters at this dinner. The opposition vote was defeated, and Pitt's government was not destroyed by his friends' actions. Eventually fences were mended and these long friendships endured.[6]

A young William saw his father's connection to power in Pitt's and

Wilberforce's visits to Kingston Lacy. Wilberforce, troubled by bad eyesight from an early age, visited more than once but was rather quickly discouraged from shooting partridge.[7] He proved to be more of a danger to the other shooters than to the partridge. As a young boy, William met these powerful political figures at Kingston Lacy and, when he was home from university, saw them in town at Old Palace Yard. At tea young William overheard conversations about state issues; as a university student, he listened to discussions at the dinner table and when the men retired to their port and cigars. In spite of this exposure, William never caught political "fever," never felt the pull of either state finances or matters of war and peace with France, never acquired the itch for power that he could sense in his father as well as in Pitt and Wilberforce, two of the most powerful men in young William's England.

By the time William took his seat in the House, his father was a significant power broker in the Commons. Never the charismatic leader like Pitt or the powerful orator like Wilberforce, Henry developed his influence through his committee work and behind-the-scenes strategies. Following his death the *Gentlemen's Magazine* lauded him as "one who endeavored throughout a long public life, faithfully and honestly to fulfill the functions of an independent representative."[8]

How could William possibly find a place in the Commons outside the large shadow cast by his father? His would be a tough act to follow for any son. In William's case he did not even get to "follow" his father but had to serve in the same room with Henry. In his first session, William supported his father's tireless efforts to pass a law restricting the Crown's right to award sinecures but otherwise voted in support of the administration, as Edward would have expected. (Henry probably was initially drawn to the issue of sinecures—paid appointments with little or no work required—as a cost issue, but after years of work on the problem it became both a moral issue and one of personal power and prestige.)

William's first speech in the Commons, not delivered until near the end of his first session in Parliament, was by all accounts unsuccessful. There was even some confusion as to his point, as he seemed to be damning Catholic

relief with faint praise. One member described the speech as "like a ranting whining bad actor in a barn speaking a full tragedy part, and mix'd up with the drawls and twangs of a Methodist preacher."[9]

In addition, William presumably struggled to clarify a complex allusion to the lake of Geneva. An unkind reference to this awkwardly expressed allusion in Lord Teignmouth's memoirs may be explained in part by the fact that, in 1822, William would defeat Lord Teignmouth and seven others to win a seat representing Cambridge. If the speech had really been as awful as described, Byron would not have encouraged his friend to participate more actively in future sessions. Still, as he rose that first time from the cross bench "owned" by his father, William must have wished instead to be dining with Byron—or even hunting in Dorset.

William's great-uncle was less supportive than Byron, though for different reasons. In a letter dated December 26, 1810, Sir William writes:

> I can not say I envy you the enjoyment of your late nights in the ... Commons. . . . You must all I suppose regret being deprived of the pleasure of passing the Holidays cheerfully and quietly in the Country. I heartily wish you may be repaid by the satisfaction of having been instrumental in bringing things to a tolerable settlement, but the prospect is but gloomy.[10]

William and his father were kept in town by long sessions debating the prospect of declaring George III unfit to rule and giving power to his son to govern as prince regent. The government faced this issue several times, as George III had bouts of insanity and then recovered his wits. The debate over Christmas was not settled until January 1, 1811, at which time the prince was made regent. Henry voted against the regency, but there is no record of a vote cast by William. Perhaps encouraged by his uncle's words, William decided he'd had enough of long speeches and headed for Kingston Lacy to enjoy some of the holiday with the rest of his family. Henry surely scolded his son for refusing to sit through the long debates until a decision was reached and adjournment declared. William, less interested in the

politics of the debate, may have calculated that his vote would not change the result. Heading home seemed the most sensible move.

While it is true that politicians of any age are likely to insist that they are faced with critical decisions that will affect the future of the country, certainly Henry Bankes's years in the House of Commons were significant in shaping the modern Britain that would emerge in the nineteenth century. In addition to debating a monarch's capacity to rule—and Parliament's right to decide such an issue—these members of Parliament developed the power of the prime minister as head of government and established a party system. They faced decisions of war and peace again and again, with the American colonies, with France in Egypt, and then in Spain as they pushed back against Napoleon's plans to own all of Europe, plans finally destroyed in 1815 at Waterloo.

William and his father could gaze at Westminster Palace, seat and symbol of Parliament, from their parlor windows. Some days Henry must have paused outside his front door to walk to the Commons with his next-door neighbor Wilberforce, the tireless opponent of the slave trade. Henry participated in private meetings with Wilberforce and other abolitionists as they developed strategies for getting their legislation through both the Commons and the House of Lords. Interesting times that William grew up in. Tough issues debated at the family dinner table must surely have captured William's attention and prepared him for a life of political involvement. But they didn't. His interests and temperament would lead him elsewhere. The House of Commons was not William's milieu, and when Parliament was dissolved in 1812, William resigned his seat and declared himself happy to be done with it.

Henry's two homes stand as symbols to his divided loyalty. In the long run his career in Parliament was probably closest to his heart. Henry's education, travel abroad, improvements to the estate, and long, dedicated years in the House of Commons mark him as the perfect Bankes. His willingness to accept William's changes to Kingston Lacy long before his son became the owner reveals that Henry's first love could be found in London, not in

Dorset.[11] William's first stint in Henry's House showed him what would *not* become his passion; he would need several more years to hone his special talents and find his passion.

Byron devoted less time to the Lords, in spite of the pride his title gave him, than Bankes did to the Commons. Soon after taking his seat, Byron left with Hobhouse, in the summer of 1809, for a journey of two years to Portugal, Spain, Albania, Greece, and what is now western Turkey. Upon his return he attended at least some sessions, but by 1813 he writes to his half-sister Augusta that "parliamentary schemes" are not to his taste, that he hates "the thing altogether," and that he does not intend to "'strut another hour' on that stage."[12]

Famous now as the author of *Childe Harold* and infamous for his various affairs, Byron—extravagant, moody, scathingly satirical—wisely left politics and governance to Hobhouse. Byron could never fully shake loose or repress his demons; Hobhouse could forget his youthful antics, button down, and lead a long and respectable public life that culminated in the reward of a lordship. Although William listened to Byron's railing against the political scene, he did not need his friend's distaste of governance to justify his own retreat from his father's House.

Byron's first tour would establish the initial itinerary for William's first journey out of England. But Byron's motives for the trip were different than William's. Byron's lawyer John Hanson warned him that leaving was a mistake, given the state of his finances that included a long list of creditors. In return, Byron makes clear that he is not running from his bills—he would never do that—but that there are other "circumstances which render it absolutely indispensable, and quit the country I must immediately."[13] Writing to Hanson from Albania, Byron mentions again that he had to leave, writes that he will never live in England, and concludes that the reason "must remain a secret."[14] Byron was trying to escape either his attraction to boys (an attraction he had been recently reminded of in a letter from the Cambridge choirboy Edleston, who was seeking employment in London) or public knowledge of his bisexuality.

Hobhouse returned from his Mediterranean journey with Byron in time to witness London's July 8, 1810, police raid on the White Swan Tavern in Vere Street. The raid resulted in about twenty arrests of gays at this popular meeting place. Many were pilloried in stocks outside the mayor's home and, after trial, were hanged for sodomy or intent to commit sodomy.

Given the ferocity of homophobia demonstrated in these events, Hobhouse apparently decided that for him, at least, it was time to stick to the straight and narrow. He did, however, keep some of Byron's revealing letters from Greece, even though he had previously begged Byron to burn his Cambridge journal—when he chanced upon it in Byron's suitcase. He also was quick to warn Byron not to discuss some of his more personal adventures in Albania and Greece with even close friends. To his credit, Hobhouse never hid his lifelong friendship with and loyalty to the friend from university whom he loved the most.

What did William think of the Vere Street raid and subsequent hangings? Did he know that his Trinity friends Charles Matthews and Scrope Davies visited one soldier and his sixteen-year-old drummer boy in prison? How did he react when the incident was discussed at parties or his own dinner table? Although the record is silent, William's internal anguish must have been severe.

Both Byron, upon his return from Greece, and William were in and out of London, both participating in the 1812 London season. We see William at this time, in the miniature painted by George Sanders (see color plate C2), looking younger than his twenty-five years, pretty and romantic, with auburn curls, dark eyes, and cupid mouth. Possibly Byron commissioned this miniature—he commissioned Sanders to paint a number of miniatures for him in 1812. More likely, knowing that Byron was using Sanders, William went to him for the portrait. William surely showed the portrait to his friend—and just as surely discussed the Vere Street arrests with him. Already contemplating travel outside of England, William also asked many questions about Byron's Mediterranean travels. Knowing Byron, we can guess that he ignored Hobhouse's advice and

provided William with tantalizing tidbits as well as a list of sightseeing suggestions.

Sadly for William, these were troubling times for his friendship with Byron. In an April 20, 1812, letter William complains that he is not responding in jealousy to Byron's literary success and reminds Byron that his was an early voice in praise of his friend's poetry. William writes that he feels something has come between them and concludes by offering "every kindest wish."[15] Byron's same-day response reveals that William complained to Byron when they were together and then went home and wrote the letter asserting a change in Byron's manner. Byron responds:

> I feel rather hurt (not savagely) at the speech you made to me last night, and my hope is, that it was only one of your *profane* jests. I should be very sorry that any part of my behavior should give you cause to suppose that I think higher of myself, or otherwise of you, than I have always done. I can assure you that I am as much the humblest of your servants as at Trin. Coll.; and if I have not been at home when you favoured me with a call, the loss was more mine than yours. In the bustle of buzzing parties, there is, there can be, no rational conversation; but when I can enjoy it, there is nobody's I can prefer to your own.[16]

Not satisfied that he had healed the wound, Byron wrote again to William, seeking to assure his friend of their continuing friendship while at the same time suggesting that William ought to be able to figure out what might be keeping them apart:

> My eagerness to come to an explanation has, I trust, convinced you that whatever my unlucky manner might inadvertently be, the change was as unintentional as (if intended) it would have been ungrateful. I really was not aware that, while we were together, I had evinced such caprices; that we were not so much in each other's company as I could have wished, I well know, but I think so *acute* an *observer* as yourself must have perceived enough to *explain this*, without supposing any slight to one in whose

society I have pride and pleasure. Recollect that I do not allude here to "extended" or "extending" acquaintances, but to circumstances you will understand, I think, on a little reflection.

And now my dear Bankes, do not distress me by supposing that I can think of you, or you of me, otherwise than I trust we have long thought. ... no one shall ever "make mischief between us" without the sincere regret on the part of your ever affectionate, &c.[17]

When William read this letter, he surely understood that Byron did not allude to something so simple as understanding Byron's celebrity, that he was surrounded at every party by adoring women. Byron is right that at the "buzzing parties" he could not free himself from his admirers to engage in "rational conversation." And while Byron certainly loved the attention, he also was made uncomfortable by it, his shyness often resulting in his having little to say, in contrast to the fun-loving fellow that his friends enjoyed in private. Byron's letter also establishes that he does not mean "extending acquaintances," his lovers, although they do take time away from conversations with William.

Byron is asking William to consider how the two of them might be perceived if they were known to spend much time together. Byron is determined to present himself to society as totally heterosexual and is anxious not to behave in any way that would reignite rumors that once connected him to the Cambridge choirboy—rumors that sent him on his Mediterranean tour. Byron may be especially sensitive on this subject because early in 1812, when he and Lady Caroline, one of Byron's many lovers, were still close, he told her of his homosexual experiences, foolishly believing that she, a rebel too, would be sympathetic, perhaps even amused. And, in response to the Vere Street raid in 1811, Hobhouse cautioned Byron to be discrete about his bisexuality. Perhaps there was also some "buzz" about William—a casual remark from time to time about William's apparent lack of interest in finding a wife—that Byron had heard and heeded.

Did William finish reading Byron's letter with his head in his hands,

crushed by Byron's coded message? The balls were boring, filled with too many flirting girls and oppressive mothers. Dinner parties could be stifling, too, when the conversation turned to finances, the Irish "problem," or war with France. These discussions made him feel guilty for leaving Parliament. Byron was busy enjoying an early fame and polishing his image in society. Hobhouse was hard at work, Davies addicted to gambling, Matthews now dead. A search for new companions was fraught with danger. His father had made it all look so easy, moving smoothly from university to political career to marriage and family. Where was William's niche? Not in the London of 1812.

4

TIME TO GET AWAY

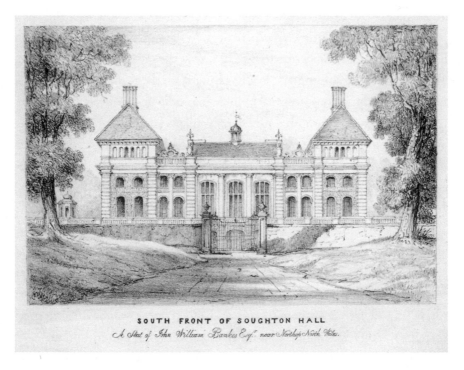

SOUTH FRONT OF SOUGHTON HALL

A Seat of John William Bankes Esq.ᵗ near Northop North Wales.

10. Engraving of Soughton Hall, Wales, inherited by William in 1815. Lithograph by N. Whittock.

Leaning out the carriage window, William watched London fade behind him. As he left the city, traveling along the post road southwest to Dorset, he thought through the clothes and books and writing paper he would need for his upcoming tour of Wales. He planned to repack for

this trip at Kingston Lacy and then head west to meet his brother-in-law Edward in South Wales. William looked forward to their trek through rural Wales and to this chance to build his friendship with Edward. Long hours spent bouncing over rutted roads or in the saddle never tired William; his spirits soared with each new vista, from Dorset's New Forest to Wales's green valleys and castle ruins.

Interested in capturing his experiences, William wrote lengthy letters to his great-uncle. William writes that he has "seen the most remarkable features of two South Welch Counties" by digressing from their original travel plans. Presumably Edward was happy to indulge his companion's desire to see more than what was on their initial itinerary. William concludes his letter to Sir William by asserting that travelers should see South Wales first because it is much more tame than the north, "even in scenes which are in themselves of a romantic cast."[1] In the south one could also find some of the wild, untamed landscapes so admired by romantics in the early nineteenth century.

The two visited towns and castle ruins and traveled along the coast, all described at length for Sir William in a travelogue that blends a general sense of the area's arresting beauty with specifics of the roles various castles played in English history. Eventually Edward left to take a ferry back to his Cornwall home, while William continued some solitary wanderings through north Wales before returning to Kingston Lacy and London.

Among William's sojourns in England was the bold—perhaps foolish— visit to the famous Fonthill Abbey, a huge Gothic-styled church and home built by the wealthy William Beckford. As a youngster, Beckford inherited a fortune worth an estimated 30 million pounds from his father, an owner of several Jamaican plantations, in addition to an annual income of possibly as much as 32 million pounds in today's values. Alleged sexual misconduct in 1784 with sixteen-year-old William Courtenay created a scandal that resulted in Beckford's decision to flee to the Continent. In Switzerland, Beckford's wife died, leaving Beckford to travel alone around Europe for ten years, after which time he returned to England and built his Abbey, often referred to as Beckford's Folly. He enclosed his estate in a six-mile-long

and ten-foot-high wall—with spikes along the top—and lived alone, never accepted back into English society.

In December 1811, William decided to explore Fonthill and later wrote to his Grandmother Bankes about his daring visit. After first contemplating scaling the wall, he tried various arguments to be let in at the gate, but the woman guarding the entrance was not moved by his entreaties. She stalwartly maintained that no one had been admitted for the last five years and that William would be excluded as well. So it was the spiked wall or nothing. "Obstinately bent upon my project," William writes to Margaret Bankes, "I changed clothes with a poor labourer and put on a smock frock and ragged hat and trousers and in this masquerade climbed the wall and pales." Ignoring his bloodied hands, William walked the grounds, studying "the abbey in every point of view." Whenever he was addressed by those working on the grounds, he asked for work but was repeatedly advised to leave. Upon learning that Beckford was driving around his estate, William boldly opened the 30-foot-high door, entered the great hall with its gilded oak roof, and climbed a long flight of stone steps to a part of the house in the great tower "which is an octagon and runs up the whole height near 200 feet. This forms the center of the grand gallery . . . which had crimson blinds and all the other furniture crimson to correspond. Beyond this at one end is the chapel." William continues:

> I saw his dinner laid out in a low moderate room to the south, a profusion of gold plate but only one knife and fork. When I had seen all that I could hope with any safety, I walked out again after not having encountered a single servant, although he keeps so many. . . .
>
> I took advantage of the workmen coming away to get out at the gate, and could not resist afterwards dancing and shouting around the old woman who was so determined I should not come in. I afterwards gave her half a crown for being so trusty to her master.[2]

Scaling the wall at Beckford's Abbey may have been the first time that William disguised himself in order to enter a forbidden place he was

determined to see, but it will not be the last. We might wonder why he did not first write to Beckford, seeking permission to visit. But, we can accept the servant's assertion that no one had been admitted for five years and conclude that the reclusive Beckford would not have issued an invitation. In this adventure, William is not primarily a prankster; he wanted to explore this much-talked-about Gothic building. And, after foiling the trusty servant, he generously tipped her. Still, William's father, the prudent public figure, must have been horrified at his son's sneaking over walls to invade a private home.

William continued his rambles in England when Parliament was not in session. His great-uncle writes that he has not mentioned William's coming to Soughton Hall, as he was not clear that it was on William's itinerary, so if he goes he will have to take it as it is. Sir William probably kept only a few permanent staff at the house in Wales. William may have visited the Hall during his Wales jaunt with Edward in 1809, but Sir William's letter apparently refers to a later visit.[3] Some of William's lists of furniture and carved wood for purchase were gathered with an eye to redecorating what will become his estate in Wales. Soughton Hall, a substantial four-story brick home with lovely grounds, was originally built as a bishop's palace in 1714. Presumably Sir William, much like Henry, did not object to William's redecorating plans prior to ownership. After more extensive remodeling in the 1820s, with some help from the architect Charles Berry, William gave Soughton Hall to his younger brother Edward and his large family.

William's travels included a trip to the north of England, rambles in Wales, but also south along the coast. In the summer of 1811, he writes to Byron at Newstead Abbey that he is happy to learn of Byron's safe return to England and notes that he would have stayed a few days longer in Dover if he had known that he could then have seen Byron on his return. William mentions the loss of Charles Matthews and observes how much he enjoyed his visit to Newstead as part of his northern tour. Because this letter opens with William wondering if Byron can imagine who is writing to him, we must conclude that few, if any, letters came to William during Byron's two years

abroad. But Byron is back—in spite of his earlier proclamation that he would no longer live in England—and William seeks to renew their connection.

William writes that he will soon be heading to his place in Wales where he will be a month "*absolutely* alone" with no family. He invites Byron to visit him there.[4] He writes again in mid-September from Soughton Hall, once more inviting Byron to come, insisting that it is not far.[5] Presumably Byron responded to these invitations, although those letters no longer exist. We do have a letter to Hobhouse, however, which Byron wrote after the first invitation, in which he opines: "I have had a letter from Bankes, of the patronizing kind, where I am invited to '*one* of *my places* in *Wales*'!!" (This is the same letter in which Byron objects to Hobhouse's suggestion that they forget the past, as a response to the sudden death of Matthews.) Byron writes that he is all alone and getting melancholy letters from his half-sister Augusta, that he means to marry for money because he "can't afford anything to Love." He wishes Hobhouse were with him so they "can laugh again as usual & be very miserable dogs for all that."[6] In short, Byron is more than a little depressed—and more than a little cruel—for there is no intended patronizing in William's letter. He clearly wants to be with Byron. Meetings between these two college friends during the spring and summer of 1812 went from bad to worse for William. Near the end of September, he writes to Byron:

> I should not have thought that friends had been so over plenty with you that you could afford to throw them away. I must however do you the justice to say that there were no pains spared to break that intimacy, that subsisted between us, & although these efforts have at last succeeded, I feel that I still owe you some thing for having held out so long, & therefore you shall receive this one kind farewell & the best wishes of one who was
> > Your very affectionate
> > > > > > Wm John Bankes[7]

William sent this sad letter to Byron at Cheltenham, so he still knew of Byron's activities. Byron responded immediately, beginning by asserting that he would accept William's farewell but not until he could provide a better

reason than Byron's "silence which merely proceeded from a notion founded on your own declaration of *old* that you hated writing & receiving letters." Byron rather cuttingly asks how he was to find "a man of many residences" but then goes on at length in a chatty style with the news that Newstead is sold and a query about the next meeting of Parliament. He apologizes for not fulfilling some orders before leaving town but explains that if Bankes knew of "all the cursed entanglements" he had "to wade through" he would not have to offer an apology.[8] Since William had begun to think of travel abroad, the orders Byron refers to may have been requests for information and letters of introduction.

Byron's letter ends with an expression of affection and his name in Greek. A week later William responds from Kingston Lacy that he is out of Parliament, at leisure in the country, and dreaming of Spain and Portugal, remembering what Byron has told him of those countries. Once again William invites Byron to visit, this time to Kingston Lacy. Once again Byron does not visit—but they do seem to be writing more warmly and talking together of travel. And, they are both courting Annabella Milbanke.

The scheming Lady Melbourne encouraged Byron's courting of her brother's daughter, Anne Isabella (Annabella) Milbanke, in an attempt to end Byron's scandalous affair with Lady Caroline Lamb. A much spoiled only daughter, Annabella at nineteen was wealthy, attractive, and well-read, with an interest in mathematics and philosophy, labeled the "Princess of Parallelograms" by Byron. Her cleverness unfortunately failed to give her insight into her aunt's plot or keep her from feeling flattered enough by the famous poet's attention to question his motives. Although Byron wrote that he had no desire to become better acquainted with her for "she was too good for a fallen spirit to know" and "I should like her more if she were less perfect,"[9] he did propose later in the year and was initially rejected, as was William. But with much encouragement from Lady Melbourne, the two agreed to be "friends" and to continue to correspond.

Perhaps Annabella did fall in love with Byron—other women did—or perhaps she was impressed by his fame and also felt that she could reform

him in some way. She surely had her aunt continuing to whisper in her ear about the wondrous qualities of the handsome poet, and so, in September 1814, she agreed to marry Byron the following year. If she had said no, Byron would have set off on another trip with Hobhouse and might well have joined William in Egypt. Instead this too smug and certainly too innocent young lady entered a disastrous marriage with a too complex, too moody, and too highly sexed man for her to even imagine, much less handle. She probably figured out that Byron was having an affair with his half-sister Augusta, and it is also possible that Byron told her of his homosexual experiences. Soon it was over. Annabella returned to her parents with her infant daughter, and Byron chose exile in Venice, understanding that many in London society would close their doors to him.

Byron needed the money that a marriage to Annabella would bring him, but why did William call on her? He does not need her considerable inheritance. And is it really possible that each was unaware of the other's courting? In a letter to Annabella, Byron describes a visit from William in the winter of 1812. William appeared looking so distressed that Byron had to ask the problem: "After much hesitation on his part—and a little guessing on mine—out it came—with tears in his eyes almost—that he had added another name to our unfortunate list. The coincidence appeared to me so ludicrous that not to laugh was impossible—when I told him that a few weeks before a similar proposal had left me in the same situation."[10] This is amusing drama: Two old friends, both so eligible, both crying and laughing over the news of their rejections by the same woman. But, this letter is written in August 1813, more than six months after William comes with his sad news. And Byron, continuing his letter, turns the tale into a compliment to Annabella.

What did William see in Annabella? It is doubtful that he believed he needed reformation. More likely he was doing what was expected of him. He could see that his friend Edward had succeeded in marriage and in producing an heir with his sister Anne. Perhaps he could do this as well. So he selected a woman who seemed intellectual enough not to get the vapors or

be silly, a woman not emotionally demanding, traits that would suit Byron as well. In a letter to Byron, Annabella enjoys mocking William, pointing out that he left so many calling cards she thought of returning them to him for economy's sake.[11] But, since William was not really smitten, what better way to give the impression of serious intent without much emotional effort than by managing to drop by when the lady is out! He could hardly have been crushed by Annabella's dismissal—annoyed for a time because he did not get his way but rather quickly relieved that he did not have to go through with the marriage. After all, he proposed just before beginning an extensive journey he had been planning for months. No impatient bridegroom here.

Unable to take the typical Grand Tour of previous Bankeses because of Napoleon's campaigns in Europe, and having heard Byron's tales of Spain and the Mediterranean world, in the fall of 1812 William, dreaming of the Alhambra, began making plans for a journey to Portugal and Spain, perhaps to Malta and Sicily, with Egypt and the Near East in the picture as well. He assures Byron that travel beckons more strongly than "becoming an Orator & a Statesman & I do not know what" in Parliament. Instead he will "tourify" (Byron's term), readying himself with "a servant, a Bed, a Canteen, some maps, a pair of Breeches, & a stick of sealing wax."[12]

When William asks Byron what else he needs, Byron prepares letters of introduction for William but also points out that the Mediterranean world is now filled with British travelers to connect with, should Bryon not be able to join him. Further advice includes not to trust the Greeks, never to be bullied, to take care about *firmans* (permits to travel in Ottoman-controlled countries), and to carry "*knickknackeries*," gifts to "the Beys and Pachas" to smooth the way.[13]

William's indulgent uncle Sir William Wynne, pleased to learn from his nephew that he intended to travel "seriously," sent William £500 for the trip and encouraged him not to hurry back because "all the world is now open to the curiosity of the traveller."[14] Sir William did warn William to expect much devastation throughout Spain, as the French troops had been in skirmishes with Spanish insurgents since the 1808 uprising against Napoleon's

brother Joseph, who had been given Spain to govern. Fortunately for the British troops, Lord Wellington (not yet a duke) embraced the concept that an army marches on its stomach and wisely maintained a supply route through one of Portugal's ports. The pillage of the French troops had left nothing in Spain for Wellington's 60,000 men—or very little except art-works, as William will discover.

Fortunately for William's pocketbook, his uncle did not see one of William's last letters, written as he waited for the ship to set sail on January 20, 1813. One was, of course, to Byron, once more entreating him to come in the summer and "buffoon with me in Palestine and Egypt." In the same letter he jokes that Byron was not to come without "*our Benjamin* or I shall send you back to fetch him or Joseph and his good natured brethren."[15] Benjamin and Joseph are likely the nicknames for some of the boys they knew at Cambridge. So much for the courtship of Annabella.

William dashed from his cabin to the deck to hand off his last letters before the anchor was hoisted. Reaching out toward his known world, toward Byron, William then turned his face to watch the ship head out into the Channel waters to begin its six-day journey to Lisbon—and the launching of his more than seven years of travel throughout the Mediterranean. Ready for new adventures, yet still wanting to share them with Byron, William could not have imagined at this moment just how far he would travel from his England, now fading from view.

By March of 1813 William had traversed much of Portugal, writing to Byron that he had "been loaded here with sweetmeats & civilities, & am to travel upon mules & Letters of Recommendation." In this letter to the silent Byron, William offers Byron the excuse that Byron's letters to him must be sitting in a dead-letter office somewhere, but William also describes the country's landscape and "delicious climate" and informs Byron that in three private homes along his way he found copies of *Childe Harold*. All is not sweetmeats and private libraries, however. Toughened now by the ship's pervasive stench and challenges to hygiene, William chose to focus more on the rugged beauty of the country than on the difficulties of travel: "There is

not an evergreen in our garden, nor a flower in our greenhouses but is there and all this close upon the margin of the Atlantic with not a house nor an inclosure to interfere with the prospect. If ever I abjure the world it shall be at Arrabida."[16] His romantic response to this rugged, isolated area is similar to his earlier delight in the wildness of Wales.

William may first have traveled into Spain by continuing north through Portugal to Spain's most northwestern tip, for he wrote to his mother from the Galicia area sometime in 1813. Off the beaten track, away from homes with private libraries, on horseback or by mule over bad roads, William took pleasure in the landscape, bedding where he could. For his mother, he described one stop where the lady of the house not only fed him chocolates but also such attention that she was in his room "both after I was in bed and whilst I was getting up,"[17] an attention he did not appreciate. When possible, he chose to stay in monasteries, although many of these had been ravaged and abandoned by the years of fighting and plundering.

In spite of the dangers in the war-torn Peninsula, and its crumbling infrastructure, William did meet other British travelers there, including James Hamilton Stanhope, who made the following observations after meeting him in Oporto (modern Porto):

> I met the other day ... a very extraordinary young man ... I never saw so singular a compound of eccentricity and judgements, of trifling & study, of sound opinions about others and wild speculations about himself, good talents applied to no future object and a most wonderful memory prostituted to old songs and tales of Mother Goose ... I like the man much for he appears to have an excellent temper, a good heart and a certain degree of freshness and independence in opinions which I do not think the travelers who come to this country generally possess.[18]

Stanhope's sketch captures the complexity of William, his talents—including his prodigious memory—and his lack of purpose or direction; his charm as well, but also an element of silliness, the "buffoonery" not yet put aside from his college days.

What did William say to warrant Stanhope's assertion that he did not seem to know himself? William had begun to draw and paint on this trip, making architectural sketches of significant buildings in Portugal and Spain—although just on scraps of paper rather than in a proper sketch-book. Did he seek to present himself to Stanhope as an architect? Or artist? There would be no reason to claim training he did not have, for a gentleman did not need a profession but would be admired for amateur talents and an interest in art or history. Stanhope's observations suggest that William still lacked purpose or direction in his wanderings, that he bragged about something in an unbecoming way, but that he was a good fellow for all that, someone Stanhope both liked and found extraordinary. The direction and purpose will come.

William's travels in Spain were determined more by troop movements than guidebook. He spent some time in Wellington's camp, not as a member of the army but as a guest of his father's good friend and because Wellington enjoyed being surrounded by dashing young men. William took advantage of this opportunity to hone his skills of storytelling in the officers' mess, but he also saw some of the army's action against the French troops. In one hasty retreat from Wellington's forces, the French commander-in-chief Marechal Soult fled on horseback, leaving his carriage as one of the great spoils of the war. The carriage was filled not only with money and jewels—and Soult's silver chamber pot—but also with a treasure of Spanish art originally obtained by Napoleon's brother from the pillaged convents and churches and then, somehow, acquired by Soult. Some of this loot came to Wellington, including Diego Velázquez's *The Water-Seller*. William, though not a recipient of any of Soult's art in Spain, knew of Soult's stash and later wrote to his father to watch for the sale of works from this price-less collection.

In the fall of 1813, while Wellington was still trying to push the French out of northern Spain and back into France, William was living in Pamplona in disguise in the midst of the French. His sneaking into French-controlled territory, possibly pretending to be Italian as he was fluent in that language,

reminds us of the fellow who climbed the wall of Beckford's estate—only with this exploit he was in much greater danger than at Fonthill Abbey. After his return to England, William recounted this adventure to Princess Lieven (wife of the Russian ambassador to London). Apparently he dined with the French commanding officer who fed him "a meal of rats washed down with strong drink, and after dinner obliged him to buy a Raphael, which he had stolen from the Sacristy of the Escorial, and a donkey, which I don't think he had stolen from anybody."[19]

According to Lieven's retelling of Bankes's story, William spent most of his money on what he thought was a Raphael and then had only enough left to book passage on a ship home for himself but not the donkey—as the ship's captain demanded! This version of the story cannot be correct, as William did not leave Spain until 1815, and then he sailed for Italy and eventually Egypt. He did, however, buy *The Holy Family with the Infant St John in a Landscape*, one of the finest works in the Bankes's collection, although now considered to be from Raphael's workshop, not exclusively from the master's hand (see color plate C6). Presumably he used the donkey to get out of Pamplona alive and then head south to see more of Spain.

To William's credit, he appears not to have plundered for art as the French officers did first, followed by the English. Wellington, bothered by the plundering during the war (according to Bankes family tradition), said to his officers: "Gentlemen, I will have no more looting, and remember, Bankes, this applies to you also." William's response to this was to jokingly send some of his art purchases home to Kingston Lacy addressed to Lord Wellington.[20]

Also to William's credit, he saw the opportunity to purchase artworks at good prices, the usual situation in wartime. He had studied art history texts as well as the art collections in English country homes he visited before traveling abroad, and had taken notes on one work by Raphael that he had seen. He seized this moment to put together one of the first large collections of Spanish art in England. He purchased works by such dominant figures as Bartolomé Esteban Murillo, Francisco de Zubarán, Francisco Ribalta, Alonso Cano, and Diego Velázquez, but also by less well-known painters

such as Pedro Orrente. And, he had a remarkable plan: to hang all of his Spanish collection in a new dining room he was imagining, according to a specific scheme he drew, with notes. Many years later, when William remodeled Kingston Lacy, he did not adhere to his original drawing in all details, but he did adopt the basic concept shown in his sketches. What we now enjoy is the richly decorated Spanish Room at Kingston Lacy.

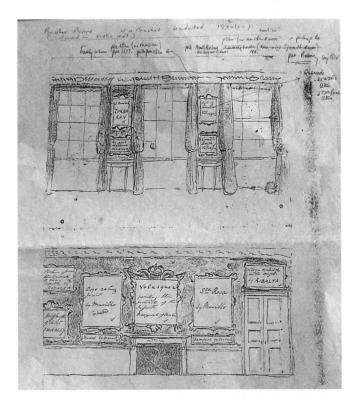

11. One page of William's plans for hanging the Spanish paintings. Note the "Velázquez" over the fireplace.

William probably purchased more than what we now see at the Dorset estate. Some works may not have made it safely to England; others were hung at Old Palace Yard or Soughton Hall and later sold for various reasons. He did not select any paintings by El Greco or Goya, although both were

well known at the time. Perhaps their works that he found for sale were too dark or too religious for his taste. Still, he purchased with great care, paying attention to provenance and authenticity as best he could, as the following list he made of works purchased in the Granada area reveal:

> The good shepherd by Murillo that was in the door of the Sagrario of the nuns del Angelo
>
> The Virgin receiving a scepter from the hands of the almighty belonged to the same nuns by Alonso Cano
>
> St Francis visited by an angel from the convent of S Diego by A Cano
>
> S. Bernardino d++ do. do.
>
> Sta Rosa by Murillo with his name from the collection of the Marquis of Diezma
>
> El Venerable Roelas de Cordova. Cano
>
> El Conception a sketch by Murillo from the Cartuxa ... I suspect this served for the model of the great one in the Convent of S Francis of Seville.
>
> Samson & the Lion & Moses and the burning bush by P. Orrente
>
> An Old Man's Head much in Rembrandt's manner bought of the widow of an artist who had a large collection.
>
> Heads of a man and woman bought of the same I think the man's is by Murillo.

In a letter to his father he explains that he bought *The Virgin and Child with Musical Angels* by Ribalta on "the opinion of several good judges ... for all the court was in Valencia at the time." William felt a need to defend his purchase since his father did not admire the work. He continues, in the same letter, to defend his purchase of the Velázquez, believing it "will be the finest in England, though not a finished picture." He describes the painting for his father and notes that he "was a long time in treaty for it and was obliged at last to give a high price."[21] William valued this painting highly enough to ask Sir Henry Wellesley, Wellington's brother then in Spain as well, to personally carry it home for him.

William thought initially his Velázquez was a preliminary oil sketch for the artist's *Las Meninas*, a painting not yet widely known and acknowledged as Velázquez's most famous work. In fact, what William purchased is the only known copy of *Las Meninas*, most likely painted by Velázquez's son-in-law Juan Bautista Martínez Del Mazo. Velázquez's famous work was painted for the royal family, kept in the royal apartments, and not displayed until it was hung in 1819 in the new Prado Museum. Velázquez apparently let his son-in-law make the copy for a patron, the 7th Marquis of Carpio. The only other known owner was the eighteenth-century art patron Gaspar de Jovallanos, whose family sold it to William in 1814.

Thus, in a way not expected, William's version is still as rare and important a work as would be a preliminary sketch by Velázquez. And it became England's introduction to this special seventeenth-century Spanish painting. Sadly, the genuine Velázquez purchased by William, the artist's magnificent portrait of Philip IV of Spain and William's finest purchase, was sold in 1896 by his heirs. It now resides in the Isabella Stewart Gardner Museum in Boston.

William's interest in his Spanish collecting continued after he arrived in Cairo in 1815. Learning that his father was going to Paris, he asks him to search for a painting by Juan de Juanes: "the only master wanting in my collection and very rare." He also urges his father to inquire quietly about Soult's plunder, especially "the famous Murillo of the *Birth of the Virgin from the Cathedral of Seville*," in the hope that it could be purchased for 3 to 500 pounds. The son presses his father, pointing out that these "are opportunities which will not occur again and Heaven has placed me in a situation where I am not likely to feel the loss of £500."[22]

In October 1814 Annabella Milbanke picked up some news of William from a friend traveling in Granada. She told Byron: "I have heard more of Bankes at Granada—he is living there in a beggarly, eccentric fashion."[23] Annabella did not have it quite right. In two and a half years William saw most of Portugal and Spain, a guest at times in homes of the rich; a visitor to the cities, the palaces, the churches throughout Spain; a camp follower in

the midst of a war; a traveler off the beaten track, getting lost and taken in by generous peasants. Did he live for some time with the gypsies in Granada or just meet them along the way? It doesn't really matter. Much of his trek through the Peninsula was in gypsy fashion—or, more daringly, in disguise among the French. But, whatever his sleeping arrangements, at least some of his time in Spain was spent in the purchase of an art collection unique in his time. His pleasures in decidedly simple living may have been "eccentric," but his spending for art was never "beggarly."

5

EGYPT

A GIFT OF THE NILE

12. The Step Pyramid at Saqqara, ca. 2650 BCE.

Illiam sailed into Cairo in August 1815, prepared for a short visit to the bazaars of the city and the pyramids at Giza. He arrived with Portuguese servant Antonio Da Costa, who would remain a faithful companion throughout William's travels around the Mediterranean. Antonio was given charge of their boat at Aswan when William had to shift to a much smaller craft at the First Cataract, and he later nursed William through a serious illness in Cyprus.

William traveled to Egypt from Spain with Antonio by way of southern Italy, Sicily, and Malta. In Italy, he picked up mail, prepared his will, and purchased new clothes. Visiting Pompeii, he avidly watched the ongoing excavations there, including the removal of a frescoed wall. Riding south of the Amalfi Coast, he paused to walk through the tall grasses covering much of the foundation ruins of the ancient Greek site at Paestum. He stared in awe at the three sixth-century BCE temples, two in the early Doric style, the third in a mix of Doric and Ionic. Fairly well-preserved markers of a magna-Graecia colony, the temples are majestic—if lonely—in their now rural world.

In Sicily more ancient Greek colonies awaited his visit. He sat on the stone seats of Taormina's third-century BCE Greek theater, renovated by the Romans and used today for summer festivals, and then rode south to sit in Syracuse's fifth-century BCE theater, also still in use, and the city's third-century CE Roman arena, large but less well preserved than the theaters. Did William sail from Syracuse to Malta or continue to explore Sicily's Greek colonies, traveling west to Agrigento, unable to pass up Sicily's most stunning relics of ancient Greece? The new city of Agrigento, a port on Sicily's southern shore, was probably a good place from which to complete his journey to the small island of Malta, from which ships regularly sailed to Alexandria. In addition, he would have the chance to ride out to one of Greece's most economically successful colonies, as its eight temple ruins attest. All built between the sixth and fifth centuries BCE, the Concordia Temple is the best preserved—because it was later used as a church—and without question the most perfectly proportioned. To visit at sunrise or sunset would have transported William back in time to the world he had studied at Trinity. And yet none of Italy's ancient sites would quite prepare William for the world of the Pharaohs waiting for him across the Mediterranean.

In Malta, William purchased Arab robes—although he continued to wear European dress—and then sailed on to Alexandria and into the "English-country-home" care of British consul Missett. On Colonel Missett's fine horses, he rode across the battlefield on which English and

Turkish soldiers defeated Napoleon's army—and was quick to observe that the remains of a fort there had actually been constructed by the Romans. He was also dismayed to see how little was left of a once glorious city founded by Alexander and inhabited by the Ptolemies, who ruled Egypt from that wealthy and beautiful city for over 300 years.

There were good reasons for William to stay longer in Alexandria. Two include the spread of plague to Rosetta and the sinking of a ship with the loss of all passengers on their way to Cairo. In addition, apparently Egypt's pasha, Mohammed Ali, unable to keep order in Cairo, had retreated with 2,000 soldiers within the locked gates of the Citadel. Undeterred, William chose to push on to Cairo, carrying papers from Missett designed to grant safe passage—though unlikely to protect against plague or shipwreck.

Seeking to provide some defense against the plague, William paid for a ship large enough to accommodate sleeping onboard. At Rosetta the British representative sent fresh fruit to his ship, including bananas, which William had not seen before, and advised against entering the town. But the unstoppable William went ashore anyway and toured the bazaar, purchasing a seated scribe statue. When swirling winds churned the water and blew sand everywhere, William and his frightened crew briefly abandoned the ship at a small village before continuing the journey to Cairo. Hardly a relaxing sail to Egypt's capital, but William was too excited to dwell on these early challenges to travel in this startlingly new landscape.

Settling into a monastery in the section of the city available to Westerners, William introduced himself to the British there and, following the advice of Bryon, prepared to present himself to Mohammed Ali, the Ottoman pasha ruling Egypt. But, there would be no "buffooning" with Byron in Egypt, as William had hoped when he first left England. Did Byron write that he had married Annabella? (He probably did not write that he was also having an affair with his half-sister Augusta.) Fortunately, William's solitary travels in Portugal and Spain and his serious art collecting had weaned him from Byron's sphere. He was ready now for new possibilities—and found them in the mysterious land of the Pharaohs.

On an elegant horse surrounded by attendants provided by the pasha, William rode into the Citadel one afternoon during Ramadan. As a result he had to wait for his audience until guns throughout the city signaled the sunset—and the pasha had his dinner. Rather than steam with frustration, William explored, admiring the Citadel's open courtyard and fountain with its cool breezes and stunning views of Cairo. Somehow, he also managed a tour of rooms normally closed to visitors. These he found impressive in their size but badly decorated.[1] Already he was reaching the conclusion that Western Europe's Gothic style had been inspired by the East. Finally he met the pasha and was promised the *firmans* needed to travel safely into Upper Egypt.

After camping with gypsies in Granada and witnessing some of the fighting between British and French forces from Wellington's camp, William felt no threat among the hot, dusty throngs crowding the narrow streets of Cairo. Day and night he was out exploring. Still in Western dress but stripped of his frock coat, he soaked one embroidered handkerchief after another while exploring the array of goods at the Khan al-Khalili, Cairo's massive bazaar, active since the Middle Ages. He absorbed the bustling life along the waterfront and peered into mosques he was forbidden to enter. Enjoying a Turkish bath, William stayed in the hot water so long that he emerged wobbly and faint into the still heat of the city.

William also met John Lewis Burckhardt, a Swiss who had perfected his Arabic after years of study in England and Syria so that he could travel throughout the Middle East and Egypt disguised as Sheikh Ibraham. Burckhardt established his travel plans when he came to England with a letter of introduction to Sir Joseph Banks (no relation to the Bankeses) and was accepted by the members of the African Association to travel through Africa to locate the source of the Niger River. In 1809 he left England for Syria, continued to polish his Arabic and knowledge of the Koran, and then traveled throughout Syria and (modern) Jordan in disguise. He arrived in Cairo in 1812, planning to join a caravan in Libya but instead journeyed up the Nile to Abu Simbel and then, when he could find no caravan heading west, went east through the desert and on to Mecca. He was back in Cairo

in 1815, still planning on a journey to the Niger River, although exhausted from the heat and hunger and bad water that he had endured.

Here was a fellow traveler, a man who could match William's daredevil spirit and pleasure in risk taking. Here was a man willing to do more than bloody his hands in laborer's clothes to assault the high walls of Fonthill Abbey one day; here was a man who for years risked immediate death should his Muslim disguise fail him. Indeed, Burckhardt was so struck when he realized that he had found Petra, the city of the Nabateans "lost" to the West since the Roman Era, that his Bedouin guides became suspicious. In his published journal, Burckhardt writes that he tried not to show his amazement at the site and hurried on to complete a sacrifice—his excuse for the trip into Petra.[2]

William, always the one who loved to do the talking, listened intently to Burckhardt's accounts of ancient sites in the Middle East and of the fabulous temples along the Nile all the way into Nubia (modern Sudan). Although just two years older than William, Burckhardt became his mentor as well as a friend, providing maps and advice. William wrote that it was Burckhardt with whom he would have most enjoyed traveling, had their plans coincided. Burckhardt described William as one "who bears his faculties, & rank, & fortune most meekly, and is both indefatigable & accurate in his researches."[3] He could see that William had the money possibly to avoid the worst of the hardships and the classical education needed to contribute to the world's knowledge of ancient ruins. William changed his plans. He would sail up the Nile—a decision that initiated more than four years of perilous journeys and amazing discoveries before he finally turned his steps back toward home.

While waiting for a ship to be outfitted for his first journey up the Nile, William decided to tour the Sinai. This decision was prompted by conversations with William Turner, just back in Cairo from a 25-day excursion into that eastern part of Egypt. The two men rode out together after dinner to explore Cairo in spite of dire warnings that the city was not safe for Westerners. William, listening to Turner's account, decided that the Sinai

was also a journey worth experiencing. Leaving just as soon as he could put together guides and provisions—and clearly seeking bragging rights—William completed the same trip in only 16 days on camels whose "pace is very unpleasant going down hill & not very safe going up." He wrote of annoying sand-flies, sickening water, and freezing nights requiring three blankets. But he was also enthusiastic about the landscape and birds of the area—and the dramatic Mount Sinai. He was pulled up to St. Catherine's Monastery by a rope, allowing him access to the building via the garden.

Turner told William that the monks owned only three bibles, no other books or manuscripts. William could not believe Turner. He conducted his own search through the monastery, certainly in areas not open to guests, and discovered at least 2,000 books and manuscripts. He commented that the books often "stand three deep, are full of dust and haunted by hideous spiders." He was either given or "borrowed" four works, which he showed to Turner back in Cairo. Only one of the books listed in Turner's travelogue now resides in the library at Kingston Lacy. Perhaps the others were later returned to the monastery.

More important than proving Turner wrong—and showing the world once again his ability to get behind closed doors one way or another—was William's stop at the former turquoise mines at Serabit el-Khadim. There he explored a temple to the goddess Hathor decorated with hieroglyphs and there he began his copying of inscriptions. A student of languages, William understood that the accurate copying of texts would eventually open up Egypt's ancient language of pictures. And the key to understanding a culture was through its language, not just its buildings and artifacts. His remarkably accurate copies of texts he could not read requires the patient attention to detail we more readily associate with the scholar than with the fun-loving mischief maker of William's college days. William has found a new purpose, as Turner's tribute reveals:

> His publication will teach us more respecting the East than that of any trav-
> eller who has yet described it; for he goes everywhere, fearing neither danger

nor fatigue, collecting more information than any other man could obtain, and never forgetting what he collects. I freely own my own anxiety, that my humble journal, if printed at all, should appear before his return, for I should not expect any one would read it after the publication of his.[4]

We should remember that even though the Rosetta Stone had been in England for more than ten years, no one was yet close, in 1815, to understanding the Egyptian language. There were no Egyptologists, no archaeologists exploring ancient ruins for insight, no linguists seeking knowledge through the study of Egyptian texts. William stood at the beginning of a new era. His first trip up the Nile launched him into the first wave of serious Egyptian exploration.

His boat readied and crew hired, William sailed out of Cairo on September 15, 1815, on his way to the Second Cataract in Nubia. Before leaving he wrote to his father, assuring him of his safety but also announcing that he will be traveling for some months up the Nile with his "brigade," just like Napoleon's army.[5] Henry's son sounds dutiful in this letter, makes light of Egypt's dangers, but also makes clear to his father that he is in no rush to return to England. He has serious work to do—as Napoleon's scholars before him.

His staff included Antonio; Haleel (an interpreter hired in Alexandria); François Barthow, his primary guide; and the former soldier Giovanni Finati, fortuitously hired by Barthow to do a bit of everything: interpret, guide, and protect the party. An Italian who had fought in the Ottoman army, Finati would end up traveling with William in both Egypt and the Middle East. Finati's *Narrative of the Life and Adventures of Giovanni Finati* was edited by William and published by John Murray in London in 1830. The two small volumes provide much of our information about William's journeys. Finati dictated his account in Italian to William who then translated it into English, adding scholarly footnotes later—and probably writing a good portion of the second volume.

As we learn from Finati, William's ship had two cabins and boasted two masts—although one broke only a short way into their journey, requiring

a stop for repairs. Typically, travelers heading south sailed whenever they had a favorable wind because the alternative was either rowing or getting men to pull the boat with ropes as they trudged along the river's edge. On the return trip, William would be able to travel on the river's current and so would have more control over stopping to explore and then starting up again. Still, excursions onshore because of stops for repairs or provisions— or because William saw something from the river that he could not wait to investigate—were characteristic of their journey south.

Reaching Thebes (modern Luxor) in twelve days, William was forced to remain in the stifling cabin while the crew took on additional provisions. He was entirely blinded by a serious eye infection. Many would have turned back to Cairo, but William, once more undeterred, pressed on. Although unable to explore Luxor on the journey south, William spent time there on his return, studying both the Karnak and Luxor Temples. He was now regularly drawing and taking notes, even if hastily and at times just on scraps of paper.

Capturing the intensity of the Nile's influence on his imagination, William writes:

> Of all the parts of the world which I have visited and countries which I have seen, Egypt and Nubia are those which interested me, beyond all comparison, the most, and have made the deepest impression upon my mind. The very face of nature, and her ordinary course and operations in those countries do not resemble any thing that we have been used to see, and a stranger does not remain long enough in them to cease to be delighted and surprised ["astonished" was written first and then crossed through].
>
> I saw the Nile, upon my first coming, full, but not overflowing; I saw it a month afterwards spread as a sea over the whole face of Egypt, with villages as if swimming upon its surface, and men and cattle wading from place to place; that I looked upon it for the last time, it was from the [summit of the—added] great Pyramid, in the month of December, it had then shrunk into its natural channel, and [originally and then crossed through: I saw that it had already turned December into spring and that the ground was] covered and already marked by the brilliant green of young vegetation.[6]

13. The Nile River. From Finati's *Narrative of the Life and Adventures of Giovanni Finati.*

The Nile today is a sleepy river, controlled by the Aswan Dam, its yearly inundation a thing of the past. But then the Thames, William's river, has also lost much of its romantic allure. Gone are the high-masted sailing ships bringing goods and travelers from all parts of the world to London's ports, the ships on which William sailed. And yet, having lived near the once mighty Thames and sailed along the coast of France and Portugal and into the Mediterranean, William still wrote in awe of the Nile. The world's longest river, the Nile—*river valley* in Greek—was also called *Aigyptos*, the source of the word *Egypt*. The ancient Egyptians called it "the black land," referring to the fertile silt deposited during each year's inundation. In Egypt alone the Nile travels 750 miles, from Aswan to Rosetta. It is formed by two branches, the White Nile from East Africa and the Blue Nile from Ethiopia. The Blue Nile is the primary source of the volume of water that each June to September spread—before the Aswan Dam—over the river's banks.

Unique in its length, the Nile has other notable characteristics. It flows through six cataracts from Sudan to Aswan. These jutting granite rocks and swirling waters made continuous river travel impossible most of the year, resulting in at least a partial physical barrier between ancient Nubia and Egypt. And, except for its southwest flow in a huge bend in Sudan, the Nile flows north. Hence Upper Egypt is in the south—at the beginning of the river's flow into Egypt—and Lower Egypt is in the north. In the best of ancient times for the country, the pharaohs are shown in temple wall drawings wearing both the white crown of Upper Egypt and the red crown of Lower Egypt; they had united the land into one state. It is the flow of the Nile that defines Upper and Lower in any discussion of Egypt's long history. So William sailed *up the Nile* from Cairo to the Second Cataract, the first Englishman to sail that far south, and one of only a few Europeans to do so by 1815.

William continues what was surely intended to be an introduction to his own book on Egypt:

> To a European the Palm tree and the Durum tree and the Sycamore and the Tamarisk, which are constant features of the landscape, are strange and exotic.

A boundless desert of sand commencing sometimes from the very river's edge, or huge [shapes?] of red granite rising abruptly from its bed to the height of several hundred feet, and balanced fantastically one upon another, are scenes that present themselves to him in his journeys up the river. The casual phenomenon of the mirage, or even the calamities of swarms of locusts on the Kampsein wind are something that he has but imperfectly conceived. It is not another climate, it is another nature that is before him.[7]

This other nature is striking indeed. One can stand close to the Nile with one foot on green, arable land and the other in a desert that stretches all the way to the Atlantic. A desert on both sides of the river, actually, called "the red land" by the Egyptians. William describes the "Kampsein" wind—usually spelled Khamsin from the Arabic word for *50*—a hot, dry wind that blows sand from the Sahara across Egypt and over the Red Sea. It can blow for several days at a time, usually during the 50 days or so from March to May. In this other nature there are hills, low mountains that in many places slope close to the shore.

The hills to the east provided gold and minerals and semiprecious stones, contributing to the country's wealth. They also offered some safety from would-be conquerors. These hills, so dramatically close to the country's central "highway," invited the ancient culture's stonemasons and artists to shape rock-cut temples and tombs and provided the limestone and granite for the great building projects. And the western hills of Luxor (ancient Waset, called Thebes by the Greeks) provided the resting places of kings and queens. Some of the tombs were safe from discovery and pillage until William's time. Others, King Tut's tomb, for example, were safe for yet another century.

William's descriptive passages shift from landscape to Egypt's ancient buildings, even as his purpose shifts from tourist to serious student of the past:

Yet this is not all, nor even, in my mind, the highest point of interest which Egypt and the country above the Cataract offer to the traveler: There are works of art which for their vastness and their singularity (and

almost for the antiquity) seem placed in competition with these marvelous features of nature that surround them. In considering the productions of man there is something in remote and almost aboriginal antiquity that particularly engages us and inspires us . . . with respect. Stonehenge in our own country is an example of this. How much has been written and conjectured, how much ingenuity and wonder has been bestowed upon that rude and uncertain structure! Yet, venerable as it is, when we reflect that the earliest period to which it has been assigned dates but little . . . before the Roman Conquest, it is not too much to ascribe a triple or a quadruple lapse of ages to those edifices upon the banks of the Nile which were erected we know previous to Rome itself, before even the heroic ages of Greece, before the foundation of Nineveh or Babylon or Jerusalem. It is only by some such scale as this that we arrive at a just contemplation of a duration so prodigious and so disproportioned to that of all the human works with which we are acquainted. We there visit Temples and Tombs which the ancient Greeks and Romans themselves visited as antiquities.

[I]n his journey up the Nile the traveler . . . may examine almost daily Temples of every species and dimension . . . many such intact and entire with their . . . roof and their mystic chambers, . . . wind[ing] through a thousand passages which were perhaps forbidden to the eyes of the profane in the day of their sanctity. . . . In observing their construction he will be mortified and be obliged to infer that at this late period of the world . . . we have advanced so little. . . . He will find that the Greeks and Romans whom we have been content to acknowledge our superiors in the greatness . . . and solidity of their monuments have gained not a step upon their predecessors.[8]

William, the classics scholar, is now bewitched, under spells recited by temple priests. He can hear them chanting as they carry the sacred barque—a shrine shaped as a ship containing the most holy sculpture of each temple's primary god—from the inner sanctuary to the open courtyard where ancient worshippers waited.

William's enthusiasm for what he is seeing for the first time in 1815, though dramatically stated in his journal, is always tempered by his knowl-

edge of earlier texts. These included the early writings of Herodotus, Strabo, and Pliny as well as British ambassador William Hamilton's *Aegyptiaca*, published in 1801, and the work of Napoleon's *savants*, particularly Vivant Denon's *Travels in Upper and Lower Egypt*, published in 1803. William looked for ruins mentioned by these earliest travelers and revealed their mistakes. He began careful measurements and accurate drawings of the sites, all with an eye to dating the temples and to assessing the Egyptian influence on Greek architecture. At times he seemed uncertain of the degree of influence, observing that the Egyptians built in stone while the Greeks built in marble. But marble is, after all, stone. The enormous leap forward is the shift from mud-brick to stone, to build for "eternity," and this the Egyptians accomplished so long ago that, as William put it, he is visiting remarkable sites that were ancient even when Herodotus traveled around 450 BCE and declared that Egypt is "the gift of the Nile."

How did they do it? Egyptologist Sir Alan Gardiner invites us to view this ancient land as a "lotus plant with the Nile Valley as the stalk, the Delta as the flower, and the depression of the Fayoum [an oasis southwest of Cairo] as a bud."[9] Although ancient Egypt extended both east and west beyond the narrow "stem" of the Nile, this image of a blooming flower reminds us of the riches that supported the blossoming of this culture. As the Ice Age ended and the swamp lands east and west of the Nile dried, leaving only a few remaining oases and more desert, nomads from both east and west trekked into the Nile Valley. They were still hunters and gatherers, collecting the wild grasses growing near the river and catching what wildlife they could, until around 5000 BCE, the beginning of the Predynastic Period of somewhat settled agriculture and a more structured society. In these distant times Egypt was a melting pot, and the beginnings of agriculture may have been taught by those coming from Palestine and Syria.

Around the Nile, the earliest settlers found water for drinking, for farming, and, eventually, for livestock watering. Large game and waterfowl were as attracted to the river as humans; they provided food and then animals for herds. The wild grasses provided cereals before more organized

agriculture produced emmer for bread. (Our wheat was brought to Egypt much later by the Greeks.) Once settled, the Egyptians grew lentils, lettuces, onions. Bees were kept for honey as the primary sweetener; dates and barley were made into beer. Grapes for wine were eventually grown in the western oases. Canals were dug to direct the overflowing Nile into fields for irrigation. The reeds and stalks of the swamps and palm branches offered materials for building; for clothing; and, in papyrus, for paper, that ingredient essential to bureaucracy. Much of this labor either required or certainly benefited from joint effort. Small groups initially, perhaps several extended families, began working together, first in flood control for cultivating their land, but eventually in greater specialization: making cloth, brewing, potting, leading caravans to Nubia for trade purposes (think ivory, ebony, and slaves), or exploring the mountains for minerals.

By the early Dynastic Period (3100–2686 BCE) market "towns" had developed and became capital "cities" in each of the provinces (called *nomes*) into which the country was divided. From provinces to a state is only a matter of time as local leaders seek greater power. The history of ancient Egypt's kings is, in part, a story of shifting capitals as early kings established a court in their area of greatest support. The large pantheon of gods also arises from the elevation of local deities to national worship, encouraged— or required—by a new leader from a different area. By 3100 BCE ancient Egypt had developed a sophisticated administration, making possible its long cultural journey of pyramids, enormous temple complexes, and magnificent wall drawings. Complex burial rites developed in response to a coherent set of religious beliefs, and these ancient people created writing and displayed a reverence for the power of language. They worshipped Thoth, the god of writing, and devoted much time to the writing of sacred texts, carving them in hieroglyphs on temple and tomb walls.

The partial physical barriers on all sides—desert and mountains both east and west, cataracts to the south and the Mediterranean to the north— in addition to the area's great wealth in a fertile strip of land, a continual source of water, and important minerals certainly helped pharaohs achieve

and maintain power over both Upper and Lower Egypt. Of course there were repeated attempts at conquering Egypt. Temple drawings showing a king slaying his enemies tell us this, and Egyptologists have identified three "Intermediate Periods" of disruption or control by foreigners prior to Alexander's conquering of the country in the fourth century BCE. Still, for much of its 3,000 years, this ancient society remained largely intact and stable enough to allow for the great art and architecture that so inspired William Bankes.

William sailed as far as Aswan at the First Cataract and then, leaving the large boat in Antonio's care, he traveled on to Wadi Halfa and the Second Cataract in a boat only large enough for William to sleep aboard under a bit of canopy. Switching to camels, the group traveled a short distance farther to Wadi Omki, making William the first Englishman to travel this far south along the Nile.[10] Although the sand-covered temple ruins at Wadi Halfa will receive William's attention on his second journey, no site will have the pull to bring him back again except for Ramesses II's spectacular temple at Abu Simbel, mostly sand covered in 1815, as William's sketches (see image 2 on p. 13 and image 3 on p. 15) reveal. Both Nubian sites will be excavated in 1818/19 by our first Egyptologist.

6

THE FIRST EGYPTOLOGIST

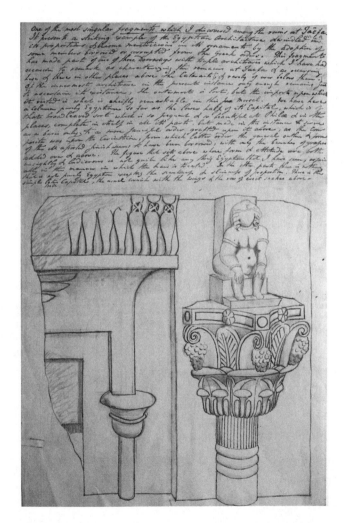

14. Unusual capital from the temple at Tafa. Drawing with
lengthy notes by Bankes.

Puzzling over the sand-covered ruins of Wadi Halfa and astonished by the great temple at Abu Simbel, William knew that he was gazing upon antiquities rarely seen by Westerners. Abu Simbel and the other ruins of southern Egypt and Nubia would lure him back for excavation and more extensive study. But even on this first journey, he sketches ruins, copies inscriptions, and seeks the yet undiscovered.

He was especially struck by the ruins at Qasr Ibrim on the top of a high cliff near the river. He writes: "I took a path across a corner of the desert through a multitude of tombs, none of which are inscribed. . . . All the signs of everyday life remain in place . . . a sort of Nubian Pompeii."[1] William explored the plain on the other side of the cliff, where he found tombs and the openings of grottoes: "Two were at a great height & seemed quite inaccessible." However, one of his agile crew members was able to climb the cliff and attach a rope that William used to hoist himself up. He notes that the paintings in the grottoes are well preserved and that he made drawings of them.

William also explored the Western, or back, side of Abu Simbel, finding the ruin of a Christian church. He thought that its architecture—resembling Greek and Roman styles—was amazing, given its location so far south. He had previously noted in his journal that the rock-cut tombs at Beni Hasan, much farther north, were amazingly similar to early Greek architecture—and he could not resist observing in his notes that Hamilton had not commented on this resemblance in his *Aegyptiaca*.

Landing almost continually on his way back to Aswan, William visited a host of temple ruins known today mostly to specialists, including Kalabsha and Tafa. At Kalabsha he copied a fresco, demonstrating the temple's use as a Christian church, in addition to preparing a detailed plan of the temple, with the Christian alterations shown (see color plate C7).

At Tafa he copied a most unusual capital (see image 14 on p. 93). Indeed, William focused considerable attention on columns and their capi-

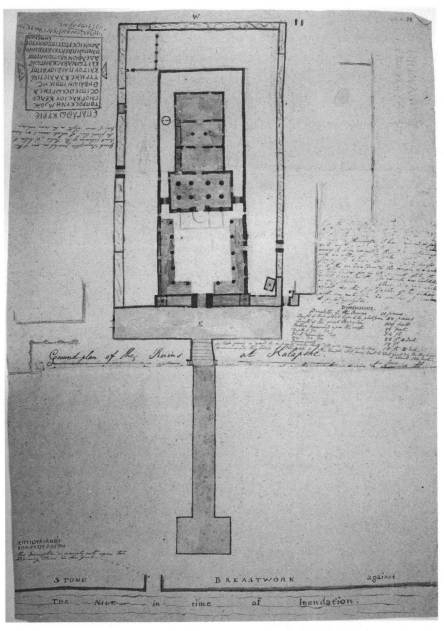

15. Plan and description of Kalabsha Temple. Lines to the
left of the entrance may mark a now lost small chapel that
celebrated the divine birth. Drawing by Bankes.

tals, drawing many, sometimes completing just enough to capture the idea of the carving. (In architecture a capital is the top part of a column. It can be as simple as a square block placed on top of the column to provide structural support for the horizontal part of the building or the arch above.) He thought that the Egyptian temples could be dated and their relation to Greek architecture shown by comparing columns and their decorative capitals. He also just delighted in their intricate designs.

Journeying on toward Cairo, the group stopped at the better-known temples of Kom Ombo and Edfu. Reaching modern Luxor, William was able, this time, to visit what the Greeks called the "hundred-gated city," so named because of the many huge gates—or pylons as Egyptologists call them today—marking the entrances to temple courtyards. He explored the great temple of Karnak and its smaller but lovely neighbor, known today as Luxor Temple. Luxor may have the most impressive entrance of all. Its massive "gates" are fronted by two colossal statues of Ramesses II and two soaring obelisks (see cover image). William prepared a pencil drawing of Luxor's plan and in that moment corrected the work of Vivant Denon, one of Napoleon's most important scholars. From this point on, William was dismissive of the French *savants'* studies of Egypt, an attitude caused in part by ongoing Anglo-French combativeness, but also in large measure because of his own careful observations. In Denon's defense, he often had only a short time to observe, measure, and sketch before required to move on with the French army, his only protection.

To William's credit, he is traveling south just a dozen years after Denon through a land not fully controlled by the Ottoman pasha. And William's army consists of the ship's crew plus Antonio, Haleel, Barthow, and Finati. Even today many of the temples contain piles of stones, broken pieces of columns, and other rubble scattered about the site. In 1815, temples had the same fallen stones interspersed among tall weeds. Inside they were rubble-filled and foul-smelling, thanks to piles of bat droppings. With the patience of Job and the will of Wellington, William scampered over the strewn rocks and rubble to take the measurements necessary to complete his remarkably accurate site plans.

16. Plan of the Luxor Temple. Squares at the bottom represent obelisks in front of the pylon. Smaller marks behind them represent two statues of Ramesses II. Drawing by Bankes.

William reveals his close study of Luxor Temple by depicting the slight bend in the temple's shape. Most Egyptian temples were built on a single axis plan—as can be seen in William's drawing of the temple at Kalabsha. And, most faced the river, the usual way of approaching the temple. Luxor's less than perfect single axis and its entrance may be explained by its relationship

to the much larger temple complex. The two temples were once connected by an avenue of sphinxes, suggesting that religious ceremonies were carried out involving both, with priests bringing the sacred barque either by water or down the sphinx-lined avenue for festivities at Luxor before returning the barque to the inmost sanctuary at Karnak. William was correct in observing that he was exploring inner rooms that only the priests entered when the temples were in use in ancient times.

William was especially intrigued by the beautiful temple to Isis on the island of Philae, between Aswan and the First Cataract. Here he found a fallen obelisk that would eventually travel down the Nile and "home" to Kingston Lacy. On his travel north from Nubia, he stopped again at Philae and tried, unsuccessfully, to move the obelisk, inscribed with hieroglyphs and broken off from its base. However, he was able to calculate the location of the missing base and rescue it from its burial in mud. In the next few years England's new consul Henry Salt and the French representative Bernardino Drovetti, dividing up areas for excavation and plundering—as if they owned Egypt's temples and tombs—engaged in some dispute over the obelisk at Philae. Still, William always considered it his. During his return to Egypt in 1818, he arranged with Giovanni Belzoni to remove the obelisk and ship it to Alexandria, the first leg of its journey to London's Deptford port. (Belzoni was a former circus strongman who found his way to Egypt and was hired by Salt to excavate Abu Simbel and many tombs in the Valley of the Kings. Back in England in 1820, he contributed to London's "Egyptomania," delighting crowds with artifacts from New Kingdom tombs in the Valley of the Kings and by dramatically unwrapping a mummy.)

The Philae Temple itself fascinated William. Like a child in a candy shop, he could not get enough, gleefully investigating early in the morning and by candlelight through the night. His enthusiasm rubbed off on Finati, who wrote: "I soon grew so accustomed to see Mr Bankes drawing and noting (from any vestiges of antiquity) [probably a Bankes addition] that I began to take some interest in the sight of them myself."[2] And he was rewarded by being the first to find a Greek inscription in the temple: "Interesting as men-

tioning the two Cleopatras (successively wives of Ptolemy Lathurus), the same who are addressed on the pedestal of the obelisk." Not surprisingly, on his second journey in 1818, William instructed Linant, one of the artists he brought with him, to render a lovely drawing of the Philae Temple.

This lovely and intriguing temple that William studied both in 1815 and again in 1819 is one of Egypt's most recent, but its site probably had an earlier temple. For the ancient Egyptians, the islands of Philae, Elephantine, and Biga, located in the Aswan area, marked the beginning of Egypt and its separation from Nubia to the south. Although the town of Aswan always contained a mix of Nubians, Egyptians, and even Bedouins from the desert, it represented the "source" of Egypt's life-giving yearly inundation. These were sacred islands indeed, a fitting place for the last inscriptions written in hieroglyphs (see image 31 on p. 177).

All was not perfect, though, in this seemingly idyllic setting. One day while sketching, William was accosted at knifepoint by a native who demanded payment for the right to draw the temple. The confrontation drew a crowd that included Finati, who was about to raise his pistol when the problem was solved by the arrival of the cashief of Aswan, who had been advised by the pasha, Mohammed Ali, to meet the traveling Englishman. The arrival of the cashief and his retinue of soldiers was enough to send the natives scrambling away, some seeking the safety of the Nile and a hasty swim from the island.

William survived this threatening moment only to move on to experience a swarm of locusts, an event that seemed to bother his crew the most. Not wanting to miss any part of his Egyptian experience, William tried roasted locusts, eaten by first pulling off the wings. He wrote that it tasted like shrimp. He also tried "booza," a kind of beer, and agreed, along with Finati, to be bitten by a snake charmer's poisonous snake. Neither was hurt, as they had guessed correctly that the charmer had previously removed the snake's venom—and then found a way to make a little money.

William knew that his three-month trip was nearing its end when he could see the pyramids of Saqqara and Giza in the distance. Still eager to

explore, he climbed up to the top of the Great Pyramid but was not quite ready for a torchlight tour of the interior. Fainting in the burial chamber, he had to be carried out and revived, more than a little embarrassed but still undaunted. He was especially drawn to the pyramids in the Fayoum Oasis because they were getting less attention than the three most famous ones on the plateau at Giza. The enthusiastic traveler setting sail for Lisbon in 1812 now wears the cloak of the serious archaeologist.

In one of his footnotes to Finati's narrative, William wonders why there are many pyramids in the area from Cairo south to Meidum and then again in Nubia, while there are none in the Luxor area, an important observation of the changing burial habits from the Old Kingdom years to the New Kingdom. In southern Egypt in predynastic times, there were organized communities, and rulers were buried in tombs. Burial in some kind of tomb probably began early in the country's history because people saw the difficulty of burying in sand that shifts readily with the wind, exposing bodies or bones to scavengers. The next step was to bury the dead under or surrounded by rock within the sand or in hillside rock-cut tombs. Then a building (a mastaba, Arabic for *bench*) was erected over the buried body to further protect it. And if this above-ground room is large enough, family can come to visit the dead and leave offerings to the gods to aid their journey into a resurrected life.

Some of the earliest kings were buried at Abydos, a temple in Upper Egypt several miles north of Luxor. Excavations have uncovered tombs of predynastic leaders, and a temple has stood on this site since at least the first dynasty—though not the temple William will explore in 1819. Abydos remained the most sacred of burial locations for thousands of years because it was the presumed burial site of the god Osiris. Ancient Egyptians trekked to the Abydos site for religious celebrations that included the typical priestly procession with the carrying of the barque—the ship-shaped shrine—holding an Osiris image.

Egyptians believed that the world began in chaos, with eight gods (four pairs) representing formlessness, darkness, the hidden, and primor-

dial waters. Out of the waters came a mound of earth on which the god Atum stood and created other gods, including Geb (earth) and Nut (sky— she swallows the sun each evening), and Osiris and Isis, a brother/sister and husband/wife duo, and Seth (or Set), the evil one who tricks Osiris and kills him. Isis journeys to find Osiris, puts most of his body back together, and buries him at Abydos. In temple wall drawings, Osiris is usually depicted with his arms crossed over his chest, in a mummified position. He is the first to be resurrected after death and burial, and he and Isis have a son, Horus, who defeats Seth but does not kill him. For the ancient Egyptians, Osiris's death and rebirth became the symbol of their own possible eternal life.

Ancient Egypt's creation stories tell us that evil is always a force in the world against which we must constantly struggle. Another point is that one needs to be buried with all of one's body parts to use in the next life. Also, interestingly, Egyptians wanted to be buried in Egypt. As a result Egyptians established few settlements outside of Egypt, except in Nubia, which was then perceived as part of the Egyptian empire. Conquered lands to the east around the Mediterranean were not usually run by an Egyptian administration living abroad and so had to be reconquered—and then the new pharaoh had to re-establish trade treaties.

Egyptian beliefs are closely tied to their experience of nature: the sun, the river, and the yearly inundation that brings a new "mound" of fertile soil for crops, so vividly described by William in his Nile journals (see p. 84). In a country that is mostly desert, its life-giving river also provided the ancient Egyptians with their image of how one would travel from this world to the next: by boat. A boat grave has been discovered at Abydos, 14 small boats in a row, dating to the first dynasty.

Egypt's rich pantheon includes several manifestations of various gods, some with animal heads, some also represented in a designated animal. Horus, for example, is shown as a man, as a falcon, and as a falcon-headed man. A wall drawing of a seated baboon with the solar disk above his head is a representation of Thoth, god of writing. Amun or Amun-Re, one of the original eight paired deities, evolves into the all-important sun god. He is

usually represented as a man with a crown of two tall plumes but is also asso-
ciated with the ram, a symbol of strength and fertility. Some kings added
"Re" (or "Ra"—Egyptologists do not agree on the spelling) to their names,
identifying themselves as related to Amun-Re and thus divine as the son of
god. Ptah, a primary god from the Memphis area, becomes associated with
"the word," the power of language, but he does not eliminate the god Thoth
or contradict the significance of Amun-Re. All have value for the Egyptians
as representations of the divine and thus warranting human supplication.

The Osiris myth embraces both religious and political messages. One of
the most important deities for Egypt's kings is Osiris's son Horus. Originally
he is viewed as the lord of the sky, hence his association with the falcon, a pow-
erful "ruler" of the sky. Probably from this association with the sky, he evolves
into the sun god, specifically as Horakhty or "Horus of the two horizons." He
is the divine son who must defeat evil and keep order in the world. Because of
that task, he is, from the early dynasties, associated with kingship. Many kings
took a "Horus" name to reinforce their connection with the divine. Although
the concept may have been more a celebration of the gods' gift of power to the
king than of the king as a divine son, the association of the king with Horus
also reinforced the idea of the son legitimately inheriting the throne from his
father. Further, like Horus, the king's responsibility was to maintain order and
justice (the Egyptian concept of *maat*), to keep chaos from returning.

It is possible that the Egyptians initially believed that only the king, a god
figure, would travel into the next world and be resurrected. However, tombs
of family members and close advisors from the Old Kingdom on have been
found with extensive wall drawings and with items needed for the next life.
These items included jewelry, furniture, food, small carved statues that would
come to life as servants, and canopic jars containing key organs removed as
part of the mummification process. Just as the sun travels across the sky each
day and then disappears into the dark, only to be "reborn" the next morning,
so the dead must make a journey through the darkness into the next life. Wall
drawings often show the sacred barque that will carry the deceased on this
journey. Pits containing parts of a boat ready for reassembling were placed

next to the Giza pyramids, although these had not been discovered when William was exploring. (The parts have been carefully pieced together, and the boat can now be seen in its own museum on the Giza plateau.)

The first pyramid, the Step Pyramid, was built at Saqqara in the Third Dynasty for Djoser, who ruled about 2650 BCE. Its architect Imhotep was justly revered for this great achievement, the first significant building in stone. As one can see from the photo at the beginning of chapter 5, it is a "wedding cake" of rectangular pieces, each one smaller than the one below. The mastaba, a rectangular building originally in mud-brick, had been used as a tomb and funerary temple before, but it was Imhotep who imagined and engineered the first large, if not yet smooth-sided, stone pyramid as a burial chamber.

The Fourth Dynasty king Snefru (c. 2650–2585) practiced until true pyramid building was accomplished. The first collapsed; the next still stands, bent at the top; and the third one, the red pyramid, is Snefru's tomb.

Snefru's son Khufu (c. 2585–60) and grandson Khafre (c. 2555–2532) are buried in the Great Pyramid and the second-largest pyramid on the plateau above Giza. The Great Pyramid was the largest building in the world until the Eiffel Tower was built in Paris in 1889. Ancient Egypt's administrative skills and the country's wealth are both celebrated in these enormous Old Kingdom building projects. They were not built primarily with slave labor but rather by farmers during the Nile's inundation, a period that left them free to haul great blocks of rock three months each year. They were also built by a literate, sophisticated class of engineers and artists and management teams. No wonder William was impressed.

Khafre's burial pyramid on the Giza plateau provides a good picture of the cemetery complex developed in the Old Kingdom and copied, with variations, into the New Kingdom. The king's granite sarcophagus resides in the pyramid's burial chamber. In front of the pyramid is a mortuary temple containing a hall with columns, several rooms, and an open courtyard. This temple is connected by a causeway down the plateau to a valley temple closer to the Nile. Thus there are really three kinds of buildings to explore: (1) large temple complexes such as Karnak and Luxor that were built to worship one or more

of the primary gods; (2) burial sites, whether they be pyramid tombs, rock-cut tombs, or the multi-chambered tombs of New Kingdom pharaohs dug into the hillsides at the Valley of the Kings; and (3) mortuary temples, those built for the continued worship of a deceased king. In the Old Kingdom, mortuary temples are built near the pyramid tomb. In the New Kingdom they are built on the west side of the Nile, across from the city of Luxor, but not in the Valley of the Kings. Aware of extensive tomb robberies over the centuries, New Kingdom pharaohs wanted priests to continue to make offerings at their shrines while at the same time they wanted to keep their corpses and all the rich belongings buried with them safe for the next life.

The causeway from Khafre's mortuary temple down to the valley temple is not in the expected line perpendicular to the temple. If it were perfectly straight, the valley temple would be where the Great Sphinx stares out. The Sphinx has the head of a man and the body of a lion. The man is wearing the head-covering of a pharaoh, its nose lost to erosion from continually blowing sand, the artificial beard denoting a pharaoh missing. The head and neck were carved from a single piece of limestone, the features resembling those of Khafre—as we know from comparison with a well-preserved diorite sculpture of the king with a falcon (the Horus image) perched on his shoulder.

The Sphinx also has a valley temple. Does the Sphinx serve as a guardian of the plateau's enormous cemetery—even at the sacrifice of the single axis and the need for a second small temple in the valley? It may have been an accident. The large limestone boulder had been left as workmen quarried the limestone below the plateau and then was found to be in the way of a straight causeway. The decision may have been to carve the limestone boulder rather than to try to remove it to complete the causeway. It may also have been planned all along as a monument to Khafre, a puzzle William did not consider and that remains unresolved. The Sphinx has spent much of its years covered up to its neck in sand, and now the large blocks from the temples also clutter around it. It doesn't matter; it is still an arresting symbol of ancient royal power.

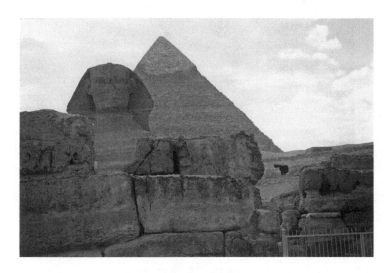

17. The Great Sphinx with Khafre's pyramid in the background. A photograph from this angle always makes the Sphinx look much larger than it is in relation to the three huge pyramids on the Giza plateau. (The blocks in front are from the valley temple.)

William clearly recognized the basic single-axis structure of most temple complexes. This recognition prepared him to spot, in 1815, the variation at Luxor Temple. The knowledge will be even more important on his second trip up the Nile in 1818/19, when he explores the Abydos Temple. His curiosity piqued, he will spend some time clearing debris from the small rooms comprising the short side of this oddly L-shaped temple—and there discover the vitally important King List, a wall devoted to a chronological listing of Egypt's kings.

But, how much of ancient Egypt's religious views did William understand? Without the ability to read the hieroglyphs carved around the magnificent temple wall drawings, probably not too much from his first journey. Still, after studying the drawings in the well-preserved temples at Edfu and Philae, he could recognize images of god figures and images of kings in supplication to the gods—and images of ships on a journey. Perhaps what is most important is William's general approach to what he was expe-

riencing. He surpassed the few travelers who had preceded him in several ways: he chose the goal of accurate measurements and copying of images over romantic renderings, resulting in the checking out of the "backsides" of temple complexes, not just drawing a dramatic front; he recognized the value of recording his questions as well as facts, questions not to be forgotten in the thrill of discovering what lies around the next bend in the river; he understood the importance of language as an access to culture, spending many hours patiently copying inscriptions he could not read. He was the first Egyptologist in his approach, even if, unlike Denon, he was unable to publish all of his findings in a timely manner.

Back safely in Cairo in mid-December, 1815, with his notes and drawings carefully packed, William lodged again at the monastery and spent evenings explaining his discoveries to Burckhardt. Compared to those who would flood the area in the next few years, William returned almost "empty-handed." He would eventually get his Philae obelisk to Dorset, but probably only because of his second journey up the Nile, a trip that he was not contemplating at all in 1815. Although he bought two lion-headed statues, they do not seem to have been sent to England. He did purchase several small stelae, which remain in his collection at Kingston Lacy, and a large papyrus, which had been "folded on the breast of the mummy," rather than more typically rolled. This copy of *The Book of the Dead* now resides in the British Library.

The stelae are significant as among the first works to be acquired from Deir el-Medina, a community built for those working on the tombs in the Valley of the Kings. Deir el-Medina would soon be extensively excavated and explored under the direction of both French and English consuls (see color plate C8).

William was now 30. He had done much more than "see" Egypt—and accomplished it on his own. Yes, he had advice and encouragement from

Burckhardt, but he was not sponsored by any group or a patron seeking "curiosities" to display at his country estate. He paid his own way and hired his own support team. Fairly bursting with a blend of enthusiasm and doggedness that left others astonished, he taught himself to explore, to record, and to think like an archaeologist. William added to our knowledge of ancient Egypt and found new purpose and direction in his life.

Palestine and Syria now awaited the traveler "who leaves nothing unexplored."

DARING AND PERSEVERENCE

FROM THE HOLY LAND TO JERASH

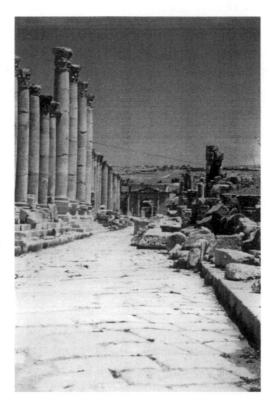

18. Columns along the main street in Jerash, modern Jordan.

S urviving a blinding eye infection in Luxor, a threatening native with a
knife on the island of Philae, and fainting in the burial chamber of the

Great Pyramid, William returned to his previous lodging in Cairo after his historic three-month journey up the Nile. He was now back within the city's narrow, sand-strewn streets teeming with Arabs, Turks, Coptic Christians, and all those travelers passing from one end of the Mediterranean to the other. He soaked in the bath while Antonio saw to a proper cleaning of his clothes. They maneuvered around the caravans from Nubia with ivory and slaves for sale to check out the stalls of the bazaar for the fresh coffee, fruits, and vegetables not often available during their groundbreaking trip to the Second Cataract.

In his rooms, William prepared his papyrus and stelae for shipment to Kingston Lacy and caught up with his mail from England. Was there a letter from Byron announcing his marriage to Annabella? (Or a more recent letter, announcing her pregnancy—or the birth of their daughter? Or that the marriage was in turmoil?) If not, did he get some of this information in letters from family? William would eventually learn that the marriage ended in the spring of 1816 with Byron seeking a self-imposed exile in Venice, knowing that rumors of incest with his half-sister Augusta and other stories from Annabella's family would close society's doors to him. If William had any of this information while in Cairo, it certainly did not encourage a return to England. He did not pack his clothes and book passage for Alexandria, the first step toward the long voyage home.

Instead, William spent delightful hours with his now good friend Burckhardt, showing his portfolio of drawings and reflecting on the startling images of temples and tombs still vivid in his memory. He soaked up Burckhardt's descriptions of Greek, Roman, and Christian ruins awaiting him in Palestine and Syria—the terms used at the time to refer to the lands of Israel, Syria, Lebanon, and Jordan today. While making arrangements for his new journey, William studied Burckhardt's maps and notes. He also grew a beard, having been convinced by his mentor to travel in Arab dress. Burckhardt had purchased robes, cloaks, and turbans for both William and Antonio, but it took some persuading to get Antonio to finally agree to dress as a native.[1]

When satisfied with his beard, William donned his Arab robes—and voila! He now had the perfect disguise for visiting Cairo's mosques, places forbidden to non-Muslims. Apparently, William looked Arab enough, especially when he strolled in alongside Finati and offered a present to each caretaker. He was able to explore the mosques of Sultan Hassan, Sultan Calaoon, and El Azahar without any "ill consequences," as Finati puts it. This will not be the last time that Finati is placed in danger by William's insatiable curiosity and determination to see behind closed doors.

While the beard was growing, William was also obtaining the necessary permissions from Mohammed Ali for his travels east. The pasha not only signed the necessary permissions but ordered seven dromedaries for William, Antonio, Finati, and Arab guides riding with the baggage and provisions. In addition, the pasha "assigned" the son of the sheikh of El-Arish to the group to ensure safe conduct. This was a lovely gesture on the part of the pasha—or cause for anxiety, depending on one's reaction to the apparent need for a kind of hostage to get the group safely to Jerusalem.

William also accepted two German travelers from Hanover looking for a way to get to Jerusalem, a decision that concerned Finati from the beginning, as this would strain their food and water supplies as well as possibly slow the group's progress. The two Germans would be walking, unable to afford their own "ships of the desert." The two pedestrians, who had been staying with a Prussian doctor in Cairo, were not in sight when William rode out of the great Gate of Victory, accompanied by Burckhardt and other friends who waved him off. Finati hoped in vain, however, that the Hanoverians had changed their minds, for they eventually caught up to William's caravan and could not be dissuaded from the journey. William frequently dismounted and walked, giving his two new companions a chance to ride. Finati and Antonio occasionally offered a ride as well, but the Arabs would have none of the two rather scruffy wanderers.

The group rode north, following the Nile to the Delta, and then hugged the coastline as they started across the desert. Their first night was spent at the home of the sheikh of the village of Anche, but their next stop, Belbeis,

was reached so late in the evening that they simply placed their bedding on the buffalo hides spread along the town's main street—a strategy the locals used as part of the tanning process. William would not leave Belbeis the next morning until he explored a large mound that suggested an ancient site. Finding nothing, he traveled four days in the desert without sighting any village.

The group's tent and a hearty fire kept the desert's cold and dampness at bay each night. William stopped again to explore a large mound and possibly a ruined fort jutting into the Sea at Tineh. Sending the others on, he took Finati and one Arab guide to visit the muddy area. He crossed the sun-heated mud barefoot but found only traces of an ancient site, plus a gun carriage abandoned in the retreat from Napoleon's bloody battle at Jaffa. When they caught up with the others, the tent was pitched and a fire blazed.

Still traveling close to the coast, the caravan crossed an area encrusted with salt, giving the appearance of snow on the desert. Soon after, William dismounted again to explore a well surrounded by column ruins—and was attacked by Tarabin Arabs coming to draw water. Their speed at drawing weapons was apparently prompted by their seeing the two Germans in western dress, a reminder to the Arabs of their abuse from the French army. Only shouts and threats from the sheikh's son as he quickly rode up to William prevented violence. William took this encounter in stride, refusing to contemplate further threats to his life that the next few months would bring.

By contrast, William was graciously welcomed by the sheikh of El-Arish, his town a fortified village that marked the last of the pasha of Egypt's area of control to the northeast. Given the size of their group, the sheikh decided that his house was too small for the celebratory dinner of lamb with rice and butter, so he decided to entertain in the village's mosque, a decision revealing the power he wielded in that small village. However, a message was conveyed that the two in "Frank dress" were not welcome in the mosque, so their food was sent out to them. Left alone, the Germans searched William's baggage to locate a leather carrying case for liquor and proceeded to become quite drunk. Although liquor cases were common in

the baggage of European travelers, Finati asserts that William's was a gift from someone in Cairo. Whatever the source, from that point on William did not carry any liquor with him through Muslim-controlled countries. Still, he was more willing than the Arabs to forgive the drunkenness on the grounds of the Germans' long journey on foot—to say nothing of being excluded from the evening's party.

While at El-Arish, William discovered a huge container, used in the village as a drinking trough, made of fine dark granite and carved inside and out with hieroglyphs. The pasha gave it to William as a gift, providing papers allowing him to remove the antiquity, but it would be years before he returned to claim the granite monolith.

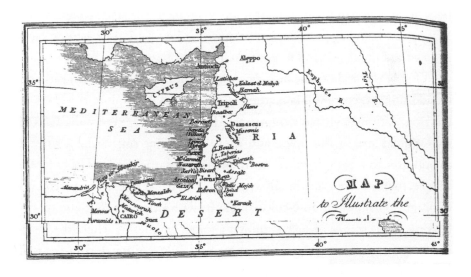

19. Map of Syria. From Finati's *Narrative*.

Leaving El-Arish the next day, William finally left the desert as well. In the evening he arrived at the town of Gaza, where the group camped in the public khan (a caravan hostel). The governor of Gaza, alerted to the

arrival of the Englishman, immediately sent an attendant to escort William to supper at the Government house. Finati went along as interpreter and, ever faithful, stopped with William for a tour of Gaza's principal mosque. The building was especially interesting to William because it was formerly a church built during the Crusades, one of many remaining in Syria, and an excellent example of the Gothic style.

After a delicious meal of many different dishes, served one after the other in the Eastern style, William returned to the khan to find the Germans' baggage strewn about and much commotion throughout the courtyard. Although the pair had not yet received physical harm, they were happy to see William and the governor's attendant, the latter quickly silencing and dispersing the crowd with his large stick. The mayhem was probably caused by a combination of the local Arabs' long memory of the French army and William's guides repeating the tale of the Hanoverians' previous drunken behavior. Although they were still early in their travels through Syria, William was already pointing out to Antonio how wise they were to have listened to Burckhardt and donned their Arab robes.

On the way to Jaffa the next day, with a soldier from the Gaza garrison an additional escort, William stopped for the day to explore the ruins at Ascalon. Although virtually empty in 1816, its well-preserved walls marked the original size of the town, and there were ruins suggesting a theater in addition to a ruin down to its foundations that was presumably first a temple, then a church, and finally a mosque. Of greater interest were remains of beautiful columns in rose-colored granite with gray tints. William speculated as to the source of such stunning granite, wondering where the quarries were that provided this stone to many of the cities along the coast as well as inland to Palmyra. The travelers spent the night in some of the mostly ruined houses, with brushwood spread over bare rafters as a ceiling. In the morning they obtained fresh milk and honey for breakfast and then continued their ride to Jaffa.

After the ten days' journey from Cairo, William arrived at Jaffa to rest for two days at the home of the consul Damiani—if one could call it rest.

The consul, wearing powdered hair and a cocked hat with Oriental robes, was hospitable, but his home was so badly built and so filled with rat holes that there was no even flooring in William's room for his bedstead, and the first night he listened to the consul's daughter-in-law giving birth in the room below. He prepared to move on, applying to the governor of Jaffa for mules and safe conduct to Jerusalem. Mules were obtained, even for the two Germans, and a guide was sent to conduct the group, which now also included a few Greek pilgrims. And so, on January 2, 1816, after journeying through the barren, often steep countryside, they could see the walls of Jerusalem. All dismounted and kneeled, and then walked the last half hour to the city gate.

During their stay in Jerusalem they were housed and well cared-for in a monastery. However, the monks quickly tired of the thoughtless behavior of the Hanoverians, and when one failed to return at night before the locking of the gate, and then tried to bribe the guard to let him in, the two were told it was time to move on. Though unhappy, they left for Acre on mules William purchased for their trip. And that was the last William saw or heard of them.

Meanwhile, William rushed to visit the many sites of Jerusalem, including the holy sepulcher and the Mount of Olives. Then he decamped for Bethlehem to see the celebration of the Greek Christmas there, staying in another monastery, one that was divided into separate sections for the Greek Orthodox pilgrims and the Roman Catholics and their guests. Although their hosts tried to discourage William from attending the Greek celebration in the Church of the Nativity, he nonetheless witnessed the crowded, all-night event. Then, to placate the monks, he agreed to stay for the Roman Church's Epiphany. Following Epiphany, a large baptism of Greek pilgrims took place in the River Jordan.

William and Finati rode at night to the Jordan, under the protection of four gun-carrying Christians from Bethlehem, so as to be there for the morning ceremony. While William took in the crowded, noisy scene of both young and old in the river, Finati negotiated with some Bedouins to

escort William's group to other sites. Unwisely parting from their Christian guides, William rode to what was left of ancient Jericho with their new Arab escort—and all found themselves in a village now in a lawless state of revolt against the aga of Jerusalem. The villagers rudely displayed food that they refused to share and warned the travelers that they would not provide safety after their night's stay.

Finati writes that the morning did not dispel their anxieties, for it was clear from the village's armed men riding out of town—and the women standing on rooftops to watch—that the travelers would be followed out of Jericho and robbed. William and his Bedouin guides first delayed their own mounting and then chose a different route to Jerusalem, disguising their exit by riding through "a thicket of thorny plants" and then scrambling over a stone-filled path up the mountain to leave no trace of their path. They rode all day, stopping only once for water and to bake some bread, using the flour the guides had with them.

Finally arriving late at night at a fortified Greek monastery, they initially had some difficulty getting the monks' attention and then convincing them to allow the group to enter. Eventually William's papers, presents, or sweet talk prevailed, and they were welcomed and given a place to rest for the night. Once more dodging serious trouble, William journeyed on to Jerusalem the following day. Learning that the lawless Arabs from Jericho had robbed many travelers all along the road to Jerusalem, he thanked the Bedouin guides for their clever escape from a potentially serious confrontation.

While at the monastery the previous night, one of their guides told William that his son was in prison in Jerusalem as a hostage because the aga believed that their tribe was responsible for stealing some of the aga's camels. William seized this opportunity to try to repay his guide, Mahomet Daheidy, for keeping them safe from robbery or worse, pledging that he would seek an audience with the aga to plead for the son's release. At first Daheidy expressed fear of even entering the city, but William was able to convince Daheidy to trust him, and he was successful in getting the son's release. Initially showing no emotion, father and son embraced with tears

of joy once all were inside the Jerusalem monastery where William had been staying. Then Daheidy, tying a white scarf on his lance and dyeing the tail of his horse with henna, "paraded through the street, proclaiming the favour that he had received from the Aga, and from the Christian strangers." Presumably no one who could cause trouble for William learned from this display of gratitude that William was not, in fact, an Arab.

The bond of mutual gratitude that was formed provided William with the means to visit Jerash and other ancient Roman towns east of the Jordan River. Although Mahomet Daheidy could not provide safe passage himself, he was happy to seek help from a more powerful tribe. While he was away on that task, William purchased two good horses in Jerusalem for himself and Finati. They sorted through their baggage, packing just the clothes and instruments and books needed for this particular journey, leaving Antonio to pack up the rest of the gear and haul it with him to their subsequent meeting point in Nazareth.

When Daheidy returned with the more powerful Bedouin, William was ready to launch one of his most significant explorations of ancient ruins. First, Jerash was probably his best-loved spot in all of Syria. After visiting in January 1816, he would return twice more during his second period of travel in Syria. He also prepared many drawings and site plans, even more carefully and thoroughly measuring and copying Greek inscriptions when he returned with British captains Charles Irby and James Mangles in 1818.

William sought evidence to prove that the town of Jerash (spelled Djerash by Finati) was Gerasa, one of ten towns in Roman times that were referred to as the Decapolis. They represented the eastern border of the Roman Empire and apparently had formed some kind of loose federation, although still under Roman control and much shaped by Hellenistic culture. William knew that both Burckhardt and the German traveler Ulrich Seetzen (in 1810) had believed Jerash to be the ancient Gerasa, but he wanted to confirm their opinions. He compared his own thorough observations with the descriptions by authors Pliny and Josephus as a scholarly process for matching the ancient cities to the sites he visited.

Unfortunately it is on this first (1816) trip to Jerash that James Silk Buckingham enters William's life. Buckingham will become much more than an "inconvenience" to William, to use Finati's understated term. A self-promoting adventurer of slender means presumably on his way to India to represent a British trading company, Buckingham was in no hurry to reach Bombay, instead spending the company's money and borrowing from others to finance travels from which he could create a book and make his fortune. Buckingham was eager to travel with William, not just to Jerash but any-where that William was going—and paying for. When they parted after the trip to Jerash, Buckingham stayed in Syria, writing several times to William, hoping to meet him first at Damascus and then later at Aleppo.

William would later learn that others had lent him money to travel to Aleppo and cover his expenses there. The British consul in Aleppo, John Barker, later wrote to Lady Hester Stanhope that William did not really want Buckingham with him on his journey to Palmyra but found it hard to refuse and that he, Barker, "was quite ashamed" that he "could for one moment . . . have believed him to possess common sense" or be anything close to William's equal. Finati dismisses him in one brief paragraph in his *Narrative,* writing that although Buckingham was with them in Jerash he bore "no part in it either with his purse or with his pencil." Clearly this comment was added to the book either by William—or by both of them—when they had to meet Buckingham later in London over a libel case relating to Buckingham's 1821 publication of his *Travels.*

With all of the complexities of travel through Syria, and the frequent dangers that William manages to survive, how could he make such bad decisions in those he allowed to join him? If William were so easygoing as not to make any judgments about character, he would not have managed to visit half the sites he recorded—or would not have lived to tell about it at London dinner parties. But even daredevils and adventurers get lonely at times, lonely for home, lonely for the company of those who speak their first language and understand something of their world.

William began his first trip to Jerash by dining and sleeping with

Daheidy's tribe in celebration of his son's release. They reached Jerash in four days, choosing to stay in tents found along a rural route rather than risking conflicts with armed farmers and villagers. Finati describes their thrill at the ruins that "are not massive like those in Egypt, but, for the most part, light, and slender, and beautiful, with almost innumerable columns standing in rows, and others curved into a great open circle" (see color plate C9). Palmyra, William conceded, is perhaps greater in the extent of its ruins, but no ancient site yet visited was "so rich and magnificent" as Jerash. William was surprised at the grandeur because Pliny gives little emphasis to the city, suggesting that it was not especially rich or powerful. And yet, they found some of the original simpler Ionic columns that once lined the main street as well as the "urban renewal" that dressed up the city center with newer, fancier Corinthian columns. The paving stones on the main streets were original, with chariot-wheel ruts clearly visible. William found two theaters, both in excellent shape, as well as ruins of several temples and baths.

There being no Bedouin camp nearby, the group reluctantly spent the night with inhospitable inhabitants in the village of Soof, who showed no regret that William's horse died from having been tethered in a field of poisonous oleander. The unpleasant situation and the loss of his horse would not stop William from spending another day at Jerash, completing his drawings and plans. The price for the additional day of exploration was, however, a pair of red boots (originally a gift from Abyssinian friends in Jerusalem) demanded by Daheidy—perhaps too much to ask from someone who had saved his son, but William agreed so that he could complete his study of Jerash. When he was finished, William took turns riding and walking with the guides as the group moved on to Oomkais, the ancient Decapolis city of Gadara. In about a week, they returned from Syria to Palestine and rejoined Antonio in Nazareth. William paid the guides with money and presents—in addition to the red boots he had already handed over to Daheidy. His first trip to Jerash and Oomkais was an important beginning to William's extensive study of the Roman cities of the Decapolis.

Along with his drawings and plans, William left manuscript pages on

the Decapolis cities he visited in 1816 and again in 1818. He also prepared lithograph plates of many of the inscriptions he copied at these ancient sites, clearly with publication in mind. In a footnote added to Finati's *Narrative*, William writes:

> The plans, elevations, and views, taken of this noble city [Jerash] during my several visits, were arranged some years since, so as to be almost ready for publication, but other matters calling me off from them, it has been delayed. I shall hope, however, to be able to produce some portion of that and of other cities of the Decapolis and beyond Judea in the course of the present year [1830].

Much of his manuscript is devoted to Jerash, especially to the arguments for and against identifying it as ancient Gerasa. In these notes he does not take a position, but in an 1822 article in the *Quarterly Review* he finally reaches the correct conclusion that Jerash was indeed Gerasa. In the early nineteenth century, European scholars had barely begun the process of excavating and identifying ancient sites throughout the vast expanse of the Roman Empire. William understood that he was an early actor in the important archaeological process of discovery and dating.

William had no difficulty identifying Oomkais as the Roman Gadara. He does add an unusual note in Finati's story that a current English translation of the New Testament cannot be correct in its description of a herd of swine running down steep places into the Tiberias Lake (the Sea of Galilee) because the landscape does not correspond to such a possibility. "However the original [i.e., the New Testament in Greek] presents no such difficulty as it says not a word about steep places & only that they threw themselves in the water," clarifies William. He observes that the most remarkable features remaining at Oomkais are the tombs, in which the town's few current inhabitants were residing.

William's knowledge of classical sources and passion for classical architecture led him to visit and revisit most of the Decapolis cities: Abila, Canatha, Gadara, Gerasa (Jerash), Philadelphia (Amman), Pella, possibly

Capitolias, Hippos—although he did not correctly identify it and was bothered in his travels that he could not locate this city—and Scythopolis (Bisan). (Dium, the tenth, has yet to be identified.) After Jerash, he was most interested in Scythopolis because of its theater. Although it was much ruined, William could still locate its cells where the "sounding vessels" or vases were placed for sound amplification. In addition to extensive discussion in his notes, William added a footnote to Finati's record of revisiting the city in 1818 that the theater there is "the most interesting of any that is extant, from distinctly exhibiting the position of the sounding-vases, as described by Vitruvius." Irby and Mangles record (in 1818) that William was not sure, initially, of the significance of the "oval recesses" but then reread Vitruvius in a library in Jerusalem to understand what he had found. He prepared an excellent sketch of the theater.

After his first excursion east of the Jordan River, William traveled to Acre, where he was well received by Solyman Pasha. There he was granted permission to visit the mosque built by Djezzar and, writes Finati, "the fine public bath was engaged and lighted up at night expressly for our use." William then moved through Tyre and Sidon to Mount Lebanon and Mar Elias, the home of Lady Hester Stanhope. Originally a convent, Mar Elias was a small, one-story building around a courtyard, now refurbished as Lady Hester's home. William stayed at Mar Elias, while Finati and Antonio were lodged in the nearby village, where her English physician Charles Meryon also lived.

Hester Stanhope was the niece of Prime Minister William Pitt and spent some time as the bachelor Pitt's hostess at 10 Downing Street. Since William's father spent many long nights at 10 Downing after meetings of the House of Commons, William would certainly have known of her, even if he had not previously met her in London. He might also have known Byron's opinion of her. Byron ridiculed her female "wit" as "dangerous"; he thought she was all affectation without substance.[2] And William knew her former young lover, Michael Bruce, from Cambridge. He had also heard the story of her excavating the previous year, at great expense, for hidden treasure at Ascalon. Finati writes that although she had "received some mys-

terious notification" she "found nothing besides a headless statue," which, in her frustration, she commanded to be broken, much to the distress of Dr. Meryon. Plenty of connections, but not necessarily ones that would make Lady Hester and William close friends.

Lady Hester had left England, with just a small stipend, after losing both a brother and the man she expected to marry. She traveled and then lived in Turkey before finding Mar Elias, where she settled with two female servants brought from England and a few Arabs from the area. Now 40, she was a tall, commanding figure dressed in male Arab clothes, more than a bit eccentric, believing that she had a special spiritual connection with the Bedouin tribes, who would, as a result, always do as she asked. William spent three long weeks at Mar Elias, restricted much of the time by bad weather. This was much too long for two strong-willed people who both expected to dominate the conversation to find themselves in the same small house.

One bright light during his stay was William's exploration of an underground Roman tomb near Sidon. The tomb had recently been discovered by accident, but apparently not investigated by anyone before William devoted time to drawing a plan and preparing a watercolor copy, by candlelight, of the nine figures holding platters of funeral meats. He then decided to remove the frescoes—having seen some removed at Pompeii—to send home. Part of one figure was damaged by Meryon as he prepared them for shipping to England, and others were damaged in a bad attempt at restoration.

20. Fresco in the funeral chapel at Sidon. Painting by Bankes.

But, two still survive at Kingston Lacy, along with his plan and watercolor rendition, the only knowledge we now have of this colorful and interesting tomb. William thought that the style was "sufficiently good," but the contrary Lady Hester considered them inferior to anything at Pompeii.

When William headed over the snow-covered mountain to Damascus he still was not out of Lady Hester's sphere of influence. First, she suggested that he take two extra Syrian servants with him, which, as Finati complains, added to the challenge of keeping everyone together and safe while traversing the mountain passage. Her servants were let go in Damascus. She complained in a letter to her lover Michael Bruce that Bankes changed his itinerary without telling her and that he wanted to see everything without paying much to do so.[3] And she infuriated William when he discovered that her letters of introduction to Bedouin sheikhs to provide guides for the desert trip to Palmyra contained only one of her seals, indicating that William was merely an ordinary person, not one of rank and significance who would be introduced with two of her seals. William of course refused to use her letters and so had to negotiate on his own for escorts.

The final blow came when William wrote to her in June, as he contemplated leaving Syria, to ask if she would hand over an enclosed letter to Dr. Meryon. The letter asked the doctor to become William's secretary and help him sort through his drawings and notes and offered to pay Meryon's expenses as they traveled in Italy. William makes clear to Lady Hester that he is first writing to her, even though it was his impression that Dr. Meryon wanted to leave her service to live in Italy. However, if she opposed the idea of letting him go, then she was to destroy his letters and say nothing, and he would "rest perfectly satisfied." He also wrote that he had gathered a bag full of cones of the famous cedars of Lebanon to nurture and plant at home and asked if she would send them to his father through the British consul.[4] (The cones did make it back to England, and the mature cedars continue to grace the grounds of Kingston Lacy.)

Although William's approach seems especially thoughtful and considerate, Lady Hester did not see it that way. She told the doctor of the offer but discouraged him from taking the position, and he decided not to leave.

Lady Hester used this incident to further complain about William's cheapness—because his letter did not offer a salary, only expenses. Since all of the records of those who traveled with William repeatedly praise his largesse, whether it be paying Buckingham's way or providing bonuses and presents to guides and staff who had served him well, we can assume that Dr. Meryon would have been handsomely rewarded if he had helped William organize his material for publication. What must have actually upset Lady Hester was the suggestion that Dr. Meryon was contemplating leaving, especially if she had been unaware of her physician's thoughts prior to reading William's letter. Lady Hester did tell Meryon to pack up the drawings and frescoes—but only because she did not want any of William's stuff in her home.

William tried to be gracious to his hostess, writing humorously that "when we are both respectable old people, we will sit at Kingston Hall under the shade of our cedars and fanning ourselves in spite of the difference of climate."[5] But she would not budge. Lady Hester complained to Buckingham, to Meryon, to Michael Bruce, to Burckhardt. William was impertinent and talked too much. He was cheap. And so on. Burckhardt wrote from Cairo to William that "Queen Zenobia . . . as You like to call her, is dreadfully angry with You for having slighted her advice and is making very free with your name, almost as free as she did with mine." Burckhardt continues that she is misguided if she believes that she understands the Bedouins or actually has any influence over the "unruly sons of the desert."[6] William ended Lady Hester's role in his life by writing back that she really could not obstruct his plans and that he had no intention of having anything more to do with her.[7] And, since she died abroad, he did not have to invite her to sit under the cedars at the renamed Kingston Lacy.

From Damascus William journeyed through the Hauran province, accompanied by a military escort and Burckhardt's directions. Fascinated by the many small villages, the architecture, and the Greek inscriptions but worn out by five weeks of bad weather and twice being robbed, he left, with regret, for Damascus. He would return, though, two years later with the British captains Irby and Mangles.

Still determined to get to Palmyra, William tried to arrange safe conduct through the motsellim of Hems. Although the motsellim could treat William to lavish entertainment at his palace, he could not provide what William needed, and so he left for Hamah, hoping that escorts could be obtained there. Here the Christian secretary of the governor entertained them, but he also could not promise safety from the Bedouins, or at least not without such a large escort and accompanying costs that negotiations ended and William headed to Aleppo. Here Consul Barker entertained William and sought to provide a different route—but failed—and so back to Hamah. William traveled to try to connect with the new pasha for Damascus, who was now at Hamah.

Finally William achieved some success, with the new pasha essentially telling the Bedouin Sheikh Nasser that he would remain as a hostage against the group's safe return from Palmyra and that he would supply a suitable escort for the agreed-upon sum of a thousand piastres. Sheikh Nasser grudgingly accepted the pasha's demands and provided a single slave—who had been stolen from another tribe—as the only guide.

After four days William arrived at Palmyra and spent the day exploring the extensive and impressive ruins. At night he entered a fortified temple ruin used by Sheikh Nasser and found the sheikh's brother there and in charge. The brother held William hostage for three days, demanding additional payment, and then invited him to go hawking, hoping that the group would try to escape. Not understanding the man he was dealing with, the brother was surprised to have his offer rejected. And so the guard was finally lifted, and William—Finati writes—spent the "remainder of that day with his paper and pencil and did not take his leave till about the middle of the next." He was most pleased to discover a Hebrew inscription above a doorway. He also noted that doors of stone were made there, as in the Hauran area. When they finally left, William offered a small gift to his jailer, as well as a lecture about how to behave better to travelers.

It was now June. They stopped again at Hamah, visiting their friend Selim, but where Finati caused William some trouble by wounding a

Turkish soldier in a dispute over winnings from a game in one of the coffee-houses. Finati was kept hidden until they were ready to leave for Tripoli, and then they rode out at night to avoid the soldier's friends still seeking revenge. At Tripoli, when Finati became ill for a few days, William used the time to forage for the Cedars of Lebanon pine cones that we know he then asked Hester Stanhope to mail to England for him. From Tripoli they rode to Antioch, stopping along the way whenever an antiquity caught William's attention, and then enjoying the beautiful, varied landscape as they approached the city. They examined Antioch's old walls and towers, visited ruins of early Christian churches, and observed that they were now hearing more Turkish than Arabic.

And then, on June 26, 1816, after six months of travel through much of what was then Palestine and Syria, William and Antonio and Finati rode down the coast to the port at Seleucia, and parted. Finati, with letters of recommendation from William and plans to return to Egypt—and no desire for a long sea voyage—said his farewells, not expecting to see William again. It was a difficult parting for both. William and Antonio sailed for Cyprus, with the expectation of travel through Greece and Italy on the way home. But, as so often with William, home will have to wait a few more years.

PACKED FOR PETRA

PAINT BOXES AND GUNS

21. House with tower in the Hauran region of Syria, with inscriptions from the tower. Drawing by Bankes.

When William set sail for Cyprus and leisurely travel through the rest of the Mediterranean before heading home, he never expected to return to Syria. He had learned of the death of his great-uncle, Sir William Wynne, making William the owner of Soughton Hall and all of the farms on that estate in Wales. He was too far away to return for the funeral, but he did now have the responsibilities of ownership and told himself that he was headed for England, even if the path led through Asia Minor (modern Turkey), Greece, Italy, and only then across Western Europe to London.

In a letter home written shortly before he left Syria, William explains that he expects to visit Constantinople (formerly Byzantium, not yet renamed Istanbul), Greece, the Ionian islands, and then Italy, making his way "to Venice & Milan & Bologna then to Florence & perhaps a third time to Rome." He would winter in Italy and then, in the spring of 1817, return to England. If this seemed too leisurely a trek home in his father's mind, Henry really could not complain too strongly. After all he had made two trips to Italy before marrying Frances and settling in to the remodeling of Kingston Lacy and his busy career in Parliament. But little did Henry know, in the summer of 1816, just how lengthy and roundabout a journey William would take before finally returning to the family homes in Dorset and London.

William did understand himself—at least his need for a secretary—if not why he seemed unwilling to go home. Without Finati and failing to secure Dr. Meryon as an aide, William left no detailed record of his travels. When Finati returned to Syria in 1818, in response to William's call to rejoin him, he learned from Antonio that they had traveled through "all of Asia Minor, and the islands of the Archipelago and Adriatic, Constantinople, and all Greece, with Albania and Roumelia [near Macedonia] and even Maina [a mountainous area in the southern part of the Peloponnese]."[1] But William's exact route and timing are unclear. There are many ruins to investigate in Asia Minor alone, an important part of the Roman Empire,

and, before that, a player in the world of the ancient Egyptians. Most likely he visited the "moonscape" terrain of Cappadocia, with its rock-cut dwellings, and Ephesus, with its dramatic, multistoried library, before heading to Constantinople, that busy crossroads between East and West. Did William lodge in the old city, or did he cross the Golden Horn to lodge on the hills where Greeks and Venetians had settled to manage their commercial and banking interests? Not knowing Turkish, William might have been drawn to the Venetian community. Without Finati with him, presumably he did not try to enter the Hagia Sophia, then a mosque, instead admiring this magnificent fourth-century Christian church just from the outside. It must have bothered him, though, not to see the inside of this massive, multidomed, more Eastern than Western-styled architectural masterpiece.

William also visited Crete and some smaller Greek islands. He purchased vases on the island of Delos and drew a nice sketch of the port of Rhodes. He saw the main sights—the Acropolis in Athens and Mt. Olympus—but devoted most of his sketching and copying to places less studied and documented.

In the spring of 1817 William hosted a ball at the home of the pro-consul in Athens. He concerned himself with the political problems of Turkish rule in Greece, writing to his father to pass on his views to the foreign minister. In these activities he was the son of Henry Bankes. But in travels through the undeveloped areas of Macedonia and the southern Peloponnese—the large southern peninsula of Greece—he abandoned formal dress and was once again roughing it, writing on scraps of paper about the landscape, whether beautiful in flower or barren and desolate. He was especially fascinated by the monasteries perched on mountaintops, seemingly inaccessible, and sketched several of them. (The St. John monastery on the island of Patmos is a tame comparison to those approached on a swaying rope ladder or a net hauled up the mountainside.)

Then in the fall of 1817, William decided to return to Syria. A second trip to Egypt was also in his thoughts. During his months of travel after leaving Syria, he had kept up a correspondence with Burckhardt, who was

still in Cairo looking for a caravan headed to western Africa. From these letters, William learned that the new consul in Cairo, Henry Salt, was engaging, energetic, and eager to support excavations and acquire antiquities. He learned that Belzoni, working for Salt, was excavating tombs in the Valley of the Kings and that the colossal head of Ramesses II had been shipped to England as a gift to the British Museum. He also learned that Belzoni, with Finati and Charles Irby and James Mangles—two British captains who were traveling around the Mediterranean—had excavated the Great Temple at Abu Simbel.

In a letter dated October 17, 1817, William wrote to Burckhardt: "You'll be surprised at my resolution to make a second journey through a part of Syria. I should have been surprised at it myself had it been pre-told to me six months ago." He explained that he dreaded the thought of a cold winter in Europe but also stressed that he had not finished his studies of some sites in Syria.[2] Sadly, Burckhardt did not receive this letter from William; he died of dysentery in Cairo on October 17. Feeling the loss of his friend strengthened William's resolve not only to return to Egypt but first to find a way to get to the "lost" city of Petra.

When William sent word to Finati to rejoin him at Acre, Finati was in Upper Egypt. He had returned to Cairo after parting with William and, employed by the new British consul Henry Salt, traveled to Abu Simbel to work with Belzoni in the opening of Rameses II's great temple there. Finati notes in his *Narrative* that the task was made more difficult because of the way the Nubian workers were handled. He praises the hard work contributed by the British captains Irby and Mangles but observes that William was always better in his handling of the workers he hired to excavate temple sites.

Although Finati returned to Cairo and then to Alexandria as quickly as possible, he had to wait many weeks before a ship sailed to Jaffa in March 1818. Meanwhile, William had arrived in November and met Captains Irby and Mangles in Aleppo. Having completed their trip to Abu Simbel, they were now traveling in Syria and soon left Aleppo for Palmyra—but not

before agreeing to travel with William upon their return. The three men were comfortable together. Irby and Mangles willingly accepted William's leadership based on his superior classical knowledge and experience—or so they told themselves—as well as on his automatically taking that role. And in the captains William found a new secretary. Although he is always referred to as Mr. Bankes in their published travels, William actually dictated much of their material on Syria. The rest they took directly from William's own notes—presumably with William's permission.

When Irby and Mangles left Aleppo, William grew impatient waiting for Finati's arrival and chose to hire another guide to continue his exploration, notably throughout the Hauran region east of the Jordan River. No one at this time covered the area and its over fifty small villages more thoroughly than William. He copied Greek inscriptions everywhere he went and was intrigued and delighted by the "dwelling-houses of a thousand years old and more, remaining quite entire." The houses were still standing because they were constructed of a black stone, "even to the very planking of the ceilings, and to the doors and shutters, which still turn upon their pivot-hinges." Stables and their mangers were also carved from solid stone. Many of the houses had square towers, sometimes attached, sometimes standing separately.

William found sarcophagi in some of the towers as well as inscriptions appropriate to a tomb and concluded that the towers, even though mixed in with the houses in many instances, must have been the ancient dwellers' burial sites. He also studied temple and theater remains, especially the theater at Bosra that had been converted into a castle. William notes, in Finati's *Narrative*, that it may be the "most entire antique theatre remaining in any country." His sketches and notes provide a valuable glimpse into the past of an area whose ancient dwellings were heavily destroyed by late nineteenth-century building.

Unfortunately, travel east of the Jordan River had not improved during William's absence. After disputes with the Bedouins of the area, William and his guide were forced to flee from Assalt by swimming with their

horses across the Jordan River and hiding in a cave to avoid further danger. Surviving this ordeal to arrive safely in Jerusalem, William sent for Finati and Antonio to join him there. Finati writes that meeting William again at the monastery in Jerusalem was a joyful day for him. If he had known what further dangers awaited him, he might not have been quite so happy to be working for William once more.

Now gathered at the monastery were Irby and Mangles, Mrs. Belzoni (escorted from Upper Egypt by Finati so that she could see the Holy Land), Lord Belmore traveling with his family on his own ship, and another English traveler, Thomas Legh, already an author of his travels in Egypt. The group watched the Greek Easter festival in Jerusalem, which was followed by a procession of thousands to bathe in the Jordan. They traveled to the Dead Sea to discover its "nauseous quality to the taste" and experience burning eyes and skin. They saw for themselves that indeed non-swimmers, including William, could easily float on its surface.

Before leaving Jerusalem, William decided to return to another unfinished project. In 1816, he had measured a large excavation site just outside the city's walls known as the Tomb of the Kings. His study of the tomb convinced him that there must be a second entrance not yet found. In Constantinople before returning to Syria, he had tried to obtain permission to further excavate the site as part of his *firman* but was denied. When arriving in Jerusalem, he again tried to get permission, this time from the city's governor, but again was denied. And so the "father of all mischiefs" was resurrected. He convinced Irby and Mangles, Legh, Lord Belmore's brother and two of their sailors, and the group's various servants to arm themselves with axes and other tools and quietly depart the city at night through different gates to avoid suspicion. They organized themselves into two shifts and left one person as a sentinel. By morning, having dug ten feet, they were stopped by a huge stone, placed exactly where William expected to find the missing opening. Undeterred, William's gang of excavators slipped out the next afternoon, this time with a strategy for breaking the stone by heating it. However, they were

discovered and reported to the governor, whose response was to give orders to fill in their excavations.

Because the group was dispersing that evening, William could not muster enough hands to try to complete their dig. Finati writes—using the language and expressing the sentiments of William—that they did not really try hard enough to convince the governor and probably could have managed to do so, had they made the effort. William concludes that he always "regretted that no further attempt was made, feeling quite convinced that some aperture existed very little below the level at which we left off."

It was time now for William to concentrate on the primary goal in returning to Syria: to find the rose-red city of Petra. He also wanted to see the castle of Kerek, both located in what is now southern Jordan. Additionally, he hoped to discover, along the way, the palace of Hircanus, a fortified temple called Carnaim, and the tomb of King Herod—quite a remarkable list.

Although a journey to find these sites did not seem all that difficult, William quickly discovered just how challenging it would be. No one was willing to grant permission for this tour. No one seemed to be in charge—or no one would claim to control the various Bedouin tribes living in the Petra region of Wady Mousa. When William had tried to get Petra and Kerek added to his *firman* in Constantinople, he was told there was no knowledge of such places. Then the governors of Jaffa and Damascus and Jerusalem were applied to, but all alike denied any responsibility for the region. When the request was made to the governor of Jaffa, he not only refused to support the trip but demanded that Irby and Mangles return the horses he had lent them! When William, Irby, Mangles, and Legh went together to speak to the Jerusalem governor, they were told by a former motsellim sitting with the governor that the Arabs of the Wady Mousa (Valley of Moses) area are "a most savage and treacherous race" and would happily kill the lot of them.

What to do now. In a charm offensive, William convinced the others that they would have to find a guide and venture south on their own. They

began by calling again on Mahomet Daheidy, who, at least in the short run, honored his debt to William and came to their aid. And, since they planned to travel first to Hebron, they also found someone from that town to join them. These two, Finati, the four principal British travelers (William, Irby, Mangles, and Legh), and the servants swelled the group to eleven.

In their *Travels*, Irby and Mangles write that although they doubted that William could have made this trip entirely on his own, they grant him "the merit of being the first person traveling as a European, who ever thought of extending his researches" to Petra and that his "profound knowledge of ancient history" and his "skill in drawing" made him the best person to organize the expedition.[3] They also observe that Burckhardt, the only other European known to have seen Petra, was now dead. And Burckhardt, traveling in disguise as an Arab, could neither explore nor sketch the ancient capital of the Nabateans without revealing his true identity—and losing his life.

William decided that the group should travel as inconspicuously as possible, all wearing the most ordinary Arab clothes and taking very little baggage with them. They carried gold coins in belts concealed beneath their robes and assumed Arab names—William's was Haleel—as if this would somehow add to their safety. Surely aware of the incongruity, they also carried "six muskets, one blunderbuss, five brace of pistols, and two sabers." They rode out of Jerusalem in the late afternoon of May 6, 1817, and spent the first night of their historic journey in Bethlehem.

On the following day William visited the Frank Mountain, once an important fortification on a high hill, now with walls and towers in ruins. The travelers dismounted to visit the Labyrinth, a natural cavern with a large chamber and many passageways, and then rode on to see the ruins of Tekoa. Riding through cultivated country and then climbing through vineyards, they reached Hebron at dusk.

The governor of Hebron, initially gracious, offered to help William and began the bargaining process for guides. But after several days he refused any assistance and told the group not to travel to Petra. Then William's friend Mahomet Daheidy proclaimed that he could go no farther. And so

they left Hebron with only a compass for their guide. After they traveled a short distance, however, two men came galloping up to say that the governor wanted to discuss the trip once again. Finati was sent back to Hebron with the governor's men while the rest of the group waited in a field. Finati eventually returned with an Arab guide and permission of sorts to travel to Kerek, in exchange for money and gifts. William happily thought that he was once again heading toward his goal, but it was not to be that simple. At the new guide's tents that night, William could not convince anyone there, at any price, to take them to Wady Mousa, "so great did they represent the dangers of that country to be," Finati reports.

Heading toward Kerek without guides, William and the others rode across the plain to the south of the Dead Sea where they found much of the ground to be salt-encrusted. They stopped frequently to collect chunks of red granite and other interesting rocks—and to wait while William made several sketches of the Dead Sea basin from this southern perspective. Camping for the night, they gathered plenty of logs but could not get a fire started, the wood being too filled with salt. Dinner, then, was flour mixed with water, as no bread could be baked or coffee brewed. The following day took them through some cultivated fields where they were graciously fed by the Arabs, but the horses suffered much from numerous large flies. As they traveled up a rocky narrow path to Kerek, several armed horsemen observed them but then let the group pass without conflict.

Finally, the castle of Kerek came into view. The ruins here did not inspire William, but he did note that the inhabitants, about equally divided between Christian and Muslim, seemed to be living together harmoniously. Most important for the journey's goal, the Muslim leader Sheikh Yousouf agreed to see them safely to Petra and back to Assalt. He did warn them, though, that additional payments might be necessary as they moved through territory controlled by other sheikhs. Much of the difficulty with this project, apparently, was over control of the stream in Wady Mousa. Just as in Egypt, William could not convince local tribes that he was interested only in studying ancient sites, not in robbing tombs or stealing water.

A four-day ride brought them to the fortified town of Shobeck, where they were received graciously once the residents saw that Yousouf was their guide. Shobeck's powerful young sheikh, Mahommed Abou Raschid, was willing to escort the group to Petra out of respect for the Egyptian pasha Mahommed Ali, whose letters of recommendation William carried. Finally Petra seemed within William's grasp—until Abou-Zeitoon (the sheikh of Wady Mousa), hearing of the proposed trip, immediately declared that they would not "enter his district, nor taste of the water there." The young Raschid would not listen to Yousouf's advice to keep peace in the neighborhood by ending plans to take the foreigners onward. He would stick to his offer and the travelers would drink the water of Wady Mousa, a determination made without any promise of money or gifts from William.

Abou-Zeitoon led his men out, as did Raschid with the travelers, while Yousouf called for reinforcements of his men at Kerek. William and his caravan stayed at the camp of a new, friendly tribe, close enough to be able to see "the great purple peaks of Mount Hor," Aaron's tomb, and the village of Wady Mousa, where a barricade was now placed around the water. And then they sat and listened through four days of negotiation, saying little except that they had no intention of poisoning the water and wanted only to see the antiquities. Raschid, his honor on the line, gathered more of his men around him, but the issue was finally resolved by some men from Damascus (who happened to be at Wady Mousa) looking at the group's papers and announcing that they were satisfactory—even though the papers were in Turkish, a language not one of the men could read. Abou-Zeitoon, declaring that the trip into Petra was now approved—and thus saving his honor—led his men out of the camp and back toward Wady Mousa. Meanwhile Raschid led the travelers straight ahead, getting in front of Abou-Zeitoon's tribe, who now could do little but watch as, at last, William and his weary band followed the narrow trail to Petra.

Irby and Mangles, using William's notes, describe the awesome entrance into Petra:

It is impossible to conceive any thing more awful or sublime than such an approach; the width is not more than just sufficient for the passage of two horsemen abreast, the sides are in all parts perpendicular, varying from four hundred to seven hundred feet in height. . . . The screaming of the eagles, hawks, and owls, who were soaring above our heads in considerable numbers, seemingly annoyed at any one approaching their lonely habitation, added much to the singularity of this scene. . . . The ravine, without changing much its general direction, presents so many elbows and windings in its course, to which the track, of necessity, conforms, that the eye can seldom penetrate forward beyond a few paces, and is often puzzled to distinguish in what direction the passage will open.

We followed this sort of half subterranean passage for the space of nearly two miles, the sides increasing in height as the path continually descended, while the tops of the precipices retained their former level. Where they are at the highest, a beam of stronger light breaks in . . . and opens to view, half seen at first through the tall narrow opening, columns, statues, and cornices, of a light and finished taste, . . . executed in a stone of a pale rose colour. . . . We know not with what to compare this scene; perhaps there is nothing in the world that resembles it.[4]

This most spectacular of the city's temples and tombs is carved out of the rock at the far side of a nearly circular space that opens up at the end of the long entranceway, an entrance easily defended, the scene of many deaths of unwelcome visitors over the years. William describes the temple at great length over several pages, a description that includes the damage by musket balls to the upper-story urn—believed to be the hiding place of great treasure—and the speculation that climbing to the top would be virtually impossible. The others waited patiently amid the oleander while he devoted several hours to his sketch of the richly ornamented front of the Khasneh. This label, meaning *treasury*, is probably a misnomer, as the building was most likely a tomb, a temple, or a mortuary temple, probably built in the middle of the first century BCE.

22. The Khasneh, probably a royal tomb, at Petra. Drawing by Bankes.

Leaving the courtyard, William followed the passageway to the right of the Khasneh until it opened into the main part of the city, which is best described, Finati tells us, as standing in the hollow of a mountain rather than in a valley or plain. They found ruins of a theater and a few columns,

but mostly "an immense display of tombs all round, . . . many rising to a vast height." Some were ornamented; others more simply carved. All were cut out of the red-veined sandstone and, William concluded, constructed from the top down.

They took time out from studying the tombs and drawing a site map to devote more than two hours to ascend and return from Mount Hor. William was rewarded by finding Aaron's tomb, with an inscription in Hebrew. Although another rock-cut marvel could be seen on a distant hilltop, there was not enough time to explore it. William did take time to carefully copy inscriptions in a language he could not identify—the Nabatean—but recognized as similar to inscriptions he had seen near Mount Sinai. (If he had published the inscriptions, as planned, he would have significantly advanced the decoding of the Nabatean language.)

As enchanting as William found the entrance into Petra that suddenly opens up to dramatically display the Khasneh, he did not lose his capacity for evaluation. His analysis in Finati's *Narrative* is a comparison of Petra's tombs with those of Egypt, in which Petra's are inferior in "majesty of effect," though not in scale. Further, Egypt's tombs have little decoration on the outside but contain many chambers, all stunningly decorated, whereas Petra's decoration is all on the outside.

In Irby and Mangles's use of William's notes we read lengthy descriptive detail of the rock-cut exteriors, the recognition that bronze fastenings had been used to hold plaques, and William's struggle to date the tombs based on the various architectural elements used. Some of the design struck William as pre-Roman, whereas other elements—columns, pilasters, pediments—show Roman influence. He felt certain that the Khasneh postdated Trajan's conquest. He also asserts that on some exteriors the overloading of ornamentation is in bad taste, "with an infinity of broken lines and unnecessary angles and projections, and pedestals set upon columns that support nothing." In sum, it "might have been the work of Boromini [Francesco Boromini was a seventeenth-century Italian architect] himself, whose style it exactly resembles, and carries to the extreme."

William also explains that although he and his men explored from dawn to dusk, the two days in Petra were not nearly enough to study all of the remains of this once wealthy nation's principal city. And he blends his criticism of some of the carving with repeated amazement over the stunning Khasneh and the "extraordinary colouring" of the mountain setting, with rock that is sometimes "a deep, sometime a paler blue, and sometimes . . . streaked with red, or shaded off to lilac or purple, sometimes a salmon-colour was veined in waved lines and circles." William concludes that "it is this wonderful variety of colours observable throughout the whole range of mountains, that gives to Petra one of its most characteristic beauties; the facades of the tombs, tastefully as they are sculptured, owe much of their imposing appearance to this infinite diversity of hues in the stone" (see color plate C10). No advertising of today's tours can outdo William's language to capture the impact of Petra's fantastical setting on its visitors.

Throughout their two days of scrambling, they were watched by Abou-Zeitoon's tribe, who had moved out of their Wady Mousa settlement onto nearby cliffs. At the end of the second day, Abou Raschid insisted that there was too much risk in staying another day, and so the group rode out of Petra—to be met by Bedouins who rather forcefully insisted that they spend the night in their tents. They were free to leave the following morning, however, and rejoined Yousouf that evening at his large tented camp some distance from Petra. At this point Abou Raschid left them, receiving thanks and presents from William and displaying sincere regret during the leave-taking, Bedouin and English alike recognizing traits of honor and commitment in the other.

William returned to Shobeck and then spent one night in a rather poor village that had the advantage of a nearby hot spring, which the travelers enjoyed, both to bathe and to warm themselves. Even though June was approaching, the nights in the hills had been chilly. The following night they returned to Kerek and the tents of Yousouf's father-in-law. Three young goats were slaughtered for a feast to celebrate their safe return. William's northward journey took him past the Dead Sea once more and then to a

temple called Beit el Karm near Rabbah, which he believed to be the temple at Carnaim, another site on his list for this trip.

Following an old Roman road—still with its ancient milestones—the group came into a large tented camp of Benysackr Arabs, the same ones William had fled from after his earlier tour of the Hauran. Yousouf himself expressed some concern for the safety of his foreigners, but William, keen to visit Medaba and Heshbon nearby, chose not to tell Yousouf of his past conflict with the Benysackr tribe. Perhaps because of the chief's respect for Yousouf, William, though recognized, was treated with kindness by the chief. Once again the travelers were feasted—and then treated to music by lamplight. The following day's exploration of ruins proved disappointing, not surprisingly after the great spectacle of Petra, but William was once again delighted when he reached Arrag el Emir (the Prince's Ruin), which he identified as the palace of Hircanus, described by Josephus.

At this point, Yousouf took a fond leave of the foreign explorers. They continued their explorations, touring the Roman ruins of Amman and then visiting Jerash and the theater at Bisan once more. They completed the six-week trip on the coast at Acre, where William parted with Irby, Mangles, and Legh, who all left for Constantinople.

The trip had been exhausting and demanding. They never escaped flies and fleas—sent to a crackling death as they shook out their clothes over a fire—and often did without food. The narrow, steep passages meant walking their horses, and to negotiate the well-worn, often broken steps to high places at Petra they resorted to scrambling barefoot, using hands as well as feet for balance. No one had dared to promise William safe passage to and from Petra. But, he had done it. William seemed to know when to be the jolly traveler with a pocket full of gifts and when to put on the robes of the tribal leader who expected respect and generosity from other leaders. He found every site on his list, and he was able to record his two-day exploration of the fabulous rose-red city in valuable sketches and notes.

Unfortunately, what William did not do was publish his discoveries from this arduous journey. Legh surprised—and annoyed—William by

publishing a travel book in 1819, before William had even arrived back in England. The title of Legh's co-authored book does not suggest that it will include an account of his Petra trip, but it is there. The account was written by Legh's travel companion, William Macmichael (who was not with Legh on the Petra journey), based only on notes given to him by Legh. Charles Irby and others expressed some dismay over Legh's actions, but all still felt that, when published, William's study would be so much richer and more significant as to easily outdo Legh's travelogue. Adding to William's frustration was the 1823 publication by Irby and Mangles, a travelogue written in the form of letters home. Initially privately published, John Murray then decided to print more copies for public sale. The exact agreement between these men seems unclear, although it certainly appears as if William consented to their use of his extensive notes. Recent comparison of those notes with the Irby/Mangles book reveals that many pages of description of Petra were written by William.

William's rest at Acre was spent in walks and rides around Mount Carmel and then further study of ancient sites north of the Sea of Galilee, an excursion that ended abruptly when his horse suddenly went blind. Returning to Acre, he did not find a ship sailing to Egypt, so he left for Jaffa.

It was now June. Fruit was ripening, and after doing without during his six-week journey to Petra and back, William could not get enough watermelon and mulberries. The result, Finati records, was a violent fever that rendered him gravely ill, even delirious at times. Not finding any useful medical help in Jaffa, Finati rode desperately to Jerusalem to return with a Spanish monk from the monastery there who had some medical knowledge. The two attended William, who remained quite ill for a month. The governor of Jaffa even suspended the firing of the fortress guns so as not to disturb William. When he started to feel better, he was so weak that he was

carried to the monastery at Ramah in a litter, unable to ride. Finati writes that he wondered about William's decision to recover at Ramah but did not wish to question him too much because the long illness "had rendered his temper irritable." William's usual charm and high spirits deserted him during his first truly serious illness—and perhaps reminded him that he was now no longer the "twenty-something" adventurer.

Before leaving Jaffa, William, still in bed, asked Finati to purchase an Albanian outfit for him. The outfit was taken with them to Ramah, and then William suggested that it was time for the Spanish monk to return to Jerusalem. Reluctantly, the monk left his patient after much advice about rest and quiet, but William wanted to be alone. He immediately told Finati to obtain two mules and a Turkish guide for a nighttime trip to Jerusalem. William shaved off his bushy beard, leaving only a moustache, and then put on the Albanian outfit, complete with pistols in his belt and a scarlet cap on his head. Without his beard and terribly thin from his illness, he was hardly recognizable.

With the new governor expected in Jerusalem any day, there was much activity, including those coming to enlist in his service. William counted on their being able to mingle without attention on a journey still not explained to Finati, who—knowing the man he served—was becoming increasingly concerned. When a military guard stopped them outside the city, a detachment of Albanians insisted that they join them for coffee. Finati did, while William hid his face in a handkerchief and excused himself with the pretense of a very bad toothache.

They reached the western gate of Jerusalem at dawn, left the mules with their guide, and walked around the city's walls to St. Stephen's Gate, the gate nearest to the Temple of Solomon. As they sat waiting for this gate to open, William explained the mission to Finati, who had already guessed the goal of his visiting the forbidden temple. William argued that the mosque keepers would not expect them to speak Arabic, given their Albanian attire, and that the soldiers—the only source of danger—rarely went into the mosques. If necessary the device of the toothache could be used to hide his face and avoid detection as a non-Muslim.

To William's credit, he allows Finati to tell this tale, to express his misgivings and avow that "for no other human being in the world would . . . [he] have done it." Finati refuses to present William as some kind of hero and explains that it was he—Finati—that had more courage in this adventure than William because he went without William's interest, having been to the temple before, and he ran the greater risk. Finati was smart enough to know that even with the penalty of death for William—if they were discovered—the reality would be that, given his status as a British subject of some wealth and position, William would have been scolded but not harmed. It is Finati who would have been killed as the example of a Muslim knowing the law and still breaking it.

The gate opened and William entered the city, with Finati catching up to him and then walking by his side into the exterior square of the temple. When the keeper arrived, Finati conversed with him in Arabic as they followed him inside the mosque and explained that his companion knew no Arabic. They toured the mosque, and then William brazenly waited for official papers listing the holy stations they had visited. Finati quickly thought to place both certificates on his shaven head, the customary sign of respect, for if William had removed his cap, his identity would have been revealed. Finati explained that he took both certificates because his companion had his handkerchief "bandage" in the way.

Not satisfied with this escapade, William then insisted that they visit the nearby mosque of the Purification and then the tomb of David on Mount Sion, truly trying the patience of the saintly Finati. By this time the guide had come to the temple in search of them and had roused the suspicions of the keeper. They were lucky to get out of the city and into the desert to a monastery, where they paid the muleteer and did not explain what had brought them to seek shelter there. The following day they rode back first to Ramah and then, by evening, to Jaffa, where all seemed to have heard of William's success in again walking through doors presumably closed to him. Needless to say, no one was amused. It was time to leave Syria. William hired a ship to take them to Damietta in the Egyptian Delta, but they were blown

off course to Cyprus, an island that William was happy to revisit. Eventually the wind became favorable, filling their sails, bringing William once more to the land of the Nile.

William may be the traveler "who leaves nothing unexplored"—including places sacred to another religion. But to continue to visit sites in Jerusalem after the Temple of Solomon, knowing that the muleteer would be asking after them because of their lengthy absence, seems reckless in the extreme. Reckless in a way quite different from his determination to get to Petra. We have to wonder what led him to extend the recklessness beyond the temple visit. Surely he would not have wanted to lose Finati, a man he so admired and appreciated, the man who had just nursed him back to health. Even if he had the power to protect Finati, he put his friend through a harrowing several hours.

Perhaps in this escapade William was testing himself, seeking assurance that he had recovered, that he was not going to die in Syria, far from home. The serious threat to his health may have unnerved him more than even he realized, leading to the childish mischief maker briefly ruling over the now disciplined archaeologist. He may also have wanted to show the Arabs that no one could stop him, that he would travel where he pleased, that he would have the last laugh. William would need some time in Cairo to regain both his strength and his equanimity.

ARTISTS SET SAIL

WILLIAM BEGINS HIS GREAT SECOND JOURNEY UP THE NILE

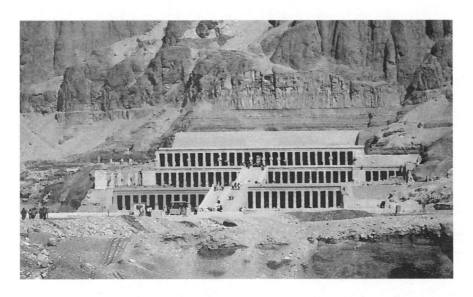

23. Hatshepsut's Mortuary Temple at Luxor, still buried in the sand in 1818.

During his return to Egypt in the summer of 1818, William learned that travel by sea could be just as difficult as travel by camel or horse. On the way from Syria, he asked the ship's captain to stop at El-Arish to retrieve the dark granite monolith awaiting removal. The waves made maneuvering the ship close to shore difficult, and the captain determined

that a smaller boat would sink under the weight of the granite. Finati knowingly writes that this operation required someone with energy and great strength of will, traits William usually possessed but was lacking after his recent devastating illness. The granite piece, covered in hieroglyphs, was left in place.[1] After wind blew the ship away from Egypt to Cyprus for a few days, William finally arrived at Damietta, explored several antiquities in the Delta area first, and then returned to Cairo in September 1818.

He was eagerly welcomed by the new British consul Henry Salt, who already knew him by reputation from Burckhardt. The handsome Salt, replacing Colonel Missett, chose to base the consulate in Cairo. His home and English-styled garden offered a place for much-needed rest. William had written to his father, as his recovery progressed, that initially he was so weak that he could not stand without help. For William, "rest" meant short trips without danger. He revisited the pyramids of Giza with Salt to see the latest excavations of new chambers and to find the Sphinx once more nearly covered by sand. In October, they hired boats for the two-hour journey to the quarries at Tura. These trips led William to observe that the Egyptians "had not only the glory of creating artificial mountains but one that is uncommon in having visibly reduced the natural ones."[2]

Further rest was required by another eye infection attack, but William continued to talk and plan even while remaining out of the sun, for his second Nile journey was ready for launching by mid-October. And planning was essential for the large group that would eventually head up the Nile together with the goal of exploring deep into Nubia. Although in a letter to Buckingham in Syria in 1816 William had deplored the idea of a large party traveling together, he may have written this as a way of deflecting Buckingham's desire to latch on to him. At any rate, he had seen the value of their group of eleven in the hazardous and trying journey to Petra, and now, in discussions with Salt, he agreed to join forces for the shared purpose of examining antiquities and making copies of them.

Henry Salt had trained as a portrait painter in London before traveling in the East with Lord Valentia and preparing the drawings for Valentia's

book *Voyages and Travels* (1809). This was followed by his own diplomatic mission, which led to *Voyage to Abyssinia* (1814). Assuming the consul position in Egypt at 35, Salt brought with him as an unpaid secretary the twenty-seven-year-old Henry Beechey, son of the portrait painter Sir William Beechey. On a small salary and with no personal fortune, Salt had already funded the excavation of Abu Simbel, led by Giovanni Belzoni, and continued to support Belzoni's excavations of tombs in the Valley of the Kings at Luxor. He was acting on the impression he had been given that the British government would pay for antiquities for the British Museum. Even though Salt and Burckhardt, having arranged the shipping, took credit for giving the colossal head of Rameses II to the British Museum, it was actually a gift from Egypt's pasha Mohammed Ali. Now Salt needed to travel with the goal of obtaining at least some antiquities that he could sell in London.

Salt probably paid for his boat, a roomy but not easily managed vessel called a mash, and for its sailors. He probably did not pay close to half the costs of the expedition, a journey that also included a Prussian naturalist, Baron Sack, who asked to join the group and traveled in his own small boat. William hired a large *canjia* with fourteen oars, which he presumably shared with Antonio and Finati, as well as a fourth boat for provisions that included riding-asses, goats for milk, and sheep and fowl for food—in addition to all of the paint boxes and candles and ropes and axes that would be needed for both excavation and copying.

A young French sailor, Linant de Bellefonds, was also hired by William as a draftsman and to help with site plan measurements. And, when the flotilla reached Luxor, they added Salt's secretary Henry Beechey and Dr. Alessandro Ricci, an Italian physician. Both Beechey and Ricci had been living together in the Valley of the Kings and working with Belzoni. They had been busy copying the wall drawings in the now-open tomb of Sety I when William arrived. William hired Ricci as both physician and draftsman, and he added Belzoni to the group to travel as far as Philae to remove his obelisk. And so from Luxor south, there were five artists (William, Salt, Beechey, Linant, and Ricci); Sack presumably with an attendant; probably at least

one servant for Salt; Antonio Da Costa and Finati with William; as well as sailors, cooks, and probably a livestock attendant. This journey would be quite different from William's virtually private 1815 exploration of Egypt.

Not surprisingly, Belzoni, who had spent much time camping out in temples and crawling through dust-filled tombs, could not resist commenting on the ease and comfort provided to those who traveled with William.[3] William might have chosen to remind Belzoni of the danger, privation, and disease he experienced during his years in Syria, but perhaps he decided instead to emphasize the serious work he expected from those he had employed for this expedition.

He understood the differences between Syria and Egypt and prepared for that. In Syria he traveled with few provisions, relying on the Bedouin culture of hospitality. If the Bedouins did not rob you and strip you naked in the desert, they would welcome you to their tents and slaughter a goat for a celebratory feast. In Egypt in 1818, the pasha and his cashiefs throughout the country ruled with much more control than any of the Ottoman governors in Syria, but the towns along the Nile were relatively poor. William planned to pay for additional provisions; he knew better than to expect his large caravan to be fed by local farmers as they traveled up the Nile. Ease and comfort are relative; having left his attractive garden in Cairo, Salt wrote that they lived on their boats in a "frugal way."

Salt also wrote to a friend in Cairo that the group was composed of "very *pleasant* and *agreeable people*." He describes William as "one of the most delightful companions I ever met with, high-bred, well informed, and possessing an inexhaustible fund of humour." Baron Sack provided amusing stories of armadillos, mice, and "monstrous" snakes. He was easily teased by William but accepted the joking with good grace. Writing of himself, Salt explains that he is still fond of teasing and joking and was able to contribute tales of Abyssinia (modern Ethiopia). Salt sounds as if he is possibly trying to compete with William's gifts for turning his experiences into beguiling stories to amuse most audiences. Salt depicts the others—Linant, Ricci, and Beechey—as shining in their "respective spheres" but as "*secondary* planets

. . . who looked up with *all due* deference to the more *brilliant luminaries*."[4]

Although Salt's underscoring in his letter suggests a tongue-in-cheek tone and a desire to amuse his reader, he nonetheless establishes the reality of a hierarchy based on position, knowledge, and age. Not especially interested in ancient Egypt's art and architecture, the baron, busy cutting up frogs and beetles, was respected for his particular talents and his title. Salt sees himself, with William, as in charge not only of their various attendants but also of the young draftsmen Beechey, Linant, and Ricci.

William saw it differently. All the artists worked for him, including Salt. Their drawings and paintings were his and would return to England with him. However, the artists made copies of many of their drawings, which they used later for themselves.

On this trip William did not have conflict over ownership with either the "secondary planets" or with Salt, but he did continue to operate on assumptions that will cause him grief later—and will cause Salt problems with Belzoni. The same issues—who is the boss, how does the "hired" person get paid—led to Salt's firing of Belzoni soon after William's 1818 Nile trip.

Giovanni d'Athanasi, also employed by Salt to excavate in the Valley of the Kings, blames Belzoni entirely for his falling out with Salt (in his 1836 *Brief Account of the Researches and Discoveries in Upper Egypt*). It is hard to judge if his view justifies Salt's position or if d'Athanasi deemed it wise to support his employer rather than defend Belzoni. D'Athanasi joined William's flotilla at Luxor and aided in the removal of the pedestal for William's obelisk at Philae.

At Philae William's party met a group of four Englishmen that included the young architect Charles Barry. Barry inspected William's drawings, was impressed with the artists' industry, and later made the observation that all of the drawings belonged to William. When both are back in England, Barry will be hired by William initially to remodel Soughton Hall, his home in Wales, and then later to remodel Kingston Lacy, the family estate in Dorset. But nothing came of their discussion, while in Egypt, of doing a book together. We see, though, William continuing to seek someone who

can help him organize his notes and drawings for publication. Perhaps he was already regretting the extent to which he had allowed Irby and Mangles to use his Petra notes for their travel memoir. On this trip William must also have been shocked to see how "busy" the Nile had become since his first voyage to the Second Cataract just three years before.

Before setting sail, William wrote again to his father, apologizing for not writing sooner after his safe return to Egypt, especially since his last letter from Jaffa described his serious illness. He explains that he is ready to leave for Upper Egypt with Salt and that this journey will be less taxing than the first because the Nile waters are really high—easing travel—and he has hired a larger boat this time. He writes in detail about the copying of an inscription from the ruins of a building in Cairo. The inscription is in Latin, not Greek, so it must have stated a general law for the entire empire, not a local rule. He notes that the stonecutter made many errors and that if his father were to compare the original with William's correct Latin he would see that his son has both industry and patience.

Although pointing out that he will not be leaving Egypt before spring (1819) as this will be a long journey up the Nile, William writes as if he longs to be home, touring Cornwall and Wales and visiting his brother George, whose cottage "will be as new to me as the chamber in the Pyramids."[5] New, yes, but not nearly as interesting. Once again William writes as the dutiful son; once again he suggests a return time that he will not meet.

William's flotilla moved slowly up the Nile because they stopped to examine every tomb and temple. At Beni Hasan, he was struck by drawings showing both a colossus and a huge stone being drawn on a sledge, the first pulled by many men, the second drawn by oxen. These tombs also reveal pictures of manufacturing and domestic activities, providing insight into the lives of the ancient Egyptians. This time William, prepared with ladders and candles,

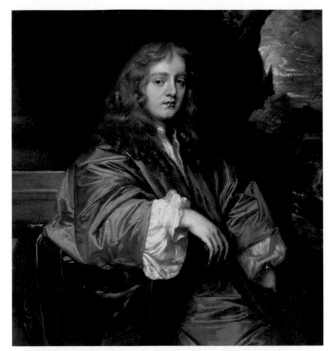

C1. Sir Ralph Bankes (1631–1677). *Painting by Sir Peter Lely.*

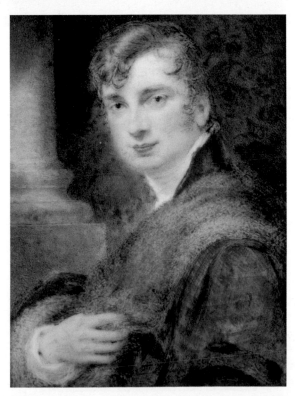

C2. William John Bankes (1786–1855). *Painting by George Sanders, 1812.*

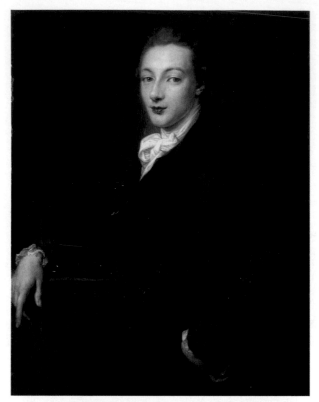

C3. Henry Bankes (1757–1834). *Painting by Pompeo Batoni, 1779.*

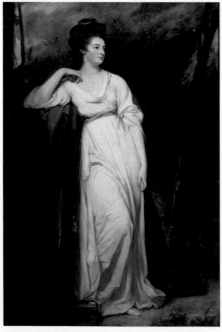

C4. Frances Woodley Bankes (1760–1823). *Painting by George Romney, 1780–81.*

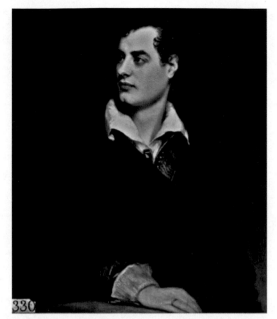

C5. Lord Byron. *Painting by Thomas Phillips, c. 1814.*

C6. *The Holy Family,* from the circle of Raphael. Purchased by William Bankes in 1813 in Spain. Bankes commissioned the frame, which has a portrait of Raphael in the circle at the top.

C7. A Coptic fresco placed over Egyptian wall drawings in the Kalabsha Temple.
Painting by William Bankes.

C8. Stela from the workmen's village at Deir el-Medina. The upper register shows the deceased's offering to three gods; the bottom register shows a family procession.

C9. The Oval Piazza at Jerash. *Painting by William Bankes.*

C10. The courtyard in front of the Khasneh, looking back to the
narrow entrance into Petra known as the Siq.

C11. The deceased and his family fowling in the marshes. From the now lost tomb of Nebamun, an official under either Hatshepsut or Thutmose III. *Painting by Linant.*

C12. Remains of the Wadi Hedid Temple. *Painting by William Bankes.*

Interior of one of the Grotts in the Rock at Ibrim, the most difficult of access of the four.

C13. Interior of a shrine at Qasr Ibrim. Bankes hauled himself up with a rope around his waist to get to the shrine and make this partially painted drawing.

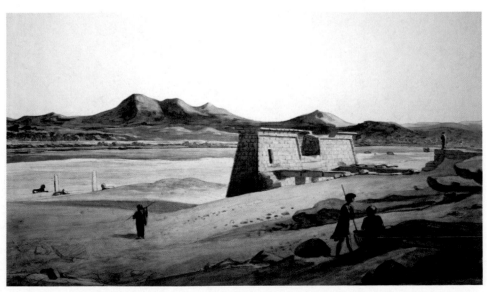

C14. Wadi es-Sebua Temple by the Nile. *Painting by Henry Beechey.*

C15. Wall drawing of the sacred barque in the sanctuary of the Wadi es-Sebua Temple. *Painting by Alessandro Ricci.*

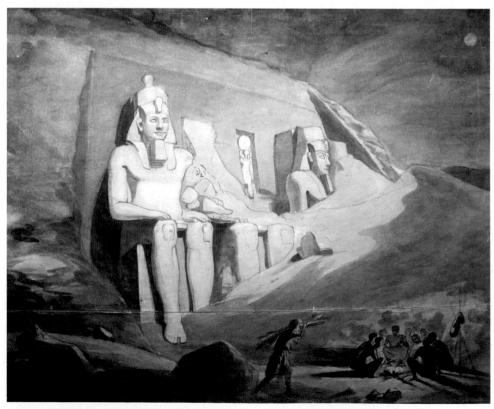

C16. Moonlight on the Great Temple at Abu Simbel. *Painting by Henry Beechey.*

C17. Abu Simbel Temple wall drawing showing Ramesses II attacking a Syrian fortress.
Painting by Alessandro Ricci.

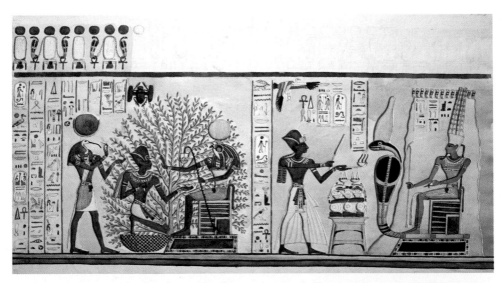

C18. Ramesses II kneeling under the sacred tree and offering incense to Amun-Re.
From the Great Temple at Abu Simbel. *Painting by Alessandro Ricci.*

C19. The columned entrance to the main temple at Abydos.

C20. The King List wall drawing in the main temple at Abydos.

C21. *The Judgement of Solomon* by Sebastiano del Piombo, early sixteenth century. Bankes purchased the unfinished painting in 1821, believing it to be the work of Giorgione.

C22. Henry Salt's gift to William of Amenemope's sarcophagus, on the lawn at Kingston Lacy.

C23. The Philae obelisk on the south lawn of Kingston Lacy.

C24. Fragment of a wall drawing showing a man offering food in flaming braziers.
Part of Bankes's Egyptian collection.

C25. Painted sketch of William Bankes. *Painting by Sir George Hayter, c. 1836–40.*

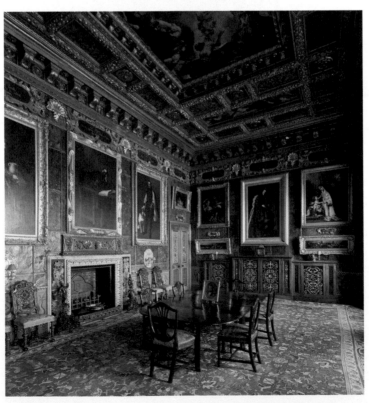

C26. The Spanish Room. *Designed by William Bankes.*

C27. The May door panel—one of twelve for the doors of the Spanish Room. *Designed by William Bankes.*

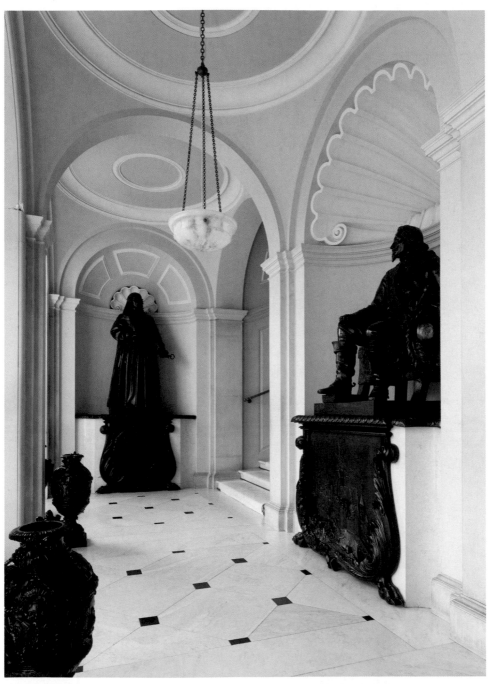

C28. The new loggia at Kingston Lacy where Bankes displayed sculptures of Dame Mary Bankes and Charles I. Sir John Bankes is in the right alcove, facing Mary. *Sculptures by Carlo Marochetti.*

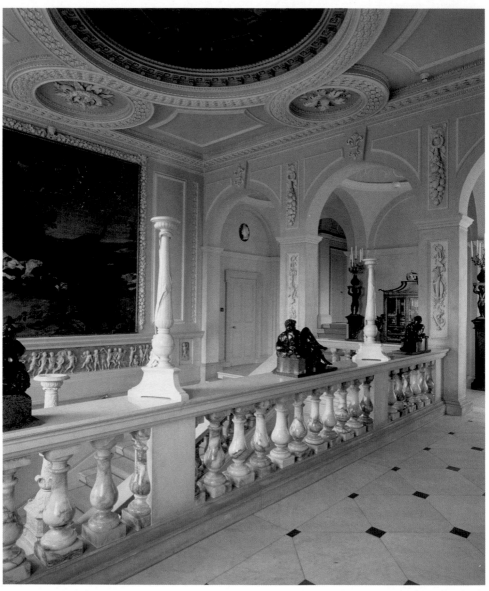

C29. The top landing of the marble staircase, showing one of the Snyders paintings, an alabaster balustrade, and commissioned sculptures.

is able to put Ricci to the task of copying the beautiful and revealing wall paintings in the rock-cut Beni Hasan tombs. The artists vied with one another to create the best sketches and worked each day from nine in the morning until dusk. What we cannot always determine, in studying the many drawings, is which ones were prepared on the outward journey, and which on the return trip down the Nile. In some cases, at Abu Simbel, for example, we know that some drawings were made when William stopped on the way south, whereas others were made on the group's journey north toward Cairo.

William learned that while the temples and the tombs of the pharaohs show scenes of travel to the next world and of kings worshipping the gods, the tombs of more ordinary citizens include delightful scenes from daily life—fishing and baking and reaping.

One wonderful example comes from the tomb of Nebamun (see color plate C11). He is shown with his wife and child while fowling in the marshes. These scenes, painted with such care, reveal much about the beliefs of the ancient Egyptians. Some scenes are selected to show what the deceased did in life or what mattered to the person—such as family. Other scenes are designed to "come alive," to provide the bread and fish and wine for the deceased in the next life. When family members stop leaving fresh food offerings at the tomb, the deceased will need the fish and fowl depicted on the walls. Much of the artwork is also iconographic, symbolic. In spite of some remarkable detail, the drawing is not "realistic." For example, since Nebamun is the principal subject, he is drawn much larger than either his wife or child. And notice how dressed up the wife is for a trek through the marsh. Other details may be symbolic of regenerating nature, of birth and rebirth. The lush scene suggests fertility; the positioning of the child suggests that she is the fruit of her father's sexuality.

At Luxor the group paused for many days, not heading farther south until mid-November. There were newly opened tombs to explore in the Valley of the Kings, including the magnificent tomb of Sety I as well as the mortuary temples of many New Kingdom pharaohs, all on the west bank of the Nile. This is where William saw the Colossi of Memnon, in front of the ruined mortuary temple of Amenhotep III. Although called the Colossi of Memnon, the two

monolithic statues represent the Eighteenth Dynasty pharaoh Amenhotep III. They are about all that is left of his once magnificent mortuary temple across the Nile from the Luxor Temple. An able diplomat, Amenhotep III had a long, successful reign. He was responsible for additions to the Karnak Temple, and he was the primary builder of Luxor Temple.

Ramesses II, apparently wanting to outdo Amenhotep III, added the forecourt to Luxor Temple in addition to erecting the two obelisks and two large statues of himself. Ramesses was so bothered by his successful predecessor that he had some of Amenhotep's statues "modified" to look more like himself. To outshine Amenhotep, he decorated the front of his showcase temple—Abu Simbel—with the *four* seated statues that so intrigued William on his first journey up the Nile.

What William did not see on the west bank is the spectacular mortuary temple of Hatshepsut, for this structure, farther west and closer to the Valley of the Kings than the other temples, had yet to be discovered and excavated. Much better preserved than most of the other mortuary temples that can be found between the cultivated fields along the west edge of the Nile and the hills farther west, Hatshepsut's temple is an example of how other New Kingdom mortuary temples may have looked (see image 23 at the opening of this chapter). The New Kingdom pharaohs wanted their temples to be accessible for worship after their deaths, but they also wanted their actual burial places well hidden in the hills to avoid the tomb robbing that had taken place since the Old Kingdom.

One evening, Finati tells us, he was returning with William from the Colossi of Memnon to their camp when they came upon some women removing mummies of bulls from a burial pit. William purchased two bull mummies, gave the women a gift, and then descended into the pit, to discover it stacked with human mummies as well. The bodies were wrapped but not placed in coffins. William and Finati searched through the stacks of bodies for papyrus rolls. They found one sheet, not rolled but placed on the breast of a female, under her crossed arms—the traditional burial pose. The woman's toenails were painted in gold leaf. The large piles of mummies in rather shallow

pits were a mark of the loss of power at the end of the New Kingdom. Kings could no longer secure the necropolis on the western bank of the Nile at Luxor. Temples fell into ruin as stones were taken for other buildings.

The plunder continued by Egyptians into William's time, as the natives busily excavated all kinds of antiquities—coffins, furniture, papyri—from discovered tombs to sell to the European travelers. In addition, the pasha gave one of the obelisks at Luxor Temple to the French. The Egyptians were joined in the antiquities search by the European explorers, largely organized by Salt and his French consul counterpart Bernardino Drovetti. A former soldier and lawyer from northern Italy, Drovetti arrived in Egypt in 1803 and worked as the French consul for many years. Drovetti employed excavators in the Luxor area—as did Salt with Belzoni—eventually agreeing with Salt to divide the area between the two countries and to let Salt—that is, Bankes—have the Philae obelisk.

If William did not meet Drovetti in 1815, he certainly met him at Luxor during this second Nile journey because in 1819 Drovetti was staying in a house built within the Karnak ruins. Relations between the two consuls seemed pleasant enough at evening gatherings, but Drovetti's men certainly harassed Belzoni at times, and Drovetti apparently changed his position on the obelisk. He may have been swayed by his workers who complained that they were losing a valuable antiquity from which they could make money. William conveniently suggested that Salt resolve the "ownership" dispute. Did Drovetti finally accept William's prior (1815) claim—or conclude that with William actually at Luxor, money and equipment in hand, the French had already lost the battle? Resolution may have been reached by both sides not wanting to involve the pasha in their conflict, fearing that such an approach would result in a halt to their excavations and collecting of objects for sale.

While at Luxor, William revisited both the Luxor and Karnak Temples, setting his artists to work on wall drawings and site plans. Karnak is one of the largest religious buildings and sites in the world. Neither temple, however, held his interest nearly as much as the temples yet to come, perhaps in part because he had already (in 1815) corrected the French *savants* with

his site plan of Luxor Temple. On this trip he speculated in his notes about the causes of the extensive ruin at Karnak, wondering if the rubble was human-caused or if most of it was the result of the temple's roof falling in. William and his team were exploring long before the temples were cleared and restored for modern tourists—as we can see from all of the rocks strewn around the temples painted by Linant.

Karnak's size is the result of kings adding to the complex to show their respect for the main deities worshipped there. Originally Montu was the principal god in the Thebes area, but his popularity diminished during the Middle Kingdom as rulers from the Theban area sought to strengthen their power by expanding the worship of Amun, one of the original paired deities representing the chaos from which the world emerged (see color plate C18). He is worshipped, with his wife Mut and their son Khonsu, at both Karnak and Luxor Temples, although drawings of other gods can also be found at these two temples. Amun was combined with the previously preeminent sun god to become Amun-Re, a clever joining of two important deities.

Many kings (possibly 30 over 1,000 years), from the Middle Kingdom to the Ptolemies, added to or refashioned the Karnak complex. A temple probably existed on the site from the Old Kingdom, but the earliest-known sections come from the reign of Middle Kingdom pharaoh Senusret (or Senwosret) I. Little remains of his structures, though, except for a small kiosk that has been reconstructed onsite but not in its original temple space. More building took place during the New Kingdom's Eighteenth Dynasty, probably in celebration of defeating the Hyksos and restoring a united Egypt. Amenhotep I initiated the process, to be followed by additions under Tuthmose I and Tuthmose II.

During Hatshepsut's reign much more was added, including a barge chapel in the sanctuary in red quartzite, and two obelisks, rather unusually placed between the Fourth and Fifth Pylons rather than at the temple entrance. After her death, Tuthmose III defaced many of the wall designs to remove images of Hatshepsut, seeking to deny her existence as a king. However, he also completed her work on the Eighth Pylon, built the Seventh

Pylon, and added a barque shrine between the two. And the list goes on, with significant additions by Amenhotep III, who was also constructing Luxor Temple and is responsible for the avenue of sphinxes between the two temples.

Work started on the Second and Third Pylons by Horemheb was completed by Ramesses I, preparing the space for one of the most astounding sections of this temple: the Hypostyle Hall, a huge "forest" of columns started by Sety I and completed by his son Ramesses II. The 12 largest, tallest columns form a central avenue surrounded by 122 columns, all carved around and from top to bottom. It is a stunning achievement of countless hours by an army of artists working over many years.

In addition to announcing the power of the king and the king's dedication to the gods, each part of the temple has a symbolic significance that reinforces religious beliefs. The basic temple style begins with a tall gateway (*pylon* in Greek) that slants, with a thicker bottom and thinner top, pointing upward to the sky. Inside we usually find an unroofed enclosed courtyard, an area that ordinary people probably could enter during festivals. Beyond the courtyard the roofed temple proper begins with the Hypostyle Hall of columns, an antechamber (*pronaos*), and then the inner sanctuary (*naos*), where the deity's shrine is housed. Only the temple's priests entered this area, where they tended to the god's needs—food and washing and clothing— each day.

The columns of the Hypostyle Hall represent the rebirth of the land from the yearly Nile inundation and from the power of the sun, and the inner sanctuary is the home of the god who holds back chaos and maintains the life that comes from the Nile and is nourished by the sun. Most temples are built on land that slopes upward, if only slightly, to suggest that the god resides on the high point or mound from which the world originally came out of the surrounding chaos. William was just one—though among the first—to gaze at Karnak's maze of columns, astounded as later travelers would also be by such work, accomplished so long ago, with so few of the tools available to today's builders and artisans.

William's primary interest in Abu Simbel and the temples south of it in Nubia shows in the scanty details of the journey from Luxor to Abu Simbel in Finati's account. Fortunately Ricci kept a brief record of stops, and Englishman John Hyde's unpublished journal provides details. The party reached Armant on November 16, within a day of leaving Thebes. The temple there, dedicated to the Theban god Montu, is gone now, so the group's drawings are especially important. (Senusret III's continued devotion to Montu shows in his additions to the Armant Temple, so close to Luxor.) The artists also drew reliefs of the rock-cut temples at el-Kab and copied wall drawings from the area's tombs before traveling on to Edfu, a beautiful, well-preserved Ptolemaic temple dedicated to Horus. At Kom Ombo, Ricci copied the wall reliefs in the *mammisi* (the small birthing temple), which is now gone. Reaching Aswan, Ricci and Linant drew scenes of the temples on Elephantine Island, all of which were destroyed soon after their visit.

Initially unable to travel through the First Cataract for lack of wind, the flotilla was successful on its second attempt, one boat at a time getting through with help from the locals using ropes, with only the last boat damaged on the rocks. Many days were spent once again at Philae, drawing and seeing to William's obelisk—a story to be completed in the next chapter. Although Finati mentions only Kalabsha and Wadi es-Sebua Temples before describing their work at Abu Simbel, the group actually stopped at a number of other temples, each time adding to William's incredible portfolio of drawings.

The thirty-four drawings of the Ptolemaic temple at Dabod can now be used to correct the information provided with this reconstructed temple housed in a Madrid museum. William drew a site plan and architectural plan that showed the roof of the temple, located the sockets for door hinges, and saw to the copying of wall reliefs, which included a drawing by Beechey of a wall now completely missing. William was able to determine the orig-

inal temple parts, what was destroyed and what was added later. His work brings back to life a temple much damaged by the building of the Aswan Dam before the temple was removed to Madrid.

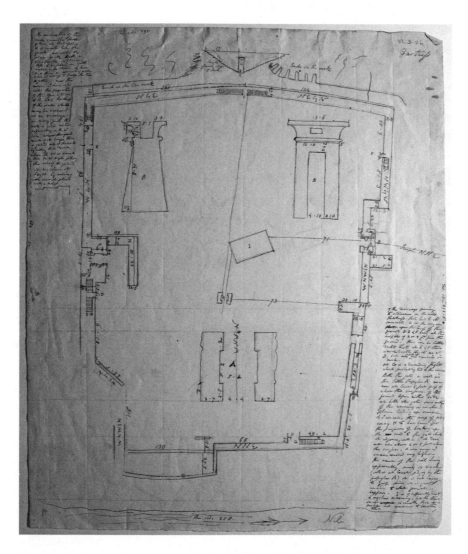

24. The fortress at Qertassi. Drawing by Bankes.

At Wadi Hedid William painted a lovely view of the only remaining column of a small temple (see color plate C12). Then the group traveled on to Qertassi, a site that has only a small temple, but the area had quarries worked by Greeks in addition to a fortress of Roman origin. William copied all of the Greek inscriptions and drew the only site plan of the garrison. His notes can be seen on either side of the drawing.

The artists also spent days at both Tafa and Kalabsha Temples, with William expanding on his earlier solitary studies. He identified the Kalabsha site as the Roman town of Talmis and decided that its late temple showed a decline in Egyptian architecture. The oldest parts of Kalabsha Temple—one of the largest in Nubia—were probably built in the Eighteenth Dynasty by Tuthmose III. His son, Amenhotep II, completed his father's work, although the hypostyle hall (the hall of columns) was added much later by the Ptolemies. The temple that William traveled so far—not once but twice—to explore and identify had been further altered in the Roman Period, probably by Augustus. Continued work on Kalabsha Temple over centuries is a reminder of the importance of Nubian resources not just to ancient Egypt but to the later Roman Empire as well.

Fortunately the Kalabsha, Beit el-Wali, and Gerf Husein temples, plus the small temple of Qertassi, have all been preserved, saved from destruction by the Aswan Dam with their removal to what is now called the new island of Kalabsha. Luckily as well for Egyptian studies, William took the time to stop at even the smallest temple ruins to investigate, excavate, and record in site plans and drawings. In spite of the pull to the newly opened Abu Simbel, William was now too disciplined, too committed to rush past even one lowly column south of the First Cataract.

10

WILLIAM MEETS RAMESSES II

EXCAVATIONS IN NUBIA

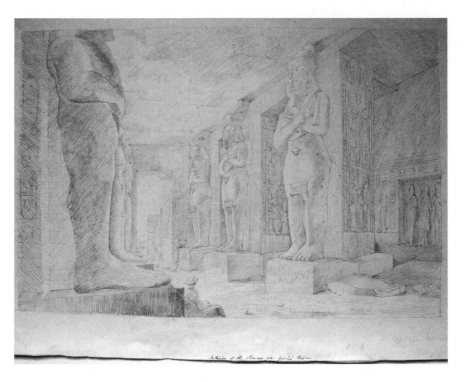

25. Interior of the temple at Gerf Husein, showing colossal
statues of Ramesses II. Copy by Bankes of a drawing by Salt.

N either the cold of December nor Christmas Day itself seems to
have slowed the work of William's team. If the explorers cele-

brated at all, the activities were too minor to receive any attention in Finati's account. Continuing to travel south of Kalabsha, William found the Roman temple Dendur, built by Augustus over an earlier shrine. On this trip he added to his basic study from 1815, looking carefully at such details as a north door added to the original plan and a small rock-cut chapel behind the main temple, whose purpose remains unclear.[1] Both the temple and the odd chapel are undecorated. Dendur was saved from loss under the dam waters by moving it to the Metropolitan Museum in New York.

William also led the study of the rock-cut temple Beit el-Wali, near Kalabsha, the rock-cut temple at Gerf Husein, and a small temple just south of the town of Quban, all built by Ramesses II to proclaim his power in Nubia. Larger than Beit el-Wali but much smaller and less spectacular than Abu Simbel, Gerf Husein contains a row of large statues of Ramesses II in the mummified pose resembling Osiris. The artists completed 41 drawings, including one of the sacred barque on the sanctuary wall and two of large stone blocks near the Nile, suggesting an original entranceway by the river. William's drawings from Quban reveal the remains of what has been documented as a large Middle Kingdom fortress, probably constructed by Senusret III to protect caravans heading to and from Nubian gold mines. Excavations suggest that Ramesses II built a small temple within or near the fortress. William's drawings of the battle scene and his plan of the fortress prove that the temple did exist there.

The interior of Gerf Husein had been used as a Christian church at some point, for the sanctuary contained a Coptic fresco of St. Peter on a wall between two earlier paintings of Ramesses II—a startling mix of figures— as well as clay lamps still with their wicks and a red earthenware chalice only slightly broken. Thirty-six drawings that included William's site plan and Ricci's rendering of the colorful wall drawings along with William's notes bear witness to this first for William: the first to open, clear, and record the rock-cut part of the temple. The sands soon covered and filled the inner temple once more, leaving it inaccessible to Champollion and later travelers of the nineteenth century. In 1964 the entire temple was cut out and moved

to a higher site to preserve it from permanent loss under the dam waters. William was the first but not the only Egyptologist to understand the value of this one among many Nubian temples built by Ramesses II.

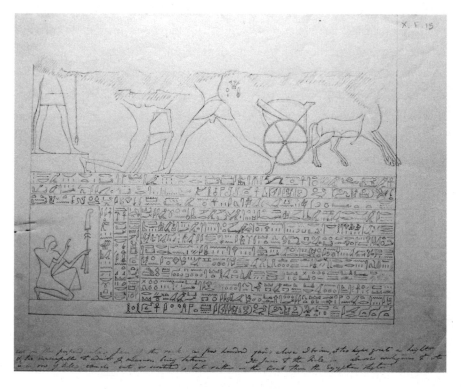

26. Stela of Sety I on cliff at Qasr Ibrim. Drawing by Beechey.

Finati ignores several other temples (Amada and Derr, for example) found and captured on paper by the artists in his desire to tell the story of Abu Simbel—and perhaps also because he had described the grottoes cut into the huge sandstone cliff at Qasr Ibrim when writing about their 1815 journey: "Ibrim is very unlike most other situations upon the Nile, being perched upon a very bold rock, in the perpendicular face of which are some small painted chambers so difficult to access that our traveler was drawn up into them by a rope round his body." Still intrigued by the site, William was pulled up again

in 1819 to prepare more than half of the thirty-three drawings of these New Kingdom grottoes (see color plate C13). He also found a large stela of Sety I, which was actually cut into the cliff face. William did not copy it in 1815, but this time he gave the task to Beechey, who made excellent, accurate copies. William was once again the pioneer Egyptologist. No other early travelers referred to or copied the wall drawings or stela at Qasr Ibrim.

Early in the new year (1819) William arrived at Wadi es-Sebua (Valley of the Lions) to study another partially rock-cut temple built by Ramesses II (see color plate C14). This temple, dedicated to Amun, Harmachis (a solar deity), and Ptah (a deity originally from the Memphis area), was approached from the river through an avenue of sphinxes and then a pylon to an open courtyard with covered porticoes on either side. Cut within the rock were several rooms, including the sanctuary. After twenty men worked five days to clear the temple of sand, William was able to inspect the sanctuary, with its wall drawings fresh with color (see color plate C15). Still unhappy that he had not opened Abu Simbel, William made a point of noting that the rock-cut rooms "had escaped all other travelers." He also compared the temple to others by Ramesses II, a more precise dating strategy than the simpler distinction between "ancient" and "Ptolemaic or Roman."

At last. William is only one of a great many travelers to Egypt who have more than once stood in awe and amazement in front of the Great Temple at Abu Simbel. There are actually two rock-cut temples at the site: the Great Temple dedicated to Re-Horakhty and the deified Ramesses II and the Small Temple dedicated to the goddess Hathor and to Ramesses's special wife Nefertari. Imagine seeing the four colossal seated figures of Ramesses II from Egypt's highway—the Nile. Imagine being Nubian and seeing it from your small craft.

William's army of artists and workmen camped at Abu Simbel from January 23 to February 18, the workmen spending nearly three weeks to

clear one of the statues down to the feet. The excavation also revealed the other larger-than-life attendant figures, one between the feet and one at each end of the chair. Seeing some letters scratched on the far left statue, William surmised that those nearer the entrance would have more carvings, but to uncover these seated statues, some of the sand that had been removed needed to be pushed back to its original position. William had thought that they could dispose of the removed sand by dumping it in the Nile, but they were too far from the river to cart that much sand without adding considerably to their time and effort. Essentially, they uncovered the imposing front of the temple in sections, and they did leave more of it exposed than when they first started their excavation (see color plate C16).

The effort was worth it for William. He discovered an inscription in Greek dating from the seventh century BCE, graffiti, in fact, left by Greek mercenary soldiers working in Nubia for the Egyptian king Psamtek of the Twenty-Sixth Dynasty. The placement of the Greek writing suggests that the temple was no longer in use by this time and that some sand had built up along the front of the seated statues.

While William was working at Abu Simbel, the Defterdar Bey, son-in-law of Mahommed Ali and governor of Upper Egypt, stopped to pay his respects—and to see what the English were up to. But, even after agreeing to enter the temple and observe the work of the artists, he could not understand their purpose and continued to ask, "What treasure have they found?" William's army of *savants* understood. While workmen were removing sand outside, the artists were inside, "for the interior," Finati writes, "during all the time of our stay, was lighted every day, and almost all day long,"[2] so that the artists could copy all of the wall reliefs and take measurements. The burning candles added to the merciless heat of the interior, making the sun-scorched sand outside seem cool by comparison. William found his time and energies divided between copying and measuring inside and directing the sand removal outside. The exertion resulted in a fever so severe that Beechey had to take over the architectural renderings for him. Forced to rest, no doubt he still tried to direct operations from his bed in the shade.

As William, with Beechey's help, noted, the Great Temple was built on the standard single axis of main hall, followed by a second hall, a vestibule, and then the sanctuary. There are, though, a number of side rooms off the main hall. The temple's front, in addition to the four seated colossi, is decorated with a row of baboons across the very top, worshipping the sun, and above the entrance, a statue of the hawk-headed Re-Horakhty, a form of Horus as sun god, also facing the rising sun. Similar to Gerf Husein, the hall contains colossal figures of Ramesses II in the Osiris pose. The main hall depicts Ramesses II's military successes, with considerable attention to the Battle of Qadesh. On the back wall of the sanctuary are more seated figures: Ptah, Amun, Ramesses II (deifying himself by placing himself with the three gods), and Re-Horakhty.

Ramesses II epitomizes the successful pharaoh. He maintained a standing army that he led into battle when necessary to defend Egypt and to expand its control and influence both in Nubia and along the Eastern Mediterranean. His local administration oversaw the building and maintaining of the all-important irrigation ditches to provide arable land for farming, and they maintained grain supplies for low-crop years. He also led the country in worship by building new (and adding to existing) temples, by participating in religious festivals, and by presenting himself in wall drawings as both suppliant to the gods and a living man/god. The wall reliefs and sculptures in his many temples announce his military successes, testify to his power as pharaoh, and reveal his deified status. The ideal leader, he maintained *maat*, the Egyptian concept of keeping chaos at bay and securing truth, power, and balance in the Egyptian universe.

Amazingly, much of Egyptian art, its forms and iconography, changed little from the beginning of the Old Kingdom. The Narmer Palette, dating from about 3000 BCE, illustrates this point. This large—probably ceremonial—palette is carved on both sides, but the side shown in image 27 is most revealing. Pharaoh, the large central figure, poses in the "smiting the enemy" stance, one arm raised, the other grasping the enemy's hair. To the right, the falcon holds another enemy among the plants, and more enemies flee in the bottom register. Two images of a cow-headed deity look on from above. The

falcon becomes the image of Horus, Hathor is depicted as a cow-headed goddess, and kings repeatedly show themselves in the "smiting the enemy" pose. Although the drawings are incomplete, we can see the same pose in William's drawing from the temple at Quban and Beechey's drawing of the stela of Sety I at Qasr Ibrim.

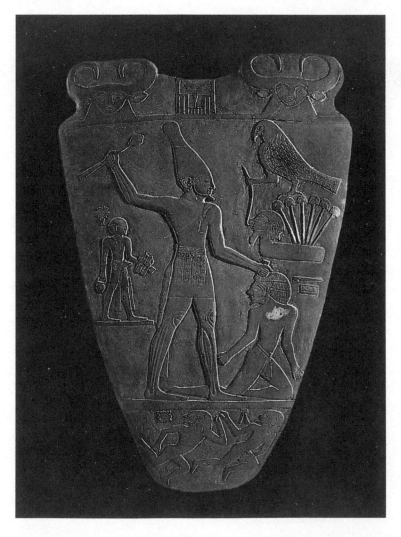

27. One side of the Narmer Palette, showing the king smiting his enemies, c. 3000 BCE. Cairo Museum.

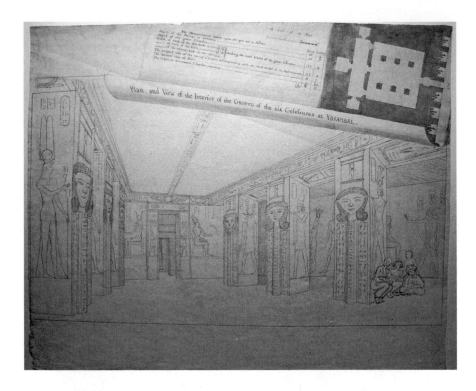

28. A view of the interior of the Small Temple at Abu Simbel,
with William's plan and notes above.

William and his artists completed an astounding 155 drawings of Abu
Simbel: views of the facade that include the work of excavation, architectural
drawings with measurements, and the wall drawings and statues in both the
Great and Small Temples. William needed to perfect his lighting plan on the
return trip down the Nile to get good renderings of the monumental scenes of
the Battle of Qadesh, and he observed that the drawing of Ramesses II in battle,
both as charioteer and archer, was highly unrealistic but effectively symbolic
of the all-powerful pharaoh (see color plates C17 and C18). William's notes
also include information from Beechey and Finati as to what they found when
they worked on the initial opening of the temple in 1817.

William wanted his work at Abu Simbel to be as monumental as the
work of those who designed, built, and decorated the Great and Small

Temples for Ramesses II. He will certainly remember Ramesses's magnificent Nubian temples, one after another along the Nile—and his own groundbreaking study of them—when he returns to London and reads Shelley's famous poem "Ozymandias":

> I met a traveler from an antique land
> Who said: "Two vast and trunkless legs of stone
> Stand in the desert . . . Near them, on the sand,
> Half sunk a shattered visage lies, whose frown,
> And wrinkled lip, and sneer of cold command,
> Tell that its sculptor well those passions read
> Which yet survive, stamped on these lifeless things.
> The hand that mocked them and the heart that fed;
> And on the pedestal these words appear:
> 'My name is Ozymandias, King of Kings,
> Look on my works ye mighty, and despair!'
> Nothing beside remains. Round the decay
> Of that colossal wreck, boundless and bare
> The lone and level sands stretch far away.

If William had not met Percy Bysshe Shelley, one of the English Romantic Movement's most significant poets, before he left London for Portugal and Spain, he had probably heard about him from Byron. Byron lived near Shelley, Shelley's wife, and Mary Wollstonecraft Godwin (author of *Frankenstein*) for a time in a home on Lake Geneva. Shelley never traveled to Egypt, but he did live in Rome in 1818 and knew John Keats there, the third of the five most important English Romantic poets. (Coleridge and Wordsworth, together with Byron, make five.) Shelley saw Egypt's obelisks in Rome and marveled at the Colosseum, though he was not blinded to the city's dirt and the overgrown grasses and weeds in both the Forum and Colosseum. Keats was the first of the three to die, in 1821 in Rome. Shelley died in a sailing accident off the coast of Italy in 1822. Both are buried in Rome.

Shelley's sonnet on Ozymandias—actually Ramesses II—published in 1818, was surely read by William after his return to London in 1820, but we can only guess at his reaction to the poet's presentation of Ramesses II as a "colossal wreck." (How do we know that Shelley is writing about Ramesses II? Ozymandias is a corruption of one of this pharaoh's "king names": Usermaatre. More on king names and reading hieroglyphs in chapter 11.) While Shelley is correct to depict the scene of the broken statue partially buried and to invoke a world of empty sand, his implication that this king— celebrating himself in his colossal images—is now meaningless would hardly meet with agreement from William. Much of what Ramesses II built does remain and is not forgotten, either by archaeologists re-creating his time for us through their studies or by the millions of travelers who continue to visit this "antique land."

Although William explored a number of other ruins near Abu Simbel— including New Kingdom rock-cut tombs, inscriptions, ruins of churches, and stelae—Finati moves directly to Wadi Halfa in his *Narrative*: "The next great clearance of sand was . . . in the district of Wady Halfa."[3] What the group saw at this important southern-most outpost of ancient Egypt when they arrived on February 21 was not inspiring, but William was correct to assume that temple ruins would be found under the sand. Ten days of organized and careful digging revealed the ruins of two temples, with mud bricks mixed in from the walls of the strategically important Middle Kingdom fortress of Buhen. Buhen, located just north of the Second Cataract—a twenty-five-mile stretch of impassible rocks and swirling water—was one of a series of garrisons in the south to protect gold mining and other trade with Nubia. During the Second Intermediate Period, Egypt was forced to withdraw from this border region, but the fortress was once again in operation during the New Kingdom, resulting in two temples built over previous ones within the garrison.

Finati writes, much too casually, that the excavation at Buhen was largely undertaken as a pastime while William negotiated with the cashief for camels and an escort as far as Dongola, always his ultimate goal on this trip.

The negotiations did take time, with discouraging results, but William also understood that Wadi Halfa offered him another opportunity to uncover ruins not seen by any other European travelers. Even with further excavation, he continued to be confused by what he had seen of the South Temple in 1815. The temple did not conform to typical features because, built initially by Hatshepsut, it was changed significantly by Thutmose III and then changed again by Taharqo in the Late Period (Twenty-Fifth Dynasty). The North Temple contained some wall paintings, unfinished or badly rendered in William's view, while other chambers showed only architectural design or eroded walls with figures "cut off about the waist."

29. Detailed plan of the lost North Temple at Buhen. Drawing by Bankes.

He did find stelae, historically significant recordings of victories of General Mentuhotep and another, now lost, inscribed for Deduantef, both in the army of Senusret I. By the time the site was re-excavated in the twentieth century, the North Temple was entirely in ruins. Thus, William's site plan and description are now the only source of information for the North Temple—including the location, once more under the sand, of two of the three historical stelae.

30. The lost stela of Deduantef from the North Temple at Buhen. Drawing by Bankes.

Neither Salt's position nor William's money could persuade the cashief to send his camels—or his own people as an escort—into territory still containing ragged bands of the once powerful Mamelukes. All they could achieve was a letter to his son, the camels, and an escort by some Arabs of the Ababde tribe to be paid at a daily rate. The Ababdes were dark-skinned but without Nubian features, wore little clothing but carried daggers in sheaths on their left arm, shields made of hippopotamus or giraffe or crocodile hides, spears, and some flat swords. Finati concludes by observing that they were considered "rather a fierce race."

Salt had become quite ill, so he returned with Linant to Cairo, but a newcomer, the British John Hyde and his Greek servant, prepared to travel south with William's group. Finati gives no further mention of Baron Sack, so presumably he also returned to Cairo. Antonio was left at Wadi Halfa in

charge of the dig. On February 26 the rest mounted ten camels while the five or six Ababdes followed on foot, resulting in a slow trek through sand—with the rocks and rapids and occasional islands of the Second Cataract on their left, a beautiful, romantic, but often empty landscape. While dreaming of the Dongola he would not see, William understood that he was one of very few Europeans to head south of the Second Cataract.

The group passed two caravans returning from Dongola with slaves and gum, the second escorted by two Mamelukes. The Mamelukes were initially concerned to see some in the party in Arab clothing but relaxed when spotting Hyde and William in European dress. Understanding that they possessed less protection from their Ababdes guides than they desired, William's "caravan" would gladly have joined any caravan headed south. But they marched on, occasionally stopping to examine and draw ruins.

Nine days into their journey, they stopped to rest and bathe in the Nile and pasture the camels, when, one by one, the Ababdes quietly slipped away from the group and then leapt all at once onto the camels and rode off. Finati chased the group naked—he had been one of the bathers—firing his gun but unable to stop them. "Our dismay was great," Finati writes with considerable understatement. They were now 150 miles south of the Second Cataract with no way to travel or haul their baggage and no one who could speak the native language.

The next day, finding a small inhabited island, they were able to communicate with the natives first by hand signals and then with some Arabic that they needed to cross to the island. The islanders fashioned a log and cord raft, held up in part by inflated water-skins attached to the sides, and then, one by one with some of the baggage, William's group was pushed across the river on the raft. Because of the strong current, the raft was pulled downstream each time, so it then had to be towed back as well as to the west bank to get the next passenger. The result was a day-long soaking process that eventually ended with everyone getting safely to the island where all were well received and fed. By this time, though, Hyde was quite ill and weak to the point that they were concerned for his life. Concerned also about

possible extortion from the natives, the travelers decided to guard the raft through the night so that they could use it the next day to cross the shorter, shallower part of the river to the eastern side.

Still without transport once reaching the village of Mograkki on the eastern bank, William sent Finati ahead to the next village, Amarra, where they were told they would find the Wadi Halfa cashief's son. Finati was directed to beg the young prince to fetch the entire group from Mograkki. The prince offering no help, Finati returned to William to find, fortunately, that the travelers had found two donkeys for hire, one from a friendly peddler. The animals would do for getting their baggage to Amarra. To get themselves there, they trudged the five miles through deep sand: "hot and weary, and creeping along like so many beggars, we reached the temporary residence of the Cashief."

In front of his people, the young prince was forced to show hospitality and so fed William's group for the three days they spent in his camp— while also helping himself to Hyde's alcohol. When William found the young cashief happily "under the influence," he used those times to argue for transportation and escort to Dongola. However, neither William's logic nor his money could convince the prince to allow either his animals or the European travelers to continue south. It would be "worse than madness" to face his enemies to the south and the Mamelukes in Dongola, the cashief insisted. He would promise camels only for the return to Wadi Halfa.

Seeing a sail in the distance, William insisted that he be allowed to go the few miles south to see the island of Sai. When it became apparent that William would go, escort or not, the Cashief provided an escort on horseback, while William and the others walked along the river. Thinking that his last hope rested with finding passage on a ship, William spent the day by the island, hoping to see another sail. Alas, no ships appeared and the group trekked back to the prince's camp, agreeing to borrow his camels for the journey back to their ships at Wadi Halfa. William's day-long search for a passing ship had angered the Cashief, however, so he rescinded his offer of the camels.

Indignant at this, Finati writes, the group prepared to depart, giving some gifts that would remain unused to their friend the peddler and lightening their load as much as possible. Once more the peddler lent his animal, just requesting that they leave it for him at Wadi Halfa. With a way to carry some of their baggage, they were ready to head north, with the Nile for their guide, until Dr. Ricci announced that Hyde lacked the strength to make the walk. Finally they found a single camel for hire to carry Hyde and give someone else an occasional ride as well.

According to Finati, no journey was performed "more cheerfully and more merrily" because the area was too thinly populated for the group to feel any threat and they were determined to survive the long and difficult march through sand by turning it into an adventure. William's endless fund of humor set the tone and, adding to the spirit of adventure, they adopted "a sort of banditti life." Whenever they came across an animal not carrying a burden and were told they could not hire the animal, they simply seized it, adding to their group as the owner followed along on foot. They did offer payment or a present each day, with the result that by the end of the trip they had "acquired" half a dozen animals which provided rides by turns. Undoubtedly they also purchased, bartered for, or stole food as necessary.

Within two days of reaching Wadi Halfa, they ran into the Ababde chief who had put them into such a bind. Finati writes that those who were riding "sprung from their saddles" and those on foot "forgot all their weariness" and all pulled the man from his camel and beat him with "whatsoever came first to hand," even the sick Hyde participating in their revenge. The owners of the various animals that had been "acquired" watched in astonishment at this informal justice. After some reflection, the group then let the chief go, not wanting the rest of his tribe to turn on them. One wonders what story he concocted to account for his bruises.

William's caravan found the old cashief in temporary dwellings south of Wadi Halfa. After feasting them, the cashief saw them on their way back to their boats, this time all mounted and with an escort. William was certainly disappointed not to have reached his goal of Dongola, but he seems to have

accepted the unfortunate events by focusing on the problems they would have faced if they had found themselves caught in the midst of a battle between Egypt's Ottoman rulers and the Mamelukes. And, as it turns out, there was still more to do—and to discover—before his Egyptian travels would draw to a close.

11

OBELISKS AND KING LISTS

WILLIAM'S DISCOVERIES AT PHILAE AND ABYDOS

31. The temple complex on the island of Philae. Drawing by
Linant.

An astonished Antonio greeted the sunburned travelers' early return
to Wadi Halfa. Fortunately he was able to lift William's spirits
a bit by guiding him through the newly discovered additional rooms and
small monuments, and William was pleased to explore Antonio's successful
excavations. Even so, William was too weary from the desert hike and unre-
mitting heat to linger long at Wadi Halfa. Still concerned for John Hyde's
health, he bustled around the campsite, pressing everyone to pack quickly
and board their boats to start the return journey down the Nile. However,

if Hyde expected a swift sail to Luxor, he was mistaken. He is, after all, traveling with William—the one who remains in charge, the one who leaves nothing unexplored. The one who also wants to slow his steps and offer prolonged farewells to his favorite sites.

A key stop was at Maharraqa, where William had earlier seen a red granite platform composed of four increasingly smaller squares. Guessing that it had originally served as the base for a now missing obelisk, he decided that it would be the ideal pedestal for his obelisk and hired Linant to send it to England. Not without difficulty, Linant was able to get the platform removed in 1822, and it finally arrived in England in 1829. William noted that the heaviest block weighed nearly eleven tons, requiring nineteen horses to drag it from the London docks to its position on the south lawn of Kingston Lacy.[1]

Always copying Greek inscriptions and seeking to date temples, William also lingered at Maharraqa to draw the ruined temple and an isolated wall still standing between the temple and the river. When the much-ruined temple was studied in the twentieth century, scholars could not understand how the wall related to the temple. William's drawings show the connection. From the inscriptions, William corrected Burckhardt's assumption that Derr (located south of Wadi es-Sebua) was the Roman town of Hierasykaminos. William correctly determined that Maharraqa (north of Wadi es-Sebua), with its late Roman temple to Isis and Serapis, was the Roman Hierasykaminos.

Even though his obelisk had safely found its way downstream, William chose to stay at Philae for nearly a month. Hyde left for Luxor after twelve days, obviously feeling much better and ready to visit Karnak for the first time and to enjoy the company of other Europeans gathered there. (He could thank William's efforts to provide—one way or another—transportation and food from Amarra to Wadi Halfa, for this surely saved his life.) William, knowing in his heart of hearts that he would not be back, could not part with what he believed to be Egypt's most beautiful temple. And so he found work to do there. He learned that "by placing himself in a side light," he could trace original letters cut into the stone but now partly hidden beneath stucco. Carefully scraping away the stucco, he uncovered what proved to be Greek inscriptions

from as late as the time of Commodus (Roman emperor, 161–92 CE). He also cleared away all the rubbish from a beautiful small sanctuary that he thought to be the oldest in the temple complex.[2]

When William and Beechey and Ricci gathered in the evenings at Philae, already reminiscing about their incredible journey, William was surely teased about the disastrous first attempt to remove his obelisk and the challenges still awaiting him to get obelisk, base, and four-step granite pedestal to Dorset. They had all witnessed Belzoni's directing of the obelisk that was moved on rollers to the water's edge where a boat awaited. And where "all hands were at work, and five minutes more would have sufficed to set it afloat; when all at once the temporary pier built for it gave way under the pressure, and the monument plunged end-long into the river almost out of sight." Finati further records that William did not say much but was clearly disgusted by the accident. William sailed on up the river the next day, leaving Belzoni to find a way out of the mess—and Finati to witness it:

> The scene of its actual descent down the cataract . . . was very striking, the great boat wheeling and swinging round, and half filling with water, while naked figures were crowding upon all the rocks, or wading or swimming between them, some shouting, and some pulling at the guide ropes, and the boat-owner throwing himself on the ground, scattering dust upon his head, and hiding his face.

But the danger, Finati concludes, lasted just a few seconds before the boat righted itself and glided "smoothly and majestically onwards with the stream."[3] Where did the obelisk reside in the Delta area and how was a ship found to carry it, finally, to London's Deptford docks? Unfortunately Finati was not there to give us these details.

We are also missing a recorder to explain to us how the ancient Egyptians made and moved these monuments. We do know that an obelisk (from the Greek for *meat skewer*, *Tekenu* in Egyptian) is a monolith cut, finished, and carved from a single piece of stone, whose four sides taper toward a pyramidion,

or small pyramid, at the top. The pyramid top was once encased in a gold and silver alloy, missing now from the remaining obelisks, not surprisingly given the value of that much gold and silver. The Washington Monument looks like an obelisk but technically does not qualify because it is made out of blocks of stone—not even the same color—not a single piece. The ancient Egyptians would have discarded such an imperfect work as unfitting for their religious—and political—purposes. One can see in Aswan today an unfinished obelisk, partially pounded out of the hillside, a fatal crack clearly visible.

The Egyptians used pink or red granite from the Aswan area, pounded out the obelisk with dolerite, probably moved it to the Nile on rollers, and transported it to its destination on barges. An alternative possibility would have been soaking the sand to create a hard, smooth pathway. Belzoni either "reinvented the rollers" or saw the tomb reliefs depicting the Egyptian use of rollers for moving large monuments. Dragging through loose sand a stone from 70 to 100 feet in height and weighing up to 200 tons would be impossible, as both the ancient Egyptians and Belzoni could rather quickly determine.

These monoliths were most likely carved with hieroglyphs once they reached their temple destination but while still lying on the ground, getting turned once each side was carved. How these huge monuments were finally erected remains the biggest question because ancient Egyptians did not have pulleys. Probably the workers dug a canal of some sort under the obelisk, perhaps filled with sand, which was then slowly removed as the massive stone was eased increasingly upright. Accidents occurred, and workers were injured as easily in the distant past as in 1818 with William's obelisk.

Egypt's obelisks—originally placed in front of temple gateways by pharaohs in worship of the sun god and as a monument to their power and prestige—were first removed by the Greeks. Although ruins of obelisks date to the Old Kingdom, the oldest surviving one was erected in 1462 BCE by the Middle Kingdom pharaoh Senusret I at the entrance to the sun temple at Heliopolis. In all there were three obelisks at Heliopolis (the other two erected in the Eighteenth Dynasty by Thutmose III) until Alexander had two removed to Alexandria to beautify his new city in the Delta. One of

these two was given, in the nineteenth century, to England and now resides in London on the Embankment; the other, given to the United States, can be found in New York City's Central Park.

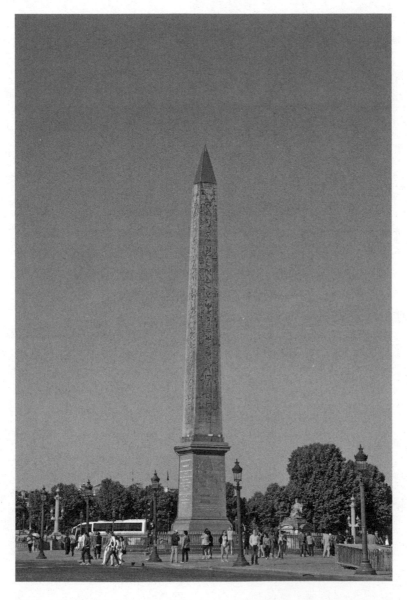

32. Luxor obelisk, Paris. (The golden pyramidion is new.)

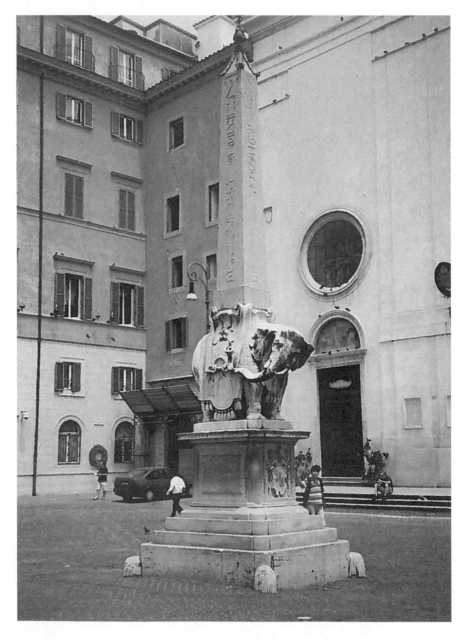

33. The "Bernini" obelisk, Rome.

When the center of power shifted to Thebes (modern Luxor) and the major god became Amun-Re, obelisks were added to the temples there. Now only three remain: two at Karnak Temple—one erected by Hatshepsut in the fifteenth century BCE—and one of the original two at Luxor Temple. William saw the two majestic monuments at Luxor, placed at the entrance in front of the large statues of Ramesses II. He would never have dreamed of taking down any of the standing monuments at these temples. Indeed, Finati makes a point of recording that William would not permit anyone in his group to cover over any of their excavations and discoveries, even though they knew that "a German artist" (probably Franz Gau) was following them and would benefit from their expense and effort to clear temples for studying and copying.[4]

Sadly, Mohammed Ali held different views and decided to give Luxor's right obelisk to the French. It now rises up in the center of the Place de la Concorde, complete with a new golden pyramidion. As a result, Luxor Temple lost the symmetry of its once dramatic entrance. (This lost symmetry is clearly seen on this book's front cover.)

Roman emperors continued the removal of these sacred icons of the ancient Egyptians, with the result that now half (thirteen) of the remaining obelisks can be found in Rome. The emperor Diocletian brought one of a pair at Sais for a temple to Isis. That obelisk, now with a baby elephant base by Bernini, stands in the piazza fronting the Santa Maria sopra Minerva Church, just a few paces from Rome's Pantheon. Perhaps best known is the obelisk that now stands in front of St. Peter's in the center of the large piazza created by Bernini's colonnades. Just as the Egyptian stelae gave us the rounded headstones so common in graveyards, their obelisks established both the ornamented columns celebrating victories of emperors and kings and the soaring steeples that are a part of Christian church architecture.

Leaving Philae for the last time, William finally joined a now large group of Europeans in Luxor. He dined with Hyde and others on crocodile—which resembled veal in taste and appearance—and opened a crocodile egg given to him to discover a partly formed fetus.[5] All visited the newly opened tombs, and William wrote to Henry Salt, expressing the wish that he had recovered from his illness in the pleasure of his lovely garden. Soon, though, William was on the move again, first to the Dendera Temple, dedicated to the goddess Hathor, and then to Abydos, the site of his most significant find.

Finati records that "nothing he [William] found seemed to give him more pleasure, or to excite more interest, than the wall of a building which he brought to light" after several days of clearing sand and debris inside the temple at Abydos[6] (see color plate C19). William did not remove the wall containing the Abydos King List. He did make an excellent copy of it—and sent a copy to Dr. Thomas Young, the brilliant physician, physicist, linguist, and the most important person in England working on the decoding of Egyptian hieroglyphs[7] (see color plate C20).

The Abydos site is very old. It contains predynastic burial grounds and tombs for many of the Old Kingdom kings. The first temple dedicated to Osiris, the first resurrected god/king, dates to the Twelfth Dynasty, making the site one of the most sacred in ancient Egypt. There is evidence of building by Middle Kingdom pharaoh Mentuhotep, and then representation of kings from the Seventeenth through the Nineteenth Dynasties.

The temple that William explored was started by Sety I and completed by his son Ramesses II, who also rebuilt a small Middle Kingdom temple located behind Sety I's large one. This small temple, referred to as the Osireion, may be considered as the burial tomb of Osiris—which would make the larger building essentially a mortuary temple for the continued worship of Osiris. This complex, which probably remained in use through Roman times, was originally enclosed by a mud-brick wall and contained storage areas between the main axis and the rooms completing the "L." It also had a causeway to the Nile and a quay.

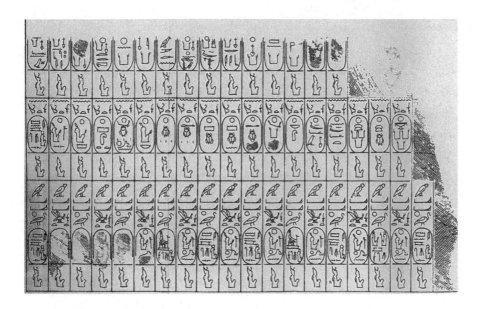

34. The Abydos King List. Copy prepared by Bankes.

Its dramatic approach today is through two courtyards, now missing their pylons but still containing two wells, and then up a flight of 42 stairs into a small entrance flanked by carved rectangular rather than rounded columns (see color plate C19). The use of stairs is not surprising; remember that a temple will always be raised above the surrounding land to represent the mound of creation. Two hypostyle halls of round columns lead to the seven main chapels at the back, each one dedicated to a god or king. The carvings throughout are among the best, and best preserved, in all of Egypt. On one chapel wall, we see Sety I offering a small statue of the goddess Maat to Osiris. Maat, always shown wearing a feather on her head, represents order and rightness, morality and justice. Sety I's offering demonstrates his understanding of the king's role to preserve order and maintain justice in a united Egypt.

Used to temples built on a single axis, William was surprised to find an L-shaped structure at Abydos—but at least this unusual design led him to clean out the small rooms completing the short side of the "L." And there,

on a side wall, he found the King List. Nearby are carvings of both Sety I and Ramesses II, each one with both arms extended forward in the "offering" pose traditional in Egyptian art, showing that they are worshipping their ancestors—that they descend in a direct line from Osiris, ensuring their divine status.

William knew immediately that he had found something important, as his carefully executed copy reveals. He had seen enough carved temple and tomb walls to understand that the ovals or rings referred to the various gods or kings. He had expressed some disinterest in decoding hieroglyphs *if* this language simply told of psalms and spells, religious writing, not information about history and chronology. But the King List could possibly provide chronology, an essential element of historical study. William also had a letter from Thomas Young, forwarded to him in Cairo by his father, in which Young makes several requests of William: search near Rosetta to see if the rest of the Rosetta Stone stela could be found, bring back a copy of the Rosetta Stone engraving in Cairo (in case it provided new information), and make copies of inscriptions so that Young would have more text with which to work. William had found a wall in a rubbish-filled New Kingdom temple that could really help Young's study. In addition, he was now a scholar far superior to Vivant Denon and the other *savants* whose copies of hieroglyphs from the Dendera Temple were filled with errors.

In his 1818 letter, Young lists a number of hieroglyphic signs and words he has been able to decipher, including the cartouches of Ptolemy and Berenice, and the pictorial signs for a god and a goddess, the ankh sign for life, and more. Young's list is correct for five consonant signs but incorrect for an additional eight, a reminder of just how difficult the process of decoding was.

Clearly the Rosetta Stone would not be sufficient to provide the breakthrough to Egypt's mysterious language of pictures. Although it must have seemed aptly named, given the stone's unwillingness to yield its secrets, actually the correct label should be Rosetta Stela. For this most popular artifact in the British Museum is not a natural stone; it is a carved stone, making it

a document, a priestly decree in fact. This stela was not carved in Rosetta, and we do not know why it was there in 1799 when a French soldier found it in an old fortress being fortified by Napoleon's troops in preparation for the Battle of Abuqir. In spite of an imminent battle—one that the French would fight without Napoleon, who had already sailed away from Egypt without notifying most of his army, and would lose to the British and Turks combined, thus ending the French occupation of Egypt—the young officer, François-Xavier Bouchard, took the trouble to inform the French general Jacques-François Menou of the find. Menou had the stone brought to his tent and cleaned and the Greek portion translated. Bouchard was given the honor of escorting the stela to the French academy in Cairo, while word was sent to France of the important discovery. Copies of the text were also made and sent to Paris, and it is these copies that were studied in France, not the original stela. The "Stone" would end up in England, one of the spoils of war. (What would have happened if Napoleon had not abandoned Egypt and was in charge of the battle instead of Menou? It's an interesting question of history that we cannot answer.)

The Rosetta Stone is not even a complete "stone." It is broken—missing its top and part of both the left and right sides. It is also not a document written in three languages. Rather, it states the message in two languages: Greek and two *scripts* of ancient Egyptian, hieroglyphs and demotic. The demotic script is the cursive writing of ancient Egypt—a script for daily work. Hieroglyphs were more complex and used mostly for religious purposes, adorning the walls, columns, and obelisks of temples and tombs for 3,000 years.

Notably, the decree, carved in 196 BCE after the crowning of the thirteen-year-old Ptolemy V, is written first in hieroglyphs, then demotic script, and finally in Greek—even though the Ptolemy Dynasty was Greek, and Greek was the court language. The priests still placed hieroglyphs at the top of the stela, perhaps in defiance of its rapid decline in use and understanding. Unfortunately, as a result we are missing much of the hieroglyphic version of the decree and so have less of this text to compare to the Greek for decoding purposes.

The greatest progress in understanding ancient Egyptian came first with the Stone's demotic script. Several scholars, one a Swedish diplomat, decoded various words, including *Egypt*, *king*, and *Greek*. However, those working on the decoding—as late as 1818—continued to mistakenly believe that the hieroglyphic script was entirely symbolic, that is, composed of pictographs, not signs representing phonetic sounds.

Writing in a narrative of his trip from 1816–1818 (published in 1822) with Lord Belmore, the physician Robert Richardson argued that those exploring in Egypt should devote more time to Alexandria. Here, Richardson asserted, one might find "the key that will unlock the hidden mysteries of the hieroglyphics." His thinking is that in Alexandria, Egyptians would have translated their language into the Greek of their conquerors. Surely a comparative grammar that they used could be found. But, William saw little that was left to Cleopatra's once glorious city and soon moved on, as did other early travelers. Richardson was correct, though, when he wrote that "no man living can write the name of George the Fourth in hieroglyphics"[8] and that current study of the Rosetta Stone had produced only conjecture regarding a few words, not the alphabet and grammar needed for understanding this ancient language.

Without the relative convenience of an ancient grammar, the challenge to decode ancient Egyptian continued long after the Rosetta Stone's discovery. With no way into the language, the only strategy is to patiently work through many texts, cataloging the uses of each of the signs. The contest for a breakthrough would turn, finally, to two figures: the noted genius Thomas Young (1773–1829) and the brilliant linguist Jean-François Champollion (1790–1832).

Perhaps the contest was never a fair fight. A practicing physician and scientist with a family, Young studied hieroglyphs on his summer vacations. Champollion, young and single, had learned to read Coptic (the last version of ancient Egyptian) and was obsessive in his commitment to break the code. In Young's 1818 letter to William, he reveals an understanding that demotic combines ideograms and phonetic signs, and he could correctly

read many word groups in the Stone's demotic section. However, in spite of identifying signs representing individual letters and seeing them at work in the cartouche of Ptolemy, Young continued to believe that phonetic signs are found only occasionally in hieroglyphs, that hieroglyphs were mostly a pictorial language, not a language with an alphabet and a grammar.

Young and Champollion engaged in correspondence regarding the decoding of hieroglyphs, and Young was present when Champollion read his now famous September 22, 1822, *lettre* à *M. Dacier* (secretary of the Académie des Inscriptions et Belles-Lettres) to a small gathering in Paris on September 27, 1822. Champollion's letter presents an alphabet and asserts that hieroglyphs include sound (phonetic) signs as well as pictographs. Champollion completed his explanation in an 1824 publication and, by 1832, had finished—though not yet published before his death—his Egyptian grammar.

The prize would seem to be entirely Champollion's. But, when scholars build on the work of others, we expect credit to be given. Champollion failed to act the gracious scholar, a trait that dominated Young's—if not always William's—behavior. Young deserves more credit than most know to give him, and William deserves more than just a brief footnote for his contributions.

Because hieroglyphs that appear on temple walls or obelisks are part of an artistic design, reading them increases in difficulty. Do we read a line left to right (the tendency of English readers), or right to left? The answer is that we normally read to the face of the bird. On the Abydos King List, all of the birds and king or god figures are facing to the right, so we read from right to left. With rows, we read from top to bottom, each row a separate register, so the list of cartouches moves from top right to the second line, right to left, to the third line, right to left, to end at the bottom left of the page (look again at the King List on p. 185). On wall drawings, however, the hieroglyphs are often clustered in meaningful "groups" in and around the

figures, adding to the challenge of decoding, but one still reads essentially from top to bottom and in the same left-to-right or right-to-left pattern, as dictated by the direction of the faces.

On the Abydos King List, each of the registers of cartouches is separated by a row of king figures—actually in the pose of the god icon—wearing either the crown of Upper or Lower Egypt. The signs above the second and third rows of cartouches are not decoration; they have meaning. The wavy line is the phonetic sign for "n," but it is also the preposition "for." Below are signs for "the king of both lands" (the white crown and the sedge plant). The birds and the two odd-looking "lines" together say, essentially, "as a gift." The entire bottom register contains various ways of writing the two names of Ramesses II, so the idea is: For the King X (whoever is in the cartouche) as a gift from Ramesses II. The list does indeed offer honor from Ramesses II to past pharaohs, just as Ramesses II honored his father by completing his Abydos temple.

Above each cartouche for Ramesses II in the bottom register are alternating signs. The circle (the sun) and the duck read "son of Re." The bee and plant are another way of writing "king of the dualities": Upper and Lower Egypt, fertile soil and desert, the human and the divine. And so Ramesses II is declaring that he is both the son of Amun-Re and the unifying pharaoh. Hard enough to decipher, but if only it were this simple. Look at the varied ways of writing a cartouche for Ramesses II. Most kings acquired several names, including a Horus name and the two usually found in cartouches: the king's praenomen, the name he took when becoming king, and his nomen, his given name, a name that may be passed on through a family, such as Ramesses.

The Egyptians did not use I, II, and so on, to distinguish father and son, and so determining which Sety or Ramesses erected which temple or obelisk depends on finding a cartouche with the king's distinctive praenomen. Alternatively, Egyptologists draw inferences from the existing artifacts—scenes depicted, style of art, all the strategies used by archaeologists for dating purposes.

Most of the names in the Abydos list are praenomens. Look at the third cartouche from the right on the second register (see image 34 on p. 185). That is the praenomen for Middle Kingdom pharaoh Senusret III. The sign that looks like a square missing its top, with an extra flourish on each open side, actually represents raised hands and is the two-consonant sign for "ka," the ka spirit. In Senusret III's praenomen, there are three of these, representing "kau." The middle sign represents "kha," and the circle at the top is "re." The praenomen: Khakaure. (The sun sign is almost always placed first in a cartouche even though it may be the last two letters of the name—though not for Ramesses.) The cartouche on the second register and third from the left contains Sety I's praenomen: the rectangle with marks along the top is "men," the god icon with a feather on her head is the goddess Maat, and then the sun disk at the top provides "re"—giving us Menmaatre.

Actually an "e" has been added between the "m" and "n." Often the vowels "e" and "o" are left out of hieroglyphs and are added by Egyptologists to make pronunciation possible. The Egyptian language contains single-, double-, and triple-consonant phonetic signs in addition to pictographs such as the goddess Maat. Sometimes a sign is added to reinforce meaning. You may have guessed that the three-pronged sign is an "m," but it actually is "ms," resulting in several spellings of Ramesses. Egyptologists do not agree on all spellings, and of course those carving in stone made errors as well. Hieroglyphs use different kinds of birds, plus ducks and a vulture. It would be easy to carve the wrong bird, or just carve the bird badly enough that we cannot now read the sign with certainty. William frequently found errors in the hundreds of Greek inscriptions he copied both in Egypt and in Syria. After all, the carvers were probably semiliterate at best; they were working from a copy prepared by a scribe.

The Abydos King List shows just how varied can be the writing of a king's name. The Rosetta Stone also reveals the challenges to reading ancient Egyptian writing. For example, the cartouche for Ptolemy appears four times on the Stone, three times close together:

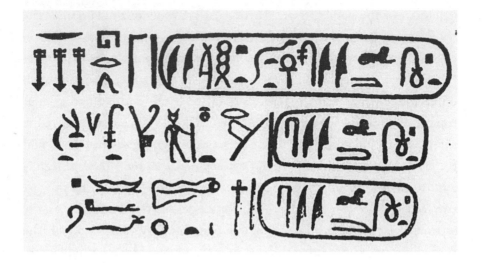

35. Part of several lines from the Rosetta Stone.

Even though Ptolemy appears only twice in a similar location in the Greek text, Young was able to conclude that the cartouches represent Ptolemy. Reading right to left, we can see that the first eight signs are the same, giving us Ptolemy, but observe the additional signs in the first cartouche. We often find expressions of praise for the king placed within the cartouche, adding to the challenge of decoding. In the first cartouche the phrases "beloved of Ptah [an important god], living forever" have been added to Ptolemy's name. This brief look at these two key sources for decoding Egyptian writing helps us understand why it took almost twenty years after finding the Stone for Young to start the serious first effort to decoding.

The controversy between Young and Champollion rests on determining who knew what and when and should get the credit, and on inferences about Champollion's character. Did he know of the work of others and build on them without acknowledgment, or did he come to his discoveries independently?

Young had started his work on decoding as early as 1814, as a brief notice to the British Antiquarian Society reveals. Aided by the work on the

demotic section of the Rosetta Stone by Swedish diplomat Johan David Åkerblad, Young could soon read large portions of that inscription. He also saw that the demotic did not perfectly match the Greek version, and of course the hieroglyphic version was only partially available on the Stone. Writing to a friend in 1814, Young makes clear that he understands the demotic section to be more related to hieroglyphs than to Coptic and that using a knowledge of Coptic as the approach to decoding will not work. He lists icons he has already deciphered and observes that Champollion, in an early work on Egypt, appeared to be blindly following Åkerblad.[9]

Young published his translation of the demotic section, and then a revision in 1816, along with some of his 1815 correspondence with French linguist (and teacher of Champollion) Sylvestre de Sacy. In his publication, Young left out some of de Sacy's remarks about Champollion for reasons that become obvious when one reads:

> If I might venture to advise you, I would recommend you not to be too communicative of your discoveries to M. Champollion. It may happen that he may hereafter make pretension to the priority. He seeks, in many parts of his book, to make it believed that he has discovered many words of the Egyptian inscription of the Rosetta stone: but I am afraid that this is mere charlatanism.[10]

De Sacy would repeat his views of Champollion to Young in a subsequent letter written in July 1815. Presumably de Sacy had good reason to write this analysis of Champollion's character, although he could also have been motivated by the teacher's jealousy of the smarter student. Sadly, whatever motives caused de Sacy to write of Champollion in such terms, his prophecy turned out to be accurate.

Young published his work up to 1819 in an article on Egypt in the 1819 *Supplement to the Encyclopedia Britannica*, including the signs he had identified and the decoding of the Ptolemy and Berenice cartouches. In this article, Young observes that it is difficult to know just how accurate Manetho's list

of kings is. (Manetho was an Egyptian priest in the third century BCE.) In a footnote to this passage, Young's editor John Leitch writes that "Champollion's discoveries, to which he was led by several passages in this article, have furnished, together with the Tablet found at Abydos by Mr. Bankes, a remarkable confirmation" of Manetho's chronology, a chronology that most had doubted prior to William's discovery. In his encyclopedia article, Young also writes, when giving his catalog of animals used in hieroglyphs, that "the CROCODILE is identified by a very distinct drawing in a manuscript sent home by Mr. Bankes."[11]

Young begins this article by describing events at the time that seek to provide more knowledge of ancient Egypt, noting the work of Belzoni and Henry Salt. He also writes: "The Quarterly Review has afforded us . . . gratifying detail of the discoveries which have been conducted in Egypt by several of our spirited and enterprising countrymen. Among these Mr. Bankes has proceeded the furthest south . . . and has made collections and drawings of a great number of striking remains of antiquity."[12]

Young's article was highly regarded when it was first published. Obviously, as work on reading hieroglyphs continued, some of his conjectures were qualified or rejected, as is the way in the world of scholarship. Because the 1819 edition was not readily available to scholars in the 1850s, they gave Champollion credit for decoding words that Young had, in 1819, already established. What this reveals to Young's editor—who is biased in his favor but does seem to have a valid point—is that Champollion "pursued a wholesale system of plagiarism in regard to Dr. Young's discoveries."[13]

According to Young, Champollion had not read his encyclopedia article until 1821, and Young did not ask him if or when he had read Young's other publications on hieroglyphs prior to 1822. While always behaving appropriately as the foreign secretary of the Royal Society, a position he held from 1802 until his death in 1829, Young does defend his early work in letters to friends. Finally, at his friends' urging, he published a letter in the *Edinburgh Review* defending his claim to early discoveries that aided Champollion's breakthrough in 1822. Young summed it up this way: "It may not be strictly

just, to say that a man has no right to claim any discovery as his own, till he has printed and published it, but the rule is at least a very useful one."[14] Young is clearly asserting in this understated comment that he published first and should be recognized as an important player in the decoding of ancient Egyptian writing.

In October 1817, Young founded the Egyptian Society to give a formal context to the gathering and study of ancient Egyptian artifacts. Both Henry Salt and William joined, suggesting that there were additional letters between Young and William that did not survive William's second journey up the Nile. Based on information obtained from Young, William was able to decode the cartouche of Cleopatra on his Philae obelisk. He arrived at this insight in part with some hieroglyphs identified by Young (the "l" and "p" and "t" are in Ptolemy's cartouche) and in part by finding the obelisk's mud-hidden base and reading the Greek inscription there—which mentions Cleopatra III, wife of Ptolemy VIII.

Apparently Salt, Young, and William all assumed that the inscriptions on the obelisk would be the hieroglyphic version of the Greek inscription on its base—like the Rosetta Stone. However, once Young started his study of the obelisk, he realized that there would be no simple match. Young had William's reading of the Cleopatra cartouche prior to William's private publication, in 1821, of the four sides of his obelisk, showing the carved hieroglyphs—as well as plans for decorating that wisely never materialized. William also sent a copy to the French scholar Denon (one of Napoleon's scholars) to be presented to the French Institute, thus providing Champollion with a copy—which included "Cleopatra" annotated in the margin next to her cartouche. Leitch, Young's editor, minces no words when he concludes that "though there is no reason to doubt that it was this engraving that really furnished Champollion with the principal materials for his most important discovery, he never acknowledged his obligation."[15]

Although Leitch gives appropriate recognition to William, he is probably being a bit unfair to Champollion. More text than the Rosetta Stone and William's obelisk was needed to produce the French scholar's break-

through. Both Champollion and Young were now studying papyrus copies of the Egyptian *Book of the Dead*, a source of spells and prayers that appear repeatedly on tomb walls. And, importantly, they both now had the Abydos King List. Young had sent a copy to Champollion, unknown to William, even though Champollion made a point of writing to William for permission to use his King List. Young notes in a letter to Sir William Gell that William would not respond to Champollion's letter because William thought the Frenchman was "a dirty scoundrel," an echo of de Sacy's earlier observations about Champollion.[16]

William inadvertently helped Young's rival, however, by including the French traveler Jean-Nicolas Huyot in his group at Abu Simbel, thus giving him access to wall drawings there that repeatedly contain the cartouche for Ramesses II, a cartouche Champollion will find again on the King List. In William's world, travelers are befriended and information is shared—until someone takes without asking or acknowledging the taking. Such ungentlemanly behavior makes the usually gracious William really angry.

Henry Salt and William wrap up this tale of Herculean scholarship and flaring national tempers in Salt's 1825 publication of a little book on hieroglyphs. William offered his friend Salt the use of his Abydos King List drawing as the book cover, and he is still proud of his discovery. Salt's *Essay on Dr. Young's and M. Champollion's Phonetic System of Hieroglyphics* is dedicated to the Honorable Charles Yorke, with William writing the dedication. He describes how he found the list at Abydos, distributed some copies about which much has already been written, and now feels "some degree of satisfaction that its first appearance, in all its details, should have been reserved to be thus associated with your name [Charles Yorke], and with the ingenious labours of our common friend, Mr. Salt."[17]

In the book Salt devotes a lengthy footnote explaining the careful steps of comparing the obelisk and Philae temple decorations and the Greek inscription on the base by which William, in 1818, decoded the cartouche of Cleopatra. Salt then observes that Champollion needed William's work to succeed in his understanding of hieroglyphs.

Interestingly, Andrew Robinson, one of Young's contemporary biographers (2007), in his subsequent biography of Champollion (2012), seeks to assess the contributions of both men to cracking the code. Robinson argues that this fascinating story of decoding required "both a polymath and a specialist."[18] Robinson also asserts that Champollion most likely saw Young's work by 1821 and that the key for Champollion was the copy of Bankes's Philae obelisk with William's handwritten "Cleopatra" in the margin. This vital document—and hence Bankes himself—Champollion never acknowledged.[19]

Salt really adds little to the challenge of reading ancient Egyptian—except to include plates with many cartouches from temple walls—and his motivation appears to be nationalistic. Another way to look at his essay, however, is to recognize that he wants to be remembered as part of the process. He was making his contribution "in the field" in Egypt, supporting Belzoni and Bankes, copying wall decorations as a part of William's second Nile journey, sending artifacts to the British Museum.

Still not quite finished exploring, William made a detour to the Fayoum area before finally returning to Cairo and Salt's hospitality. Staying there as well was Salt's friend Nathaniel Pearce, whom William had first met in Upper Egypt. Pearce, just returned from Abyssinia (modern Ethiopia) with his Abyssinian wife, interested William. Baron Sack and Hyde were also in Cairo, adding to Salt's group that included Beechey and Ricci as well. The heat, that late August and September, rose regularly to 110 degrees, resulting in a schedule of riding before dawn, eating dinner at midday, and then enjoying a siesta for several hours before paying visits or visiting Cairo sights and then having supper after sunset. The men studied William's drawings, offered advice to those traveling to Syria and Mount Sinai, and debated European politics.

William also had commissions to assign: Dr. Ricci was to return to Beni Hassan to make detailed drawings, a task never completed by him; Linant was assigned the copying of inscriptions at the Oasis of Siwa followed by a journey to Meroe in Nubia, tasks completed though not quickly enough to satisfy William. Further, Finati was to retrieve William's obelisk base from Philae—where Belzoni had left it—and send it on to Alexandria. Finati fusses a bit in his narrative that he could have completed his assignment speedily (while the Nile waters were still high) if he had left Cairo immediately. But William did not want his companion of so many adventures to leave until he himself was ready to depart from Egypt.

After William's departure, Finati traveled with Linant to Nubia, so the obelisk's base was left for Salt to retrieve in 1821. Finati proclaims his disappointment because he "should have felt a pride and pleasure in promptly rendering this service to one" whom he would always remember "with gratitude and attachment."[20] Finati also felt pride and pleasure in William's desire to postpone their parting as long as possible. Both men felt the pain of their eventual farewells, knowing that they were closing the book on a significant chapter in their lives.

William stayed on into September to attend Salt's wedding—his gift a pair of diamond earrings for the bride. He promised to stay in touch and to look after Salt's interests in London, particularly in the selling of artifacts to the British Museum. And then, finally, William and Beechey sailed from Alexandria on a Greek ship bound for Trieste and their required period of quarantine. Coming to Europe through Trieste is not exactly the shortest route back to England. But, it was close to Italy—and to Byron in Venice.

THE EXPLORER RETURNS

36. Decorative wrought-iron window covering on a private home in Venice. Drawing by Bankes.

Promising to return to Egypt in a year or two, William began his homeward journey by way of Trieste so that he could travel once more through Italy. He also hoped to see his college friend again. He probably already knew the details of Byron's marriage failure and his living in Venice, but if not, he would have heard the story in Trieste from John Cam Hobhouse's cousin. William's chance meeting with Henry Hobhouse, while he waited—with Henry Beechey and Antonio Da Costa—through their quarantine period, was enough to convince William to write and invite Byron to visit him in Trieste.

Byron could not respond immediately as both he and his daughter Allegra were seriously ill, Byron with a nightmare-producing fever, probably a result of his having caught malaria during his youthful travels in Greece. He woke one night to see his English servant Fletcher and his mistress, the Countess Guiccioli, sitting on either side of his bed, both sobbing. The image of these mourners must have motivated him to get better. During his recovery, the elderly Count Guiccioli arrived in Venice and quarreled at length with his beautiful nineteen-year-old wife. Although Teresa wanted to stay with her lover, Byron was able to persuade her to go home to Ravenna with her husband. And then he suddenly decided that he and his daughter would return to England, possibly with the thought of eventually settling in Venezuela.[1]

Throughout the years of his exile, Byron wrote repeatedly—to his Trinity College friend John Cam Hobhouse (now a member of the House of Commons), to the poet Tom Moore, to his publisher John Murray II—that he would never again live in England, that the vile English society would not have another opportunity to turn its collective back on the brightest poet of the age. But, without Teresa, he found Italy a sad place. His belongings were packed and much was already in transit with servants, when, just as impetuously as when he ordered the packing, he decided to stay.

Certainly part of his decision came from learning that Teresa was now seriously ill—to the point that her father and her husband concurred that Byron should be asked to come to her.[2] But it is also true that Byron's love/

hate relationship with England would never end. Although the poems he wrote and sent to Murray for publication were not set in England, they continued to be, at least in part, satiric of English society. William, with the stable family and ownership of country estates, turned out to be much more the traveler, more the citizen of the world, than Byron.

Feeling better and once more established in his Venetian home, Byron wrote to William on November 20 and, with great enthusiasm, invited him to visit in Venice, explaining that he was still tied there because of his daughter's illness and then indicating that he had followed the news of William's travels and discoveries:

> I have not been ignorant of your progress nor of your discoveries and I trust that you are no worse in health from your labours;—you may rely upon finding every body in England eager to reap the fruits of them— and as you have done more than other men—I hope you will not limit yourself to saying less than may do justice to the talents and time you have bestowed on your perilous researches. . . . It is now seven years since you and I met;—which time you have employed better for others & more honourably for yourself than I have done. . . . Should you come up this way—and I am still here—you need not be assured how glad I shall be to see you;—I long to hear some part from you—of that which I [expect] in no long time to *see*—at length.[3]

William left Trieste first for Florence and then traveled to Venice to stay with Byron in his grand rooms in the Palazzo Mocenigo. The palazzo was high ceilinged with stunningly decorated drawing rooms, study, and bedrooms that Byron delighted in showing to one of his richest friends. The Mocenigos were an old Venetian family who gave the city many doges, but times had changed for them and now the palace was for rent—for the tidy sum, in 1819, of £200 a year.[4]

From the balcony, William watched the gondolas on the Grand Canal and the foot traffic across the Rialto Bridge. Turning back into the drawing room to look at his college friend, William struggled to contain his surprise.

He saw a still-young man looking "coarse," a stout man wearing side whiskers. By contrast, Byron saw the once fair-skinned and soft William now tanned and slim, and wearing his hair long. Having started the purchase of Western-styled clothes in Trieste and Florence, William chose to hold off on the haircut until he could present himself in Venice looking the part of "the Nubian explorer," perhaps a bit of romantic one-upmanship.

Byron's habit was to stay up much of the night, writing, and then sleep until afternoon, so William used his solitary mornings to stroll the city and seek possible art for Kingston Lacy. One day he chatted with an English visitor, Mr. Saunders, who observed that Byron's poem *Don Juan* was all "Grub Street," not quality literature. William chose to repeat the disparaging comment to Byron, perhaps expecting him to dismiss Mr. Saunders with a satirical barb. Byron did just that, declaring that Saunders was merely a "d-d salt-fish seller" and so could hardly be expected to appreciate Byron's poetry. However, when Byron wrote to Thomas Moore about the incident, he also recorded that the judgment stung enough to keep him from working on a new canto of the poem for some time.[5]

Not in the habit of treating his hosts unkindly, William was surprised to see his friend still so sensitive, given the poet's great success and fame. William may not have been aware of just how much maligning *Don Juan* had received. Indeed Murray was rather brave to continue to publish new cantos in the midst of the firestorm of protest in the English press—and in many drawing rooms. Fortunately the incident did not stop Byron from enjoying the rest of William's visit in Venice and then later in Ravenna.

With his daughter Allegra apparently on the mend, Byron felt free, in late December, to follow Teresa to Ravenna and invite William to join him there. Byron was beginning to tire of his role as "cavaliere servente" to Teresa, living as he described it in "the strictest adultery." She was young and beautiful but possessive, and he was less in control than he liked—and not inclined to fidelity. But, having compromised her (she eventually was separated and returned to the "care" of her father and brother), he was too honorable to just walk away. And so at Christmastime he traveled to Ravenna,

staying first at a hotel and then in rented rooms on an empty floor of the count's palace—an interesting arrangement that revealed the count's willingness to take money from any source.[6]

William joined Byron in Ravenna and met Teresa and the society there and participated in Carnival events, as Byron described it to Richard Hoppner at the end of January 1820: "The Carnival here is less boisterous [than in Venice] but we have balls and a theatre—I carried Bankes to both and he carried away, I believe, a much more favorable impression of the society here than that of Venice . . . Bankes and I buffooned together very merrily."[7]

By mid-January William had left Byron in Ravenna to go in search of art purchases in Florence and Bologna. He wrote to Byron to express his interest in *The Judgment of Solomon*, a painting at the Marescalchi Palace, a work that both Byron and William thought to be by the Italian Renaissance painter Giorgione. Byron wrote in response that he remembered the painting and thought the real mother in the canvas was "exquisitely beautiful." "Buy her, by all means, if you can and take her home with you; put her in safety; for be assured there are troublous times brewing for Italy," Byron wrote.

The political conflicts on the horizon were, for Byron, a good reason for William to leave Bologna for a return visit to Ravenna. Noting that he was waiting for William with impatience, Byron also wrote that he had more copies of Scott's novels, which he was enjoying (Byron never doubted that the anonymous Waverly novels were written by Scott) and reminisced that he first read Scott's poetry in William's rooms at Trinity.[8] Before hearing from Byron, William had trusted his own judgment and purchased the painting.

The Judgment of Solomon is a magnificent work, although unfinished. Restoration has revealed several different arrangements of the figures, and the disputed baby is not yet in the scene (see color plate C21). The painting would have been the jewel of William's collection if it had remained a Giorgione (who died young and left only a small collection), but since art scholar Bernard Berenson's 1903 attribution to Sebastiano del Piombo, it has been credited to del Piombo. William was excited by his opportunity to purchase the painting and Byron concurred. William's father, however,

was beside himself when he discovered that William had drawn £500 to pay for—in his mother's words—"unfinished pictures of masters" not admired by Henry.[9] Was it the money or the art itself that most bothered Henry? Or, William's lavish spending and determination to act on opportunities before actually owning Kingston Lacy that kept father and son at odds? Henry repeatedly vacillated between indulging his son and trying to keep control of the purse strings.

William purchased two other great works from the Bologna collection: the superb portrait of Cardinal Camillo Massimi by the Spanish painter Velázquez, and the arresting portrait of Nicolo Zen by the Italian Titian. What else he did in Florence and Bologna is unknown, but Byron still hoped—perhaps expected—him to return for a second visit.

On February 19, he invited William to come in spite of the weather and stay with him in his rooms in the count's home: "Neither dangers nor tropical heats have ever prevented your penetrating wherever you had a mind to it, and why should the snow now?—Italian snow—fie on it!—so pray come. Tita's heart yearns for you, and mayhap for your silver broadpieces, and your playfellow, the monkey, is alone and inconsolable."[10] The compliment to William is charming, but this letter apparently also suggests that Tita is "available" should William be interested. (Strong but gentle Giovanni Battista Falcieri, Tita, was Byron's gondolier and a devoted servant who traveled with him to Ravenna and also to Greece, where Byron, only 36, would die of a fever at Missolonghi, with both Tita and his English servant Fletcher by his side. Tita then obtained various positions in England, using the fame of his attachment to Byron.)

Byron continues his long letter in a chatty style, filled with his usual dashes, but he also seems anxious to convince William to return, suggesting activities for him during the morning when Byron is still sleeping and also expressing a desire to hear about Cyprus. He requests William to "call at your banker's at Bologna, and ask him for some letters lying there for me" and establishes that he will also ask William to carry home with him some new cantos of *Don Juan* to pass on to Murray for publication.[11] The requests

imply a renewed affability but also put some pressure on William to return to provide the letters and collect the poetry. William surely forwarded Byron's letters and asked him to send the cantos to Rome for safe carriage to London. He did not, though, return to Ravenna. Once back in England, he wrote to Bryon and sent him a copy of his publication showing the four sides of the Philae obelisk. Presumably he also received letters from Byron, although none from the poet's last years survived the Bankes family's censorship of William's papers.

Byron's renewed friendship with William lifted his spirits, however briefly. He admired William's exploits and wrote to Murray about William's "miracles of research and enterprise" and proclaimed that he "is a wonderful fellow." He declared that he knew only three men willing to help him—presumably when Lady Byron moved out and the bailiffs marched into their house in Piccadilly—one a now dead nobleman, the second Murray himself, and the third was William. Byron continued in this letter that William would have helped him "from good will—but I was not in need of Bankes's aid, and would not have accepted it if I had (though I love and esteem him)."[12] The always proud Lord Byron would not have accepted financial assistance from William in spite of his ever mounting stack of unpaid bills, and yet he appreciates the gesture and continues to value the friendship.

Still, the despair returned along with a feeling of time wasted in comparison with his Trinity buddies, spurring Byron to become involved in the Greek push for independence from the Ottoman Empire. In 1823 Richard Hoppner, British consul to Venice, concerned about Byron's depression and mistaken notions of aiding Greek independence, wrote to William, asking him to try to convince Byron to return to England. William tried but was unsuccessful. He never saw Byron again.

Having parted with the faithful Antonio—who returned to his native Portugal—William moved on to Rome to meet his youngest sister Maria and her husband Thomas Stapleton, just married and traveling on their honeymoon. Maria wrote to their mother that her brother was much altered, but she thought that his long hair accounted for his changed looks. She held

a teenager's memory of the fair 20-something William, who is now 34 and changed both physically and emotionally from his travels. William undoubtedly played travel guide in Rome, taking Maria and Thomas to the Roman Forum and Colosseum, St. Peter's and the Pantheon, pointing out—and surely commenting on—the Egyptian obelisks scattered throughout the city. They probably took tea at Antico Caffè Greco, a café near the Spanish Steps and the home of poet John Keats that was popular with British travelers in Rome.

Meanwhile in London Frances Bankes is ecstatic in anticipation of her son's imminent return. He is in Milan, preparing to travel through the Simplon Pass in spite of still-heavy snows. He is in Geneva, though travel through the pass resulted in a fall that could have been serious—but only his lip was hurt. Her youngest son Edward's marriage to the wealthy Frances Jane Scott on April 11 is recorded with little fanfare—but William is now in Paris.[13] Finally, at long last, the explorer arrives home on April 24, 1820, seven years and some months after his departure for Spain. William might have told himself that he did not know either Maria or Edward well enough as adults to speed his trip home for their weddings. If he believed those thoughts, he was denying the reality: He just could not pull himself away from the Mediterranean world that had been his home—and the world of his fantastic adventures—for so long.

Byron's many letters to London connections and an article in the *Quarterly Review* announcing William's discoveries prepared the way for his triumphal return. Immediately, his parents celebrated with a mostly family dinner that included Anne and Edward, the Earl of Falmouth, William's sister and brother-in-law. Frances records the event in her diary, declaring that William was "more agreeable than ever and in great spirits." The next day she took him to call on his sister and others—and writes that she can do nothing but follow him around "like his shadow."[14] Frances also took William to a dinner given by the Royal Academy at Somerset House. Presumably in her fluttering around him she prevailed upon William to have his hair cut.

And then on May 13, Frances and Henry held a dinner at Old Palace Yard to celebrate William's return—and to reconnect William with the Duke of Wellington. In the party were the Arbuthnots, Charles an MP and Secretary to the Treasury at the time, and Harriet, the daughter of an MP and grand-daughter of the 8th Earl of Westmoreland, a highly influential couple. Harriet wrote in her journal that it was a "very pleasant party to meet Mr. Wm. Bankes, who is just returned to England after . . . traveling over Greece, Asia Minor and Egypt, in which latter country he has gone further than any European has ever been."[15] She found his travel accounts delightful.

After dinner, the Arbuthnots went on to Lady Bessborough's to meet Belzoni, who was in London to sell antiquities. The following year he would stage an exhibition of Egyptian artifacts—unwrapping a mummy in front of a startled audience—and in 1822 his two-volume *Narrative* was published by Murray, written in English, for he knew he had an audience among the British.

Belzoni's activities did not overshadow William at all. Instead, William was in even greater demand because, unlike the former circus strongman, William belonged in London's drawing rooms. Launched by Frances and Henry, he was the center of attention at dinners, a frequent visitor at the Arbuthnots, and often a part of Wellington's theater parties. An entry in Harriet's journal for June 1821 states that William and the duke and several others dined with them and that "Mr. Bankes was excessively entertaining & told us many stories of his travels, and of a stay of some time which he made at Palmyra."[16]

William did not limit his stories to the amusement of ladies—although those with unmarried daughters may have been especially attentive. He joined the Society of Dilettanti, an exclusive dining club of only seventy men with a desire to support the fine arts. The major requirement for membership was having traveled to Italy, a requirement hundreds of men would have met. William's extensive and daring travels certainly tipped the scale in his favor, although there is no record of his taking any leadership roles in the club.

He did, however, share his knowledge of the East in more serious conversations. In a May 1820 diary entry, Stratford Canning (who will become ambassador to the Porte) writes that he dined at Brompton with Mr. Frere (who had been at the embassy in Constantinople when William was there), William, and others. William was "particularly entertaining . . . with great fluency & liveliness, more memory . . . than judgement, more singularity than wit, and yet with a sagacity and promptitude that might often pass . . . for those more valuable qualities." Canning remembers William talking when he arrived and concluding the conversation at the end of the evening, "his power of utterance unwearied, and his stores of memory . . . undiminished." Canning continues his lengthy diary notes:

> He talked of his travels in the East. Cairo, he says, is visibly wasting away under the effects of the commercial monopoly exercised by the Pasha of Egypt. He being almost the only merchant in his territory, that valuable class cannot exist under his government, and their former habitations are consequently deserted and going to decay. The distress caused by this extends to the country, and the Mamluk Beys are regretted, unpopular as they were in the time of their power. At Jerusalem there is no similar appearance of decay; that city is the great market town to the surrounding country.[17]

Canning had listened intently to William's analysis of government and commerce. He also sized up William in ways others had before: a prodigious memory and quick and amusing chatter that at times passed for wisdom. William understood commerce; his tenants needed to turn a profit to maintain his lifestyle. And he understood the value—as well as the pleasure—of great art. It was the day-to-day "business" of politics and society that he, like Byron, could not take seriously.

Not everyone shared Canning's mixed reviews of William's conversation. The poet Samuel Rogers, in a book of anecdotes about Sidney Smith, wrote that as "witty as Smith was, I have seen him at my own house absolutely overpowered by the superior facetiousness of William Bankes."[18] (Smith, an Anglican clergyman and writer, was well known as a great wit.)

Canning would have accepted "facetiousness" and still argued that William's conversation lacked weight. Although Harriet developed a close friendship with William, she was not so blinded by his charm as to lose her judgment. In 1826 she records that "Mr. Bankes, who dined also at the Duke's, provoked us excessively by engrossing as much as possible all the conversation, & talking so loud as quite to drown Sir Walter [Scott]'s conversation. I never saw such bad taste in my life, I almost thought he was drunk."[19] William spent years traveling in Arab countries without carrying liquor, but dinner at the duke's is not the same as camping under the stars at Abu Simbel. His need to dominate the conversation, to be seen as the cleverest, wittiest person at the table, reveals a continuing discomfort or insecurity in London society.

Long before 1826 William thought of returning to the East. Early in 1822 he wrote to Byron that he found England much as he had left it, with either the same people or the same sort being "very dull, very meddling, very silly, & very false. The Sotheby's flourish, the Wordsworths write, the Hobhouses speak." "For my own part," he continues, "I am pining for the sunshine & intense blue skies of the East, for those enticements to curiosity & interest which abound there, & for the free & vagrant life which I led."[20]

Earlier he had told Harriet Arbuthnot that he meant to return to Africa, to go far south into the country in search of the source of the Nile, and to return by sailing around the southern tip of Africa. Harriet writes that if he goes, she fears "he will never return,"[21] an apprehension that expresses more about her emotional ties to William than about his demonstrated skills as an explorer. However, there was no need for the fear. William wrote to Byron that he was finding it harder to initiate a new journey than to end one, and he wasn't at all sure that he had "the spirit & resolution to plunge again."[22] Given how long it took him to conclude the first journey, there would be little chance of his finding the spirit to initiate a second one.

Not fulfilled by London society, William continued his travels, this time in France and England. He attended the baptism of the Duc de Bordeaux in Notre Dame in May 1821. During this visit to Paris, William met Vivant

Denon, one of Napoleon's *savants* and the author of one of the books on Egypt that William carried on his travels. Did William point out the error in Denon's site plan of Luxor—or did they discuss more generally the challenges of measuring and drawing Egypt's huge temple complexes?

Apparently these two most important early explorers in Egypt connected with one another, for Denon, who had been director of the Louvre Museum until the Restoration of the monarchy, marked the occasion with a gift to William of some print copies of great artworks from Florence's art gallery. In contrast to 1812—when William began his journey—France was now open to the British. William studied the Louvre collections and visited country houses, reflecting on art and also looking for remodeling ideas.

In England his first remodeling took place at Soughton Hall, now William's to decorate and manage. He traveled often to Wales, to escape the meddling and silly world of London, to take control of the running of his estate, and to begin some of his renovations. To change the eighteenth-century mansion's south entrance to the north side required the altering of nearby roads and the making of a long avenue lined with trees, a dramatic entrance that cost William some years of conflict with neighbors. The enclosing of his estate—primarily for privacy—was also not well received, but he tried to ease conflict by giving some of his land for public use.

To remodel the interior, he turned to Charles Barry. William had met Barry in Egypt, and they had discussed writing a book together. William asked one of Barry's friends if Barry would help him organize his notes, but Barry was intent on becoming a successful architect. A slow beginning to this goal was aided by his recognition that William would be a good source of contacts. He sent William a lovely drawing, in color, of Karnak Temple, a gift that William knew was expensive and could not graciously be either returned or ignored. William connected Barry with the Archdeacon of Cambridge, the church's commissioner for the building of churches, and Barry's career was launched. He also brought him in to help at Soughton Hall. Apparently, though, Barry did little more than convert William's sketches and ideas into architectural drawings for the Clerk of Works

because he does not list the house among those he designed in the Italianate style. It is also possible that he chose not to claim the house, believing that William's plans were not coherent. Barry may have been unable to change William's thinking or unwilling to argue with him.

Changing the entrance allowed William to erect a grand hall sweeping in from a courtyard. He selected mullioned windows, searched for dark, richly carved wood, and planned to enclose his courtyard with cloisters, an unusual blend of his old love of the Gothic with newer influences of the Islamic East and the open, Italian villa.

Finati, who would spend some months at Soughton Hall in 1824, describes the house as similar to old villas in Italy that he had seen when young, with "towers and much ornamented stone-work and walled courts about it, and lines of trees in almost all directions; and instead of the trim and compact" style of typical English houses, "there are . . . large open chambers and galleries, very lofty, but quite naked of furniture."[23] (But Finati did understand that Soughton Hall was still a work in progress.) William seemed more than pleased with his changes, writing to his mother that he was sure "that both my father and you will find it a much better job than you have any idea of" and that it will be among the prettiest houses in Wales.[24]

Dividing his days between country and town, William spent enough time in London drawing rooms to embarrass himself in a flirtation with Lady Buckinghamshire. He confided in Harriet Arbuthnot, who wrote in her journal that "it appears he is very much in love with Anne, a very young & handsome woman who has been married about 3 years to a man she cannot endure, & who is still more desperately in love with him." Anne separated from her husband because "their tempers and tastes do not suit," but she obviously thought—or hoped—she had a subsequent plan, to have William take her to Africa disguised as a boy. Harriet also writes that she "is very clever & eccentric, which suits him exactly."[25]

William dazzled the young woman with descriptions of temples and tombs, with the vagrant life he missed and his longing to return to the sun and warmth of Egypt. He offered a different kind of romantic future to his

"eccentric" friend, who perhaps even grasped his sexual preference when she offered to travel as a boy.

Apparently the two were indiscreet, for others left diary records of the affair—although it is not at all clear that "affair" is the correct word in spite of Lady Buckinghamshire's initial separation from her husband, a separation that was mistakenly perceived as an elopement. Lord Buckinghamshire initiated charges against the two but was then persuaded to let them drop, probably on the argument that no adultery could be proved. Harriet writes that she, of course, advised William not to pursue a course that would ruin both of them and notes that he took to encouraging the lady to return to her husband. If she would just leave town with her husband, Harriet wrote, then William would come to his senses and resist further temptation. Harriet knew that William was not quite so much in love as Anne, less in search of a wife than of that "spirit and resolution" to initiate another journey.

The "affair" ended and with it any further pursuit of matrimony. William's determination to remain single was stronger than either his doting mother's endless demands or the hard work of other mothers with daughters to marry. And attention turned abruptly away from William's minor scandal when, in August 1822, Lord Castlereagh—a highly esteemed Foreign Secretary as well as close friend of the Duke of Wellington and the Arbuthnots—committed suicide, his response to blackmailers accusing him of a homosexual relationship.

Perhaps William learned something of discretion after these events. Frustrated by his inability to make major changes to Kingston Lacy—although one could argue that raising an obelisk on the south lawn was a major change—William convinced his father to accept one other alteration. An architect was hired to connect the closet attached to his upstairs bedroom with the backstairs, providing William with greater privacy in his or a servant's coming and going.

William continued to be engaged in "things Egyptian" throughout the 1820s and 1830s. Shortly after returning to London, he gave copies of both Greek and hieroglyphic inscriptions to Thomas Young. He also offered all of his papers at Old Palace Yard for Young's study, and they developed a comfortable relationship, as the following amusing note from Young reveals: "I hope on Saturday or Sunday to make another attempt to break into the temple at Ebsambal [Abu Simbel]. Pray tell me if I shall find it accessible about 3 o'clock."[26]

Young pressed William to publish something—perhaps the Abydos King List with some additional items to let readers anticipate further publication. When he saw William's delay, he worried that more recent explorers would upstage him and even offered to publish "as a Specimen of your Egyptian Collections a Series of the Kings of Egypt, consisting merely of 3 or 4 large folio plates, or perhaps rather 5 or 6 quarto plates, with a few explanatory pages of text." Young would do all the work of writing and arranging, but the book would come out under William's name, and Young would agree to any means of publication: either William or a publisher covering the expense or William and Young sharing the costs. Few would have passed up such a generous offer, but William did, perhaps telling himself that he would soon get around to the bigger book on Egyptian architecture that he wanted to write. Proud to be the "Nubian Explorer," William may not have wanted to appear to need Young in order to be published.

William maintained a lengthy correspondence with Henry Salt until Salt's untimely death in 1827. They worked well together, a relationship based on genuine friendship and respect. William tried mightily to get his friend an appropriate price for the collection of antiquities he sent to London to be sold to the British Museum. Having endured considerable outcry over the expense of the recently acquired Elgin marbles, the trustees of the museum balked at Salt's asking price of £4,000. William wrote to Salt

that he had worked both publicly and privately on Salt's behalf, but he was in the awkward position of being the son of one of the trustees.

Eventually the museum offered Salt £2,000 for everything but the stunningly beautiful carved alabaster sarcophagus from the tomb of Sety I. Fortunately for Salt—given how much of his own limited funds he had spent supporting excavations in Egypt—he was able to sell the sarcophagus to the architect Sir John Soane for his original asking price of £2,000. (It now resides in the Soane Museum in London)

In Egypt, Salt was kept busy managing the commissions William established before leaving Cairo. Linant was supposed to leave promptly for Nubia, specifically to find and study the ancient town of Meroe. Ideally he would follow behind the pasha's army, which moved into Nubia in 1820 to destroy the remaining Mamelukes who had fled there. Instead, Linant and Ricci made several other trips—to the Sinai and the Siwa Oasis—and so did not leave, with Finati, until the following June.

Ricci was not supposed to be a part of this expedition; William left money for a salary and expenses only for Linant. Salt decided, however, that sending Ricci along was a wise move, given Linant's rather fragile health, offers to Ricci from others (resulting in competition), and Linant's capacity for spending money, which the doctor might be able to control. These are the arguments he gave to William, who was fuming in his letters to Cairo—objecting to the waste of both time and money. Ricci and Linant did not travel well together— perhaps they needed William's balm of jollity as well as his focus on the task at hand—but they did find Meroe and produce a significant collection of drawings and plans that Salt was certain would satisfy William.

Ricci, it turns out, made his fortune on this trip that he moped through and then left. He became the physician of the pasha's son, saved Ibrahim Pasha's life, and was rewarded with $8,000 in cash. The money was sufficient for Ricci to return to his home in Florence, never having completed his commission for Bankes: To return to Beni Hasan to prepare drawings of the rock-cut tombs there. Ricci returned to Egypt in 1831 with Champollion and Rosellini in the Franco-Tuscan expedition. Ricci died back in Florence in 1834.

Salt was correct about the increasing pace of competition in the 1820s. In Nubia, Linant eventually caught up with the French explorer Frédéric Cailliaud, who had followed close behind the Turkish army. The two Frenchmen, friendly on the surface, saw themselves as rivals. Not surprisingly, Cailliaud published his four-volume *Voyage a Meroe et au Fleuve Blanc* in 1823, even before Linant arrived in England (in November 1824) with his portfolio of work for William. Salt tried to calm William by reminding him that Linant was young and his eye for the ladies often diverted his attention. More importantly, the Frenchman could do it all: execute accurate site plans, copy accurately, and sketch and paint with good perspective.

Sadly for Egyptology, Linant's portfolio gathered dust with all of William's other drawings in a cabinet he had made for his collection. However, Linant enjoyed successful years in Egypt working for Mohammed Ali, eventually as the Minister of Public Works. He published maps and a memoir, in French, but these works did not include the drawings prepared for William.

Perhaps realizing that he was letting off steam to the wrong person, William graciously offered his Abydos King List as the cover for Salt's book on hieroglyphs, a significant gift to his friend but also a way, finally, to make this important record available to everyone. And Salt, after all, had sent William the gift of the granite sarcophagus of Amenemope, discovered in Luxor in 1821 by d'Athanasi. It resides on the south lawn of Kingston Lacy, not far from the Philae obelisk (see color plate C22). William expected to maintain this mutually pleasurable friendship and enjoy Salt's company upon his retirement and return to England. Salt's early death was unquestionably a loss to William.

The Philae obelisk arrived at London's Deptford port in September 1821, receiving a notice in the *Times*. A happy William mentioned it to the Duke of Wellington, and the duke "brought an immense party with him" to see it the very next day. "He has a great wish to take charge of it himself completely, & to carry it down all the way by land" on a converted gun carriage. William also observed that it was in excellent shape and a treasure that he could never "remove . . . out of sight of the House."[27] Its original base

was still in Philae, however, waiting for Finati to retrieve it, and the granite pedestal steps were still way upriver, waiting for Linant to package and ship them to England.

Even as much as William prized this treasure, the obelisk lay on the lawn for ten years, awaiting its base and the step pedestal. The pedestal eventually arrived, with the help of John Barker. Barker was British consul in Aleppo when William was traveling in Syria. He was now—in 1827— seeking William's help in getting the consulship in Cairo, vacant as a result of Salt's death. William helped Barker with money and a recommendation; he became consul in Cairo and was able, finally, to send the granite steps to England. In 1827 the Duke of Wellington came to Kingston Lacy to lay the cornerstone. Prior to this step, William had been experimenting with place- ment by using long poles. He wanted the obelisk to be just the right distance from the house for greatest effect (see color plate C23).

William spent time with his poles on the south lawn to determine the ideal location for his obelisk, but he could not find time to publish his inscriptions, work he always regarded as valuable for scholars. On more than one occasion he cites "indolence" as his problem. In 1822 he writes to Byron: "I am always thinking of it [publishing], &, from a strange mixture of indolence and industry always deferring it. I hate, and always did, method & arrangement, & this is what my materials want."[28] William actually initi- ated the process in 1821. Fifty-six lithographic stones were prepared, and some of the stones were inked, as proofs were found with William's papers. The stones contain inscriptions from Egypt and Nubia, the Sinai, Syria, and Asia Minor as well as some drawings by Linant.

Apparently William paid to get the work started, but the project was dropped by Murray in 1825 with no explanation, just the project crossed through in his ledger with the word "loss." After selecting the material to be published, William could not get the accompanying text written in a timely manner. Murray wisely decided, by 1825, that William would never sit still long enough to write.

Although unable to complete the publication of his inscriptions, William

continued to connect to travelers and scholars in the field and was consulted regarding his copies of inscriptions. In 1822 he helped finance a trip to North Africa by Beechey and his brother Frederick to do a survey of the coast. In 1833 he examined Joseph Sams's Egyptian antiquities, which included two rare chisels. In 1839, the Egyptologist Karl Richard Lepsius visited Kingston Lacy to copy some inscriptions. And, as late as 1841, William received a letter from the archaeologist Jean Letronne—forwarded by the ambassador William Hamilton—with a query about the inscriptions on his obelisk.

William's Egyptian artifacts included (in addition to his immense collection of drawings and notes and copies of inscriptions) a number of rather significant stelae, significant because they come from the large workmen's community near the Valley of the Kings, the home of those who dug the tombs and the artists who painstakingly decorated the walls and ceilings (see color plate C8). He probably purchased these from Egyptians doing their own searching for artifacts to sell to the French and British. He also took out two wall sections from an unknown tomb, one showing the offering of flaming braziers, the other showing a harpist (see color plate C24).

Maybe William was comparing himself to Thomas Young when he somewhat unfairly charged himself with indolence. Young was the ideal scholar, experimenting or decoding, and then quickly publishing to share his discoveries with others—and get first claim to what he had accomplished. Perhaps William was also comparing himself to Byron, a most undisciplined man in many ways, who was, nevertheless, disciplined in his nightly writing sessions in spite of the temptations of the beautiful Teresa.

William showed both discipline and insight throughout his years of exploration, and he was hardly lazy after his return to England. Indeed, he kept himself too busy during the 1820s and '30s, dividing his time among competing interests. But, unlike both Young and Byron, he lacked the temperament to sit still and write. William probably convinced himself that he would get around to the sorting through and organizing of his pile of notes and sketches, even finally publishing his inscriptions, when he was older, less active, more at leisure. It did not happen.

FATHERS AND SONS

37. England's Big Ben, symbol of the new Houses of Parliament, designed by Charles Barry.

W hen William, only two years back from his groundbreaking travels around the Mediterranean, managed to briefly amuse the drawing-room crowd with his bit of an affair, he had several choices for deflecting this wrong kind of attention. He could have completed renovations to Soughton Hall more rapidly and shown off his artistic skills and some of his collection there. He could have settled in to write a book about his discoveries and firmly establish himself as one of the most important Egyptologists. He could have entered Parliament and become a tireless

committee man like his father. He let himself fall into the trap of trying to do a little bit of everything.

In the fall of 1822, William was encouraged to run for one of two seats in the House of Commons given to Cambridge University. One source of encouragement was Henry, but Wellington also pressed William to run. One seat was held by Secretary of War Lord Palmerston (his Irish title did not exclude him from holding a seat in the House of Commons), the other now open because of the death of John Henry Smythe. Palmerston was expected to hold his seat, so the contest was essentially for one seat among three men: William, Lord Hervey (who had the support of Prime Minister Liverpool), and James Scarlett, a Whig with three years of experience in the Commons.

William began his canvassing for votes rather late in the contest, but he worked diligently to catch up. He wrote letters to the Duchess of Wellington, asking her to use her position to help him. The encouragement he received from Harriet Arbuthnot led him to believe that she would actively canvass for him. This put his friend in a tough spot because her husband was a supporter of Lord Liverpool—and thus of the candidate Lord Hervey. William also begged Byron's publisher John Murray not to lose "a moment in thinking of any body not only that has a vote but that has a Brother or a fifteenth cousin *& compel them to come in!*" [that is, come to Cambridge to cast a vote for William; the seat belonged to the university, not to the town of Cambridge].

He sought the support of Anglican clergy in the country and charmed university faculty in discussions about his travels and discoveries. Having just heard from Linant that he had found a papyrus with part of Homer's *Iliad* written on it in Greek, William further managed to use his Egyptian discoveries to advance his campaign. He placed a notice of the discovery in the Cambridge papers—but commented wryly that "it is an odd thing to get Homer canvassing for me!"[1]

William won by a huge majority, surprising Palmerston and creating a buzz in London political circles. He won by riding his fame as the Nubian

explorer. He also won by pushing the Tory anti-Catholic emancipation ("No Popery") platform, letting the Whig Scarlett and the Tory Hervey (who leaned toward emancipation) divide reform votes and lose.

To have any sympathy for the Tory position in 1822, one has to remember England's history: its rejection of Catholic James II and invitation to the Dutch Reformed William of Orange and the Anglican Mary to come from Holland to be their king and queen, and its great fear of the Roman Catholic Church unseating the Anglican establishment to become once again the state church as it was in France. Mary, daughter of James II but an Anglican, and her husband William were invited by Parliament in 1688 to serve as joint monarchs. The result was a stronger Parliament and weaker monarchy, a new Bill of Rights, and restrictions on Catholics that meant they could neither vote nor hold office. More recently in British history, England had struggled through many years of war with Catholic France, and it still had not solved "the Irish question." Restrictions on Catholics would remain for another decade, until the Reform Act of 1832, Whig control of the Commons, and the end of Henry Bankes's long parliamentary career.

William held his seat for Cambridge until a new election, in 1826, brought a crowded field that infuriated Palmerston, who complained to friends about the need to spend time canvassing for votes. An ambitious— perhaps arrogant—Palmerston, with his eye on a cabinet position and a desire to become prime minister, had little regard for any of his opponents, including William.[2] At one point, ahead of Palmerston, William pushed for a fourth day of voting, presumably hoping that more Tory clergy would come to Cambridge to vote for him. He also refused to agree to the end of the time-honored practice of paying traveling expenses for voters and insisted on a show of strength between himself and Henry Goulburn, the candidate who would end up finishing last, in the hope that Goulburn would quit the race. Both tactics had been common practice, but with all kinds of voting reforms now under discussion, William's actions made him look both old-fashioned and ungentlemanly. He lost the election.

Then, instead of walking away from Cambridge altogether, he tried again in 1827, when John Singleton Copley (the winner with Palmerston) was given a peerage and moved to the House of Lords. The second loss at Cambridge not only kept him out of Parliament until 1829—when he was elected to represent Lord Ailesbury's pocket borough for Marlborough until 1832—it also led to some ridicule. Complaints were made that he talked too much and in a disagreeable voice (possibly a voice high enough to sound whiny on occasion). He also seems to have annoyed people by acting too cocky, too sure of winning. Some complained of his morals, citing the silly to-do with Lady Buckinghamshire, while these same men ignored Palmerston's numerous affairs, including a long affair with Lady Cowper—whom he finally married upon the death of her husband. Wellington was also a man of many mistresses, but his bedroom heroics seemed only to enhance his image, not damage it. Much of politics is the art of managing one's image, and this William had trouble doing. He was unable to project either an image of calm self-assurance or a sense of *gravitas*.

As an MP for Marlborough and a friend of Wellington's, William took the first journey of the Liverpool and Manchester Railway in September 1830. He sat in the celebrity car with the Duke and Harriet Arbuthnot, all thrilling to the amazing speed of 16 miles in about forty minutes, and anticipating the dinners and other festivities scheduled in celebration.

When the train stopped to take on water, some of the men left their cars to walk around, even though they had been told to stay on the train. When he suddenly heard the sound of an engine on the other track, another MP, William Huskisson, alarmed, tried to get around it to return to his car. His left leg was severely crushed by the oncoming train, causing over nine hours of agony before he finally died. The group quietly returned to Childwall, the house they were visiting, the festivities all canceled. Still, it was a great moment of change for England. The railway system would shrink travel time and provide industries in the Midlands with an easier way to move their goods to wider markets.

In spite of widespread Whig victories in the 1832 elections, William was

successful in a race for one of three seats representing the county of Dorset. This is not surprising. The Bankeses were one of the largest landowners in the county and widely known there. However, Henry and William and the Dorset Tories were swimming against the tide of change. In 1832, when Henry's long tenure in Parliament was celebrated at the King's Arms Tavern in Dorchester, and William was toasted and cheered when his willingness to stand for election in Dorset was announced, the Reform Bill had already been passed. And even in conservative Dorset, there were plenty opposing the Tory Old Guard. While the toasts and cheers resounded within the tavern, a large crowd gathered outside, and someone in the crowd tossed a brick through the window, knocking over Henry's gift of a silver candelabrum. William's 1832 campaign would lead to his last seat in Parliament.

William was stung by his two losses at Cambridge, a place filled with youthful memories. He knew that the liberal Whig John Cam Hobhouse (and Byron's best friend from Trinity) was happy to see him out of the House for several years, and their old rivalry for Byron's attention would not have been lost on William.

While in Parliament, his speeches in opposition to Reform were at best merely competent, and there was also a time or two that he would have wished to be anywhere but on the floor of the Commons. In 1824, speaking in favor of government spending for new churches, William said that government ought to provide for "the union of sexes" (instead of "sects") and continued: "That union had been an object much attended to in Ireland. It was an union that it was of the greatest consequence to keep up." He finally stopped, to the increasingly louder roars of laughter, aware that he had misspoken. "The funniest thing I have heard" was William Horton's summary, although he continued with "you have never heard children laugh more,"[3] a not-too-flattering judgment of the MPs enjoying themselves at William's expense. The man who could tell a great story at the dinner table would never learn to be at ease in his father's House.

On the plus side, he worked hard to preserve from loss some fine Gothic elements in Westminster Abbey and elsewhere, and he was asked his opinion

on the purchase of antiquities for the British Museum. In addition, he was probably the Bankes who served as Chair of the House Committee debating the rebuilding of the Westminster Courts of Justice. When William addressed his passions—art, architecture, Egyptian antiquities—he was confident of his views and thus comfortable speaking, especially if the venue was a committee meeting, a gathering that did not include his father.

William spent much of the 1820s racing from one activity to another: canvassing in Cambridge, sitting in the Commons for long afternoons and into the night when Parliament was in session, journeying around England and spending time at Soughton to manage his estate and oversee renovations, and enjoying dinners and the theater in London during "the season."

And he was trying to manage—long distance—the delivery of the three parts of his obelisk: obelisk, base, and the heavy pedestal steps. Their weight limited the number of ships willing to take them on as cargo, once they were brought down the Nile to one of the port cities. When the steps finally arrived at Poole by ship, William hired men in addition to the ship's crew to off-load the pedestal. Then he needed nineteen horses to drag the granite steps from the roadway to Kingston Lacy's south lawn. If Henry watched the arrival from a window, he was certainly adding up the cost of this addition to his estate.

When William was out of Parliament from 1826–29, he had some free time—and used it to push for changes at Kingston Lacy. His efforts were mostly unsuccessful except for influencing Henry over the placement of new artwork. Henry tried to remain in control of his house and suggested that William worry only about his home in Wales. In a letter to George's wife Georgiana, Henry makes a neat distinction between *his* lawn at Kingston Lacy and William's courtyard at Soughton Hall:

> There is a walled court before his [William's] principal front, much better adapted to it [the obelisk] than my spacious lawn. But I submit to it as a disorder in the Bankes family, which sometimes passes over one generation like madness or gout or the King's evil and breaks out again in the next.[4]

Although Henry worried most about the money he knew his son would spend once the Dorset home was his, Henry is also not yet ready to release control to his heir. He gave in on the obelisk, but not without many hours of debate with his determined son—who surely made the argument that it would be very expensive to get the obelisk to Wales and then staggeringly costly to return it to Dorset once Kingston Lacy belonged to William. When William writes that he cannot imagine having the obelisk far from "the House," he means, always, Kingston Lacy, not his Wales estate.

When John Murray decided, in 1825, that William would never complete the publication of his inscriptions, Murray was more than a little unhappy with both father and son. The issue was a libel trial. James Silk Buckingham brought legal action against Henry Bankes in July 1825 for attempting to keep Murray from publishing his book *Travels in Palestine*. The story of the trial actually begins, though, in 1816, when Buckingham joined William on his first trip to Jerash (see p. 118). The story resumes in 1819 when, in Luxor, William saw an advertisement in a Calcutta newspaper announcing Buckingham's forthcoming book to be published by Murray. Furious, William wrote to his father, asking Henry to dissuade Murray from publishing, explaining that Murray would be producing a book with materials belonging to him.

Henry was successful with Murray and actually obtained the illustrations that Buckingham had sent with the manuscript. Although *Travels in Palestine* was published in 1821, with illustrations, by Longman, Buckingham still successfully sued Henry. The jury awarded the author damages of one shilling—a small success for Buckingham's pocketbook but a huge success for his image.

William wrote two other letters in 1819 in response to the advertisement, and these would lead Buckingham to sue William for libel, a case

that was not finally tried until October 1826. The first letter was sent to Buckingham in Calcutta—where it arrived one year later. The second letter, created from the draft of the first one, was given to Henry Hobhouse as William was leaving Egypt. William gave the letter to him open, with the request that he use it at his discretion to discredit Buckingham in India, but with the advice to be merciful if Buckingham had decided to end plans to publish *Travels in Palestine*.

William begins his angry letter by pointing out that he refuses to open with a courteous salutation because Buckingham does not deserve such respect. He then writes:

> It will require, however, no long preface to acquaint you with the object of this letter, since your own conscience will point it out to you from the moment that you shall recognize a hand-writing which must be familiar to you, since you have copied it, and are about to turn the transcription to account.

William then complains that including Burckhardt in a list of friends as part of the book's advertisement is "rash and ill-timed" because Burckhardt "lost no opportunity of testifying his contempt and aversion for your character," including in letters to William.

He reminds Buckingham that plans to travel to Jerash and Oomkais were already made and the guides hired before Buckingham introduced himself and asked to join the expedition. And he presented himself under false pretenses, letting William believe that he was a free agent, never revealing that he was on a paid mission and presumed to be going directly to India. William asserts in this letter that he covered the expenses of the trip, that Buckingham had agreed to take notes for William, and that Buckingham did not copy any inscriptions or complete any drawings of his own—as he brought no drawing materials and had no ability to sketch. William also notes—with an unkind emphasis on class differences—that Buckingham could not have copied inscriptions because he knew neither

Latin nor Greek. (Not a good argument, of course; William copied hiero-glyphs without being able to read them.)

The letter concludes with the demand that his sketches and notes—copied by Buckingham—be returned by placing them in the hands of Sir Evan Nepean (in India) and that the "portion of the work advertised, that treats of a journey made at my [William's] expense and compiled from my notes, be suppressed." Failure to comply will result in Buckingham's char-acter becoming as "notorious in England and in India, as it is already in Egypt and Syria."[5]

William was really angry—and long before he might have become frus-trated by his own foot-dragging to publication. He also readily shared his notes with the naval captains Irby and Mangles in travels they made together during William's second trip to Syria, notes that the two naval captains used almost verbatim in their travel memoir. William's explosion against Buckingham was primarily fueled by his special attachment to Jerash as well as by his expectation of publishing inscriptions copied throughout Syria.

But he is also angered by the thought that someone he does not respect would use his work without permission. Buckingham can produce gracious earlier letters from Burckhardt, but William knows that before his death Burckhardt wrote letters of apology to friends once he learned details of Buckingham's willingness to sponge off of others (including the company paying his way to India) and to seek opportunities to travel in Syria so that he could publish and make some much-needed money. Buckingham was no gentleman.

In January 1822 William attacked Buckingham again by writing a sev-enteen-page review of *Travels in Palestine* for the *Gentleman's Magazine* (a journal published by Murray and edited by the Tory William Gifford). Although the scathing review was anonymous, everyone knew that no one but William had the knowledge to write it. Essentially William charges that the author is not competent to write about the area as he lacks knowledge of both biblical and classical history. Specifically, he is wrong in his names of Roman towns and details of history and his map is inaccurate. He also

misused his employer, Mr. Briggs, by traveling in Syria rather than going directly to India, the latter an attack on the author's character, not the contents of the book.

Buckingham saw the review in August 1822, as it was reprinted in the *Calcutta Journal*. This only strengthened his determination to sue, although his suit was technically based on William's 1819 letter—or rather on the copy of the letter carried to India by Henry Hobhouse and shown to the Calcutta merchant John Palmer and to an officer of the Supreme Court in Bombay, Mr. Erskine. (The result was Buckingham's banishment from India.)

Although Henry's trial took place in 1825, William's day in court did not come until October 19, 1826. Not all of the delay can be explained. Buckingham was back in London by the date of Henry's trial, and both Finati and Antonio Da Costa had arrived to testify for William by the fall of 1824. Finati writes in his *Narrative* that in spite of his dislike of travel by sea, he was content to once again serve William. Antonio, arriving from Portugal ahead of Finati, traveled to Liverpool with one of Soughton Hall's grooms to bring Finati to Soughton—but not before Finati had toured Liverpool and attended a ball there, at which he attracted much attention because of his Turkish clothes.

While awaiting the trial date, Finati enjoyed his long stay in Wales, walking or riding around the area and hunting on occasion. Linant and his wife also joined the group at Soughton, leading Finati to observe that "almost the same party was assembled at the foot of the Welsh mountains, as beyond the Cataracts of the Nile."[6] Of course Finati exaggerates a bit here. Missing from the group were Salt, Beechey, and Ricci. Still the gathering was an astonishing event, surreal almost in its reenactment of happier times for William.

Finati also writes that he had hoped to see the obelisk again, but the group went directly to London from Wales, not stopping at Kingston Lacy. Probably Henry did not oppose a visit to Dorset. More likely, William thought it best not to try to accommodate this odd group of guests at Kingston Lacy. Where, exactly, would he put Antonio and Finati, men whose company he had shared

during his "free & vagrant" travels in the East? In his brothers' rooms on the second floor? In the stable block with the male servants? In the 1820s, distinctions of class and roles could not easily be ignored.

After the reassembling of this group and their time spent waiting in Wales, the trial lasted just one day. Henry Brougham—already famous for successfully defending Queen Caroline in 1820 and destined to give his name to a single-horse carriage—was Buckingham's lead barrister. He argued that Buckingham shared expenses of the trip, that the copy of the letter given to Henry Hobhouse was essentially a *published* libel, and that when two people travel together and discuss what they are seeing, their discussion becomes "common property." He also ridiculed William in a lengthy opening speech, observing that while much in the libelous letter was childish and ridiculous there was enough that would damage Buckingham, especially with the weight of William's wealth and position behind it.

In a counterattack on character, Brougham described William's considerable resources as: "a little experience—a well-known name—some ability—respectable connections—unquestionable wealth," all used spitefully to damage someone just trying to make his way in the world. This belittling of William's accomplishments is grossly unfair, but it surely made for compelling courtroom drama.

Although Finati and Da Costa had rehearsed with William, their performances in court did not help him much. Their need for an interpreter at times to understand the questions weakened their credibility when they explained what they had seen and heard: who had paid the guides (William), what Buckingham had copied (the site plan), even that Buckingham had asked Finati for ten dollars. In their journeys together, William had spoken Italian with both men, so their English was still rather limited—while their anxiety in an English courtroom was understandably quite high.

Henry was subpoenaed, but he did not appear and apparently was not held in contempt. Henry Hobhouse, the one who actually showed William's letter to at least two people in India, sought to avoid any appearance but was finally subpoenaed as well and required to give evidence. (Probably

worse than testifying at the trial was listening to John Cam Hobhouse rant at Henry's ever agreeing to do what William had asked.) Captains Irby and Mangles and Henry Beechey also appeared for William, and Charles Barry testified that Buckingham's published plan of Jerash was inaccurate and therefore fictitious.

William's lawyer made the good point that although Buckingham asserted that he had visited Jerash a second time and used that visit to make his own measurements and observations, there are no references in *Travels in Palestine* to a second visit. Thus, it is an assertion without evidence, and there is no one who was traveling in Palestine at the time who can vouch for this second visit. (Given the challenges to travel east of the Jordan River that William experienced and Buckingham's limited revenue, a second trip to Jerash is not credible.) But William wanted to win on the merits of the case: He organized; he paid; he took or dictated notes; he copied, measured, and sketched. Buckingham either did not do these things or could not do them. And William never agreed to let Buckingham use any of his materials. Therefore, any material on Jerash must have been taken from William's work and constitutes intellectual theft.

William's lawyers probably should have worked harder to discredit the man himself, to present details that led to Burckhardt's changed view of Buckingham, to emphasize that Briggs and Co., his employers for the trip to India, required the return of some of their funds because of his delay in completing the trip. However, these tactics most likely would not have affected the outcome. Before the day of the trial, the public court of opinion had already ruled in favor of Buckingham. Before either trial took place, the *Times* asserted that William was probably jealous of Buckingham's publication and concluded that the public was on the former sailor's side. After hearing evidence, the judge told the jury that the defendant had not proved the statements in his letter and thus the letter was libelous. In less than one hour the jury ruled that William must pay £400 to Buckingham.[7]

The money, though not insignificant, hurt less than the lingering pain of believing that justice was not served. On the merits William was correct.

Buckingham saw an opportunity and seized it. And all of the publicity generated by the trial surely added to book sales, as William was quite capable of understanding. However, William's letter was intemperate, and his use of the copy he made was unwise. Hobhouse's showing of the letter to the right people in India was essentially as damaging as publishing the letter in the *Calcutta Journal*. By 1826, William had also lost much of the earlier mystique of the Nubian explorer. His best defense against Buckingham would have been to publish his inscriptions before the case went to trial—to show the world that he was the scholar, not Buckingham.

Some good for William can be found in this otherwise sad business. In his 1822 review of *Travels in Palestine*, he does conclude that Jerash was the biblical Gerasa, one of the ten Roman towns at the eastern end of the Roman Empire. This was an important identification, and he was the first to make it. He was also reunited for a time with companions from his journeys, enjoying riding and hunting in Wales and reminiscing in front of the fire at Soughton Hall. And Finati pressed William to get back to work on his *Narrative*. He was able to tell the story of his trip to Nubia with Linant and Ricci and then use his arrival in London as a nice way to wrap up his tale.

Out of Parliament in 1826 and with the trial behind him, William began work in earnest on *Narrative of the Life and Adventures of Giovanni Finati*. He translated and revised, included details from his own notes, and added scholarly footnotes throughout, more than justifying his name as editor on the title page. Murray published the two-volume book, finally, in 1830. As he pushed himself to finish before resuming duties in Parliament in 1829, William began writing to Murray, suggesting two small, "pretty" volumes and requesting advertising prior to publication. He stewed over the title and the lettering on the title page—and fussed at Murray over the lack of advertising. He then requested publication in time for the sitting of the new Parliament and expressed his annoyance when publication was delayed and advertisements could not be found in even "one of the papers."[8] (And Murray thought Byron was a difficult author to handle.) The shape of the volumes, the size of type on the title page, the timing of publication: All of

these details mattered to William. They mattered because this is the same person who checked and rechecked his measurements and copied inscriptions with great care, the same person who carefully determined the most effective placement of his obelisk on the south lawn.

When William, forty-four at the end of 1830, looked back on his ten years at home after more than seven abroad, did he reflect on his own interests that had kept him busy—as well as on the demands and expectations of family? He was part of the conversation about Egyptian hieroglyphs and was lucky to have known the brilliant and kind Thomas Young. He raised his obelisk, a unique tribute to his Egyptian explorations. And he finally completed the story he shared with Finati. He had spent about half of the decade in the House of Commons, trying to be the typical Bankes and please his father. (He would win one more seat, in 1832, to sit in the first reformed Parliament. This was a success that must have given the aging Henry—now out of the House for the first time in fifty years—much joy.) Although he knew that he had not met the standard his father's career had set, William had tried to gain the approval of a man he admired. He was also pleased with his renovations to Soughton Hall and spent much time in rural Wales. Apparently he found solace there. Perhaps he had a companion in the neighborhood or a young groom to whom he became attached. He would need to find comfort somewhere to cope with the people he lost at this time.

In October 1823, William's youngest sister Maria died at 32, probably in childbirth. She was buried with her baby. Her one living daughter, Mary Frances, spent time with Frances at Kingston Lacy. If William attended the funeral, he did not linger but returned to Soughton Hall. To the Duke of Wellington he explained his absence from Dorset as his mother's request. Frances knew that William's presence would distract her from giving all of her attention to the comfort of her granddaughter. And she was already feeling a loss of strength and energy. Only a month later, Frances died quite suddenly. Not well, she had traveled with Henry to London to see a doctor. Nonetheless her health declined rapidly, and by November 22 Frances was dead at sixty-two.

The funeral took place a week later at St. Margaret's (the small church next to Westminster Abbey), with Frances's three sons leading the procession of family and friends, including the duke and many members of Parliament. Henry, still recovering from a bladder operation and in such grief that his doctors worried for his health, did not attend and was not told of the day of the funeral.

These family losses were not the only untimely deaths William had to face. On April 19, just a few months after Frances's passing, Byron died in Greece. Hobhouse and Byron's lawyer Douglas Kinnaird did not receive the news until May 1824, and then waited for his body to be returned to England. Byron's funeral was held in London on July 13, but not at Westminster Abbey, where he was refused burial. Although many of the aristocracy stayed away, or sent empty carriages as their only mark of respect, the procession of about thirty carriages heading out of London was still notable. William did not attend the funeral and was not included in the small group of friends who accompanied Byron's body to the family gravesite in Nottingham for burial. However, he probably watched as the coffin was carried from the ship at the Palace Yard steps near Westminster Palace. He then paid his respects to one of the most important people in his life during the week that Bryon lay on view in Sir Edward Knatchbull's home on Great George Street. From the Arbuthnot home, he may have watched the procession of carriages following the hearse out of London after the funeral.

Harriet watched and later wrote in her journal that even though the procession was "nothing very fine" it was still hard to imagine anyone paying respects to a man "whose writings are so profligate that they are not fit to be read, & who was good for nothing in every relation of life."[9] Her harsh comments reflect much of the thinking of the Tory aristocracy. Yet in spite of their judgment Murray made money from the publication of Byron's poetry. Harriet continues her journal entry by noting that she often spoke of Byron with William, who explained that at Trinity he was "almost the only person Lord Byron was ever much attached to; that he had implicit confidence in him & used to confide all his iniquities to him." William also

told her that Byron's "genius, his enthusiasm & even his caprices rendered him so attractive that, tho' he [William] knew him so well, he could not help liking him."[10] Some, including Sir Walter Scott, excused tales of Byron's vices as invented or exaggerated by Byron himself, a man who wanted to shock others and to be viewed as a tragic figure.

William knew better. He knew Byron's early history of sexual abuse. He knew of sexual behavior that Regency and Victorian England would condemn as among the worst of vices. William also knew Byron's charm, the fun he could be when he chose to be merry, and the sensuality that drew both men and women to him.

Byron's executors held a meeting at Murray's Albemarle Street home at which time, in spite of Thomas Moore's protests, Hobhouse spurred the group to agree to burn Byron's memoirs, a journal given to Moore when he last visited Byron in Italy. Moore watched in horror as the pages were consumed in the drawing room fireplace. Hobhouse defended his actions as a protection of Byron's image, but he was also much concerned to protect his own image as a leading Whig member of the House of Commons. He wrote much later, in his own memoirs, that William concurred with the group's decision, making the argument that Byron's friends should turn to his poetry to know the man rather than allowing all the details of his life to be published.

Sometime after the funeral, Hobhouse sent William a mourning ring with some of Byron's hair attached and another lock of Byron's hair, cut when he was dying, all left by the poet as gifts to William. In an accompanying letter, Hobhouse assures William that it is indeed Byron's hair, even though it is quite gray, much grayer than Byron was when William last saw him in 1820.[11] William participated in the group decision to commission a full-length rendering of Byron by the Danish sculptor Bertel Thorvaldsen, planned as a memorial to stand in the poet's corner at Westminster Abbey. Once again the Abbey refused. The likeness was accepted, in 1845, by Trinity College and stands in the Wren Library on that campus.

In his last letter to Byron, William had encouraged his friend to continue writing new cantos of *Don Juan*, in spite of ongoing attacks on the work. He

also laments that Byron had not worked William into any of his poems or dedicated a poem to him. He tells Byron that it would have given him pleasure to see their friendship recorded for posterity in this way.[12] He created his own small memorial to Byron, placing Hobhouse's letter, the ring, the lock of hair, and a seal of Byron's on bloodstone together in a cabinet at Kingston Lacy. In 1844, William wrote from abroad to his brother George that these items at the house should always be kept together. Subsequent Bankeses removed everything except the letter. But William never stopped loving his college friend.

The decade of the 1820s began with the death of George III and the end of the Regency Period, as the prince regent now became King George IV. Reform was coming; Tory power was waning. But William was in Parliament where Henry wanted him to be. And then, on June 6, 1833, William was taken to the Tothill Street police station, arrested along with Thomas Flowers, a private in the Coldstream Guards, and charged with meeting for "unnatural purposes." A volunteer night watchman saw two men talking and then going into a public convenience near St. Margaret's Church. He went in search of a policeman, and, when they returned to the area ten minutes later, the two men were found still in the toilet designed for only one person. They were searched at the station, with the report noting that Flowers's trousers were partly unlaced and William had a sovereign in his cloak pocket. They were required to spend the night at the station.

The next day the event was covered at length in the *Times*, and a large crowd, learning of the arrest of an MP, gathered outside the station. William and Flowers needed police protection to get to the magistrate for their hearing. After two hours of questioning—with no legal representation for either man—the magistrate decided to send the case forward for trial. Flowers returned to jail, and William was released on bail of £12,000.

Again William—and Henry who had arrived during the questioning—needed police protection from the gathered mob to get to St. James Park and Henry's waiting carriage.

The press regaled Londoners with stories of Henry's refusal to look at his son, even turning his back on William. But none of these stories was ever confirmed, and, in fact, it seems that Henry never doubted William's innocence. He was the one who suggested to William that he keep his underwear as it was that night to demonstrate his innocence. William and his family had to endure six months of painful waiting for the trial, during which time William worked with his lawyer and lined up his witnesses, including Wellington, Samuel Rogers, and Lord Burghersh. He did not attend Parliament, even though no rules restricted his attendance. He chose to avoid raucous jokes about "the union of sexes" by some and silent disdain from others.

William was defended by Sir James Scarlett, ironically one of his opponents vying for the Cambridge seat in 1822. William's explanation was that after dining with Lord Liverpool, he started back to the House for an upcoming vote when he realized a need to urinate. He stopped to speak to the soldier, initially thinking he was someone met during his travels, and then went into the public convenience. The most significant problem with this account is the fact that his own home at Old Palace Yard was only a short walk from the public toilet—why didn't he just head home before continuing on to Westminster Palace?

William's valet was called to testify that the linen was clean and that William maintained a formal relationship with the staff. His brother George testified that William had always gone for long hours without urinating and then was slow to finish, thus accounting for the length of time in the bathroom. The doctor William had consulted about his problem proclaimed that he was indeed a patient. Those convinced of William's guilt thought that the doctor had been encouraged to lie, but, given the fact that Henry had been operated on for a bladder problem, the testimony might have been the truth. Henry provided moving support by stating that he "had lived with

him as with my best friend; we were like brothers." Wellington confirmed that he had known William for twenty years and that William had spent time with him and his aides during the Peninsula War. He was certain that William was incapable of the offense for which he was accused. This testimony may have been the most significant. The duke's heterosexuality was not in doubt; if he perceived William as "manly" too—like his officers—that settled the issue.

Wellington's assertion of William's manliness was important to combat homosexual stereotypes prevalent in nineteenth-century homophobic England. William's failure to marry and his interest in art and architecture would be strikes against him, but these details could possibly have been balanced by the roughness and danger of his travels abroad. The duke tipped the scales to innocence with his testimony. Also in William's favor was an increasing solidarity among the aristocracy and landed gentry, all of whom were feeling great pressure from the expanding middle class and a restless working class in the new industries. The "mob" did not want William going free just because he was rich and well connected. But Scarlett appealed to the jury that if one can be so easily accused of crime by a mere night watchman (and a new police force still seeking its identity and authority), no gentleman is safe from slander.

After a brief conference, the jury not only acquitted William (and Flowers) but declared that in their view the defendants could "leave the court without the least stain on their characters from this trial."[13] A relieved William sent word to Wellington and received a congratulatory reply. The duke wrote on the subject to the Marquess of Salisbury: "I consider Bankes as he is described by the verdict; and if I had a party of persons . . . with whom he had been on terms of intimacy I should ask him to meet them. If Bankes is wise, however, he will not expose himself to the world for some time. He might be formally or coldly received by some; which would make a lasting impression upon him. . . . A little patience will set everything right."[14]

Of course "patience" would not "set everything right" for William. Although France had ended prosecution of sodomy in the eighteenth

century, it remained a capital offense in England until 1861 and thereafter continued to be illegal well into the twentieth century.

William returned to his duties in the House for a brief time and continued to socialize with Wellington. Then, on October 16, 1834, the Houses of Parliament burned dramatically. William's choice to serve one last time in the reform parliament resulted in our having another portrait of William. The portrait was prepared by Sir George Hayter for his composite painting of the 1832 parliament (see color plate C25).

When a new Parliament was formed in 1835, William did not seek reelection. His decision to retire was primarily a personal choice, though, for two months after the fire Henry died, freeing William from the burden of his father's expectations. Henry died December 17, just two days shy of seventy-eight years, while visiting his daughter Anne and her husband Edward at their estate in Cornwall. He was exhausted from the various problems of the last few years, including William's trial, and sought rest away from London in his visit to Anne. Throughout Henry's long career and longer life, he had remained loyal to a commitment he made as a young Member of the House of Commons—along with his close friends William Pitt and William Wilberforce—never to accept a peerage and leave the Commons. He also never lost confidence in William. In his last will, written in November 1833—after William's sodomy trial—Henry declared that his "dear son William John" was the executor of the will and his sole heir.

Anne and Edward journeyed to Kingston Lacy with the coffin. Henry's request for a private funeral was honored for the most part. It was well attended but not fancy. Mourners—in carriages, on horseback, on foot—followed the hearse from Kingston Lacy to Wimborne Minster, where Henry was buried in the family vault after a brief service.

William was now the owner of Kingston Lacy.

FINAL JOURNEYS

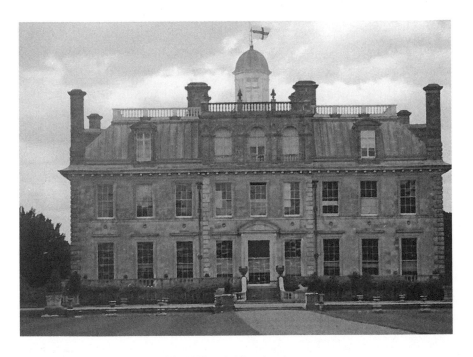

38. William's Kingston Lacy.

After his return from Egypt in 1820, William served in three parliaments: for Cambridge, for Marlborough, and, in 1833, for Dorset. But his loss in seeking a second term for Cambridge hurt him, and he knew that his record in the House of Commons did not come close to matching his father's. William saw the world give most if not all of the recognition for decoding ancient Egyptian writing to Champollion. Only Young's

circle of friends and scholarly associates recognized that both Young and William had failed to get deserved acclaim. Further, William had suffered the humiliation of two trials, leading to public attention of the wrong kind. He had been unfairly treated by the outcome of the Buckingham mess—but he knew that he was fortunate to survive the public exposure of his actual sexual orientation. He must have felt that Henry Salt's 1825 publication displaying the Abydos King List that he had discovered was only a small consolation, though it clearly mattered to him, as his dedication reveals.

As if these challenges and disappointments had not been enough for one person to bear, William also lost his college friend Byron and three family members—his youngest sister, his mother, and, most recently, his father. Probably the most painful for him were the death of Byron at such an early age and the sudden death of his mother. Although he surely mourned the loss of his father, he could be comforted by Henry's long life and notable career.

Added to these losses was the early death, in 1827, of Henry Salt, followed in 1829 by the death of Thomas Young. Young had several jobs and many interests that kept him busy after Champollion's work on hieroglyphs stole the show in that arena, but he might have been a sounding board for William if William could have found a secretary and started to work on his inscriptions and a study of Egyptian architecture. Salt might have been happy to serve William as secretary after ending his stint as consul in Cairo and returning to London. He was not wealthy; he would have needed employment. Salt might have been the one who could have helped William to "get his work done." What would William do now?

For the next six years, William devoted much of his time to extensive changes to *his* new home.[1] To give special emphasis to his remaking of Kingston Hall and to honor the history of the Dorset estate, he renamed it Kingston Lacy. William's renaming recognizes the de Lacys, the Earls of Lincoln, who, in the thirteenth and fourteenth centuries, were tenants on what was then a royal estate. Kingston Hall in the fourteenth century was a large estate with rich farm land, but by the fifteenth century the manor

house was left to deteriorate, its stone taken for the building of Wimborne Minster, the Bankes's family church. Sir John Bankes, a barrister and Member of Parliament, bought the estate, part of Corfe Castle lands, in 1635, the first Bankes to own what would become, with his son Sir Ralph, Kingston Hall.

As work on William's home progressed, he complained—with only mock anguish—that he was again "a prisoner to my workmen." This was actually what William wanted. Once he knew that he would not travel again to Africa, he had waited, not altogether patiently, for this opportunity. He loved the remodeling, supervising the storage of furniture and artwork in the attic and at Old Palace Yard. He loved watching the Italian artisans brought in to create his villa in Dorset County. And he escaped the noise and dust from time to time with stays at Old Palace Yard and activities in town.

William continued to participate in the social world of the Duke of Wellington, dining at Wellington's beautiful London home Apsley House. (So famous was Wellington that his address was No. 1, London.) Harriet Arbuthnot filled in as hostess when Wellington's wife was in the country and after her death in 1832, a situation that may have added to the gossip that the two were lovers. More likely, Charles Arbuthnot, Harriet (twenty-six years younger than her husband), and the duke were a close threesome, and the Arbuthnot home was one place where Wellington could relax and be himself. Harriet also served as a buffer to the many women who threw themselves at Wellington—he actually received letters from unknown women asking to be his mistress. And if others were surprised that Wellington did not give Charles a position in the cabinet during his tenure as prime minister (1828–30), it did not ultimately destroy their closeness. William was fortunate to enjoy Harriet's friendship, for she continued to include him in this fascinating, powerful circle.

All three men suffered a great loss when Harriet died suddenly of cholera in the summer of 1834. A messenger was immediately dispatched to the duke, who was tracked down at dinner elsewhere and collapsed on a sofa when informed. All were devastated; William had another painful funeral

to attend. The disconsolate Charles, who had been devoted to Harriet, eventually moved into Apsley House with Wellington, and there he died in 1850 at eighty-three. The duke survived his good friend by just two years, dying also at eighty-three in 1852. William offered a bridge in age to these important figures—older than Harriet but younger than Wellington and always deferential to him and his position.

William wrote to Wellington in the fall of 1840 to give notice that his remodeling of Kingston Lacy was nearly complete and that in the new year he would be happy to show his friend what had been done: "The house is not yet in a state fit for reception, but the few of those who knew it before who have looked it over seem to admire it extremely and to think that it will combine much comfort with a sufficiency of splendour."[2] William hired Charles Barry in 1835, and, during the next six years, together they made enormous changes. And it was a partnership; William listened to Barry's suggestions but had also given much thought to the changes he wanted. He even composed a list of reasons for the remodeling, not to reassure himself that the process was worth the time and expense but to have his reasons at hand to justify changes to his brother, the cautious, frugal George. The list included the following points:

- The only way to the bedroom in dirty boots is through the saloon (Henry's ballroom).
- The saloon's ceiling height makes all other rooms look insignificant.
- The dining room is not large enough for entertaining and access for both company and servants is the same.
- There is only one watercloset and it's in a conspicuous location.
- There is no entrance hall with room for coats, just an immediate flight of stairs. And the view from the principal stairs is unattractive.
- The entrance is on the short side of the house, surely not intended by the original architect.
- More bedrooms are needed, as well as a place to hang two large oils by Frans Snyders (acquired by William in 1827).

William had two goals: more comfort (more light and airy design with better movement through the house) and a home appropriate for displaying his art collection and entertaining the cream of society.

Barry, now one of the most famous architects in London, designer of the Traveller's Club (of which William was a member) and soon to be selected to rebuild the Houses of Parliament, provided a basic design that let William achieve these goals. Early in the process, the red brick of the original Pratt House was faced with Caen stone. Barry provided William's grand new entrance on the north side by lowering the ground on that side eight feet and dropping the cellar floor by four feet to provide greater height for the entrance hall.

William took much of the credit for the magnificent, 30-foot-wide staircase of white Carrara marble, which swept from the lower-level entrance hall to an airy, half-landing loggia (that provides access to the garden) and then on up four flights to the attic level. (William gave Barry the credit for the loggia.) Italian craftsmen were brought in to install the staircase and do much of the inlaid marble work throughout the house—but not before such major changes to the core structure of the house resulted in William's struggling up and down wooden planks where the stairs would eventually be placed. He continued to use his second-floor bedroom until most of the new entrance was in and the first-floor remodeling was finished.

Barry enlarged the new dining room in the southwest corner of the main floor (formerly Henry and Frances's bedroom) by significantly shrinking the backstairs. Both the dining room and drawing room ceilings were created by Barry from designs in other country homes that William had seen and admired. William's bedroom was now in the northeast corner. It retained the small stairs installed in the bathroom/dressing area up to his former bedroom on the second floor. The library remained in the southeast corner, and Henry's dining room became the Spanish Room, William's dramatic showcase for his Spanish art collection (see color plate C26).

William's plan for hanging his Spanish art (see p. 73) was originally designed for Henry's dining room. But in his now much larger dining room,

William chose to hang the two huge Snyders—rather gruesome pictures of hounds and wolves attacking their prey. (After a fire in the twentieth century, the dining room was paneled. Now the Snyders, their canvases bent back at the top to fit, hang at the top of the marble staircase. One can be seen on color plate C29. The Spanish art would still hang together, now in a room ornately decorated to create a perfect setting for this special collection. The room includes both those pieces purchased when William traveled in Spain and subsequent purchases in London. The concept was unique. Not only would he show off his large Spanish collection—unusual in itself for the time—he would bring the pieces together in one place. And they would be displayed in style.

Plan of the main floor, 1791.

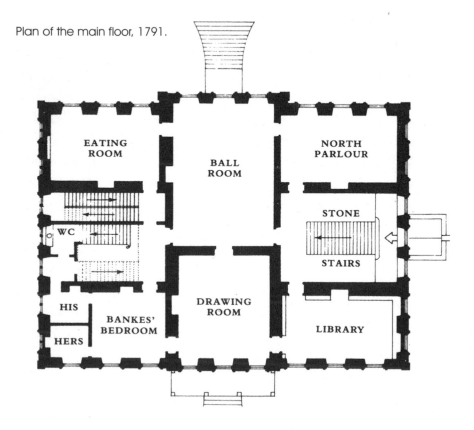

William purchased the Spanish Room's ornate gilt and coffered ceiling in London and had it adapted to fit during 1839–40. He was told that the ceiling and its paintings were original to the Palazzo Contarini Corfù in Venice, but in fact the paintings are copies of those in the Ca' Pisani in Venice. William designed the elongated ovals above the paintings to contain labels for each painting. The tooled and painted leather covering the walls was found in another Venetian palazzo in 1849. Because not enough could be purchased to cover all the wall space, in 1852 William commissioned Antonio Caldero to prepare additional leather pieces to match the skins that he had already restored for William. All were shipped to Kingston Lacy

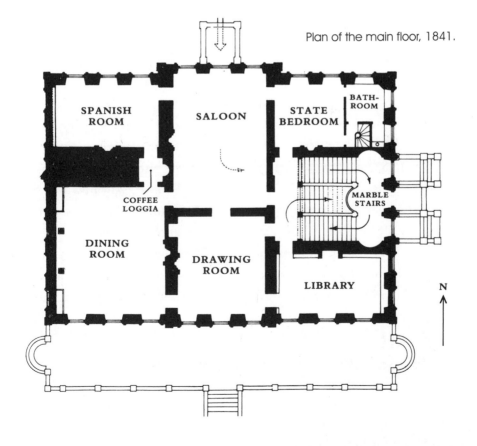

Plan of the main floor, 1841.

39. Floor plans show changes made to Kingston Lacy by William.

and placed on the walls in 1853. The additional decorative metalwork was not added until 1854 (see color plate C26).

William hired a Venetian artist to prepare twelve pear wood panels for the inside of each of the three doors to the room—four for each door—representing the twelve months, all designed by him: "They constitute, I believe, my best and certainly my largest work in drawing," William wrote to his sister Anne.[3] The wood panels were completed and sent to Kingston Lacy in 1851 (see color plate C27). The two panels on either side of the fireplace, not prepared until 1855, are carved from marble probably obtained in a quarry near Florence and mounted on black marble from Belgium. William kept Henry's Axminster carpet, purchased in 1820, because the flower design on the red background harmonized so well with the rest of his opulent design for the room.

The paintings themselves remain a remarkable collection in spite of the fact that not all have retained what William believed to be their attribution. In some cases, a painting is now designated as from the artist's studio or "after the artist" or "attributed to" but no longer assuredly by the artist. The painting *Cardinal Gaspar de Borja y Velasco*, for example, was sold to William in Spain as an original Velázquez, but art historians are no longer prepared to say that William has the original. And we know now that his *Las Meninas* is not a preparatory sketch by Velázquez but a copy of the original made long before this painting was well known and widely admired as it is today. Although it does not hang over the fireplace as William had intended in his original sketch of the Spanish Room, it is still an important part of this amazing collection. His *Cardinal Camillo Massimi*, purchased by William in 1820 in Bologna, is definitely a Velázquez and now considered the most significant of his Spanish paintings.

During the period of remodeling, William spent some time in Paris and saw, in 1837, an equestrian statue of Philibert Emmanuel of Savoy exhibited at the Louvre. By Italian Carlo Marochetti, the work made a great impression not only on William but on all the French who came to see it. His enthusiasm for Marochetti's skills bubbles forth in a letter to Wellington's

niece, Lady Burghersh. His particular goal in writing to her, however, is to influence the Glasgow Committee's selection of Marochetti as the sculptor to prepare an equestrian statue of the Duke of Wellington for the city of Glasgow. He assures Lady Burghersh that the sculptor would be pleased to be awarded this commission even though he has also been given a commission in France to execute a monument to Napoleon.

William writes that he likes the idea of the same artist sculpting a statue "of the greatest living hero of our age" as well as "the tomb of the greatest dead one." And "posterity would grieve" if it learns that Glasgow missed an opportunity to employ "the first of living sculptors" to prepare the duke's likeness. William expresses concern over the rumor that Wellington will refuse to sit for anyone other than the British Mr. Campbell and begs Lady Burghersh to encourage the duke not to refuse to sit for Marochetti should he be selected.[4]

A few days later William wrote to Wellington in answer to a letter from him indicating that he will let the committee consider all candidates equally and that he will abide by their selection. William assures Wellington that he is satisfied to learn that the duke will sit for whichever artist is selected. The committee did select Marochetti, in part because of William's efforts not to discount the excellent Italian in favor of a British artist, but primarily because Campbell, the other leading candidate, died during their deliberations. The statue was completed in 1844.

William probably first met Marochetti in Paris in 1837 and then saw him again when he was in London a few years later. From this time William conceived the idea of life-sized statues of his ancestors sculpted by Marochetti, whose dramatic work spoke to his romantic love of the complex and richly detailed. Discussions ensued, but final decisions were not worked out until 1853—and then not easily, as was often the case with William. He sent sketches to the sculptor, who told William he admired the sketches but finally asked to be able to work in his own style, not in imitation of another's. William did insist that the small keys in Dame Mary's hand shown in Marochetti's sketch be much enlarged to represent the key

to the huge castle door. William understood that small keys in the hand of a woman would always denote a housekeeper. Debate also occurred over price, but finally a contract was agreed to for £2,500. Their agreement also required that Marochetti build a replica in his London studio (where he was now settled and doing work for Queen Victoria, among others) of the half-landing loggia at Kingston Lacy where the three bronze statues would be placed. The bronze frieze on the wall below Charles I showing the burning of Corfe Castle was included in the contract.

Marochetti sent a photograph of the frieze to William in Venice in 1855, which pleased him immensely. He wrote to his sister Anne: "Never, no never was, in my opinion anything so admirably rendered combining as it does delicacy and sharpness and finish with the utmost freedom and spirit. . . . I am *charmed* with it." With the self-awareness of age and reflection, he requests Anne to convey his pleasure directly to the sculptor—just in case he should think that William could not be satisfied. He concludes that if the statues are executed with the same high standard as the frieze, then no private home in England will have such a magnificent family monument (see color plate C28).[5]

The new ceilings are finished, the Spanish paintings have been brought out of storage and framed in gold, the walls are painted, the carpets re-laid, a new dining room table placed in the now larger space: In the spring of 1841 William begins making plans for his first entertainment in the new Kingston Lacy. It will be a grand ball as his parents had held—a ball for "all the women of fashion in London," as Hobhouse chose to ridicule in his memoirs.[6]

Hobhouse's carping notwithstanding, William was asked, in June 1841, to give his advice to the Select Committee on Fine Arts for the new Houses of Parliament. His art purchases in London, his work on Kingston Lacy, and his connection to Charles Barry resulted in recognition of his expertise. He actually recommended a German painter to plan and supervise the decorating, arguing that true patriotism is found in a commitment to artistic perfection, a recommendation that did not please everyone but was consistent with William's citizen-of-the-world outlook with regard to art.

And then disaster struck. On August 29, 1841, William became an outlaw. He was arrested a second time—for indecent exposure, the intent to commit sodomy, even assault. The arresting policeman's story is that he saw William and a guardsman walking on Constitution Hill and then entering Green Park around 12:30 a.m. When the constable arrived, the soldier sprinted away, but William was caught, with his underwear unbuttoned. It is hard to say exactly what the officer saw in the dark that resulted in charges of assault—the guardsman was fit enough to escape arrest and never reappeared to show the effects of any presumed blows. The assault charge was most likely gratuitous, unnecessary on top of the ruinous charge of indecent exposure. Oddly, given what was removed from William's papers, the family chose to keep the written indictment, with all its graphic details describing a person of "a wicked lewd filthy and unnatural mind and disposition."[7]

William's behavior upon arrest may seem to have added to the problem, but there really was no way to add difficulties to a second arrest for "unnatural behavior." He did what he thought might get him out of the hangman's noose. First, he tried to bribe the policeman; then he entered an alias at the station, declaring that he was John Harris, a servant. Then he admitted to being a gentleman (his clothes and purse had already announced this) and suggested that he be given bail in the name of John Harris in exchange for the promise of retiring permanently to his country home. All suggestions were rejected. He was given bail and required to appear in court on September 20.

Even in shock, William knew that he must act quickly. He immediately saw his solicitor J. S. Gregory. Solicitors rarely handled criminal cases, so not surprisingly Gregory was not well versed in the legal issues and possibilities relevant to William's "crime." He advised leaving England at once. Both knew that if the Crown chose to respond to a failure to appear for his court date it could declare him an outlaw, which would result in the forfeiture of

his entire estate. Although there was certainly a chance that the court would do nothing—just let the matter drop if William failed to appear—the possibility of forfeiture seemed too great to risk. Gregory probably should have taken the time to research the extent of the declarations of outlawry in the 1830s, as there was increasingly less use of this strategy by that time. On the other hand, everyone felt the pressure of only 20 days in which to act.

There also seemed to be no hope of beating this second charge. Who would take the stand as a character witness this time? Even though it would be William's word against the policeman's as to exactly what had transpired, concocting a believable story—in light of attempted bribery and entering a false name—would have been a challenge even for William. The added charge of assault would also be used against him, making William appear twice the villain for forcing himself on an unwilling young guardsman.

William also sought advice from his good friend Edward, Earl of Falmouth, Anne's husband, and he always felt that Falmouth was the most helpful and supportive during the crisis. First, Edward recommended that William put his estate in the hands of several trustees, not just one. William selected his brothers George and Edward and Falmouth's son Lord Boscawen. The earl also suggested that William seek to keep as much control of the estate as possible—in part by establishing with the trustees that he retained the possibility of returning to England and of marrying and fathering an heir. All of the family, but Falmouth in particular, made an effort to keep Anne from reading graphic newspaper accounts of the affair. It also fell to the earl to ward off callers, handle letters, and discuss legal issues with Gregory. He spent much of September in correspondence with Gregory and helping William at Old Palace Yard. The document assigning all of William's estate to his three trustees, drawn up by Gregory, was dated September 13.

A letter from Falmouth to Gregory on September 14 refers to someone who is presenting himself as a contact with "a friend" and who will then meet Falmouth on Thursday at 2:00 in St. James Square, a date Falmouth considers to be a "fixed appointment." A letter to Falmouth written September

25 requests an interview at the lord's earliest convenience to "settle the matter." The writer asserts that if it is left to him, he would "avenge it, to the greatest and utmost satisfaction of our law." And on September 30, William writes to his brother-in-law that since they have agreed that there will not be a trial under any circumstances they should get rid "of him at once." On October 2, Gregory writes in answer to William that in his opinion they should have nothing to do with the "foreigner" who has written to Falmouth about solving the problem.[8]

This correspondence is indeed strange. Apparently someone knows someone involved—either the guardsman or somebody else connected to the incident—and this connection should be pursued by William and his supporters. Meetings in parks and various pubs suggest either a surreptitious search for a witness on William's behalf or—more likely from the almost coded language of these letters and the meetings in public places—an attempt at blackmail of some sort. Will this person be able to produce the guardsman with a story that will set William free—for a price?

Meanwhile Gregory has also tried to get some understanding of the government's position. On October 5 he writes again to William, this time to say that he "is grieved and surprised at the course taken or rather threatened by the Home Office." He adds that it "either shows a subsurvency to an official whose masters they ought to be" or a desire to respond to "public clamor for the sake of gaining a title to a little short lived popularity among the lower grade of society by affecting to deal an equal justice to the great and the little."[9] With this sense of the government's commitment to prosecution, Gregory accepts William's decision that no trial should take place.

Was William caught in a sting? And if he was set up, why? After the Vere Street pub raid forty years before, gays in London found other meeting places, but they had to be extremely careful. Rewards were available for aiding in the capture of homosexuals—"mollies," as they were called. There was also the threat of blackmail, as the former Foreign Secretary Castlereagh learned. If William was set up by gay-haters, then they were partly successful. If he was entrapped by would-be blackmailers, then their scam failed

because of the Home Office's determination to prosecute, a determination that sent William to France rather than pay for a solution.

In spite of the risks, the two parks—St. James and Green—both near the barracks and close to Old Palace Yard, were known to be frequented by mollies. And part of the appeal of secret sex, for both gays and straights, is the frisson created by the flirting with discovery. William the daredevil understood this. It would, however, defy all odds that during the only two times in his life in London that William chose to seek casual sex he was caught. The first time, when he was found in the public convenience near St. Margaret's Church—and near his own home at Old Palace Yard—he most likely ran into the soldier unexpectedly on his way back to Parliament. Still they had probably met before. This second time in Green Park seems likely to have been planned; either the two men had been together previously or a third person had arranged this initial meeting.

William's panicked response suggests that he had felt reasonably safe with this encounter—late at night, in the dark, under some trees in the park, with a willing partner. After all, when he entered the Temple of Solomon in Jerusalem in 1818, he was disguised as a soldier and faked a toothache; he did not just stroll into a "death if discovered" situation without controlling the risk to some degree.

William was willing to take risks, but he was not stupid. It is a sad commentary on his times that his need for sex—or sex with risk—was such that he failed to pay attention to movement around him in the park or that he allowed himself to walk into a trap. Perhaps Vivian Bankes is correct about her ancestor when she writes: "William John Bankes loved danger as some men love one woman: in spite of reason, warning and experience."[10]

John Cam Hobhouse would not have called it sad; he described the event in his memoirs as monstrous folly. But then Hobhouse, jealous of William since Cambridge days, wanting Byron all to himself, was happy to be given any opportunity to ridicule William. Hobhouse also wrote that he could not agree to be a witness at William's 1833 trial because he could not have said anything helpful. What Hobhouse should have written, had he

wanted to be honest in those memoirs, was that he feared taking the stand because he would not want to be examined by the prosecution about his knowledge of William's sexual preferences—and how he knew about them.

Hobhouse had carefully guarded his public image for many years, although he did not marry until in his forties. He had three daughters, held office until 1852, was awarded the title 1st Baron Broughton, and died in 1869, outliving everyone from his Trinity set. He certainly did not call on William after reading of his arrest in 1841. Did Charles Barry drop by? Did Wellington send a note? The answer to both questions apparently was no.

After arranging the transfer of his estate to his new trustees—while seeking to keep as much control of funds as possible—William did some packing at Old Palace Yard and then left his home in London for Kingston Lacy. Falmouth may have accompanied William to Kingston Lacy to continue discussion of details while William faced the miserable task of further packing—and bidding farewell to family, servants, and his beloved home.

In the few days he had in Dorset, he tried to find Byron's key to one of the poet's early collections, *Hours of Idleness*, for Tom Moore. Moore had either written or called at Old Palace Yard, asking for whatever William had that would help him write the first biography of their friend Byron. Too distracted to think clearly, William could not find the written guide Byron had shared with him, but it was in the house and remained safe there for future Byron scholars.

By September 18, William had traveled by carriage to Southampton. He wrote to Gregory from there, asking him to direct future letters to him through his servant William Prince, poste restante. William wrote to Gregory again on the 24th, this time from Le Havre. Both letters continue to explore the issue of power of attorney and the transfer of stock. William was able to arrange for regular drafts from his London banker. Another letter from Le Havre on the 25th admonishes Gregory not to meet him in France. If anyone should come it should be his servant Cooper with the remainder of his clothes and a cart, for he will be heading to Rouen. Cooper can then return to England. Presumably Prince continued to travel with

William, while Gregory continued to do his best to handle William's legal affairs and provide support.[11]

And William is on the move. He traveled from Le Havre to Honfleur, that lovely fishing village not yet made famous by the arrival of Impressionists choosing to paint *en plein air*. He stayed in Honfleur for a few days, perhaps still hoping that he would hear something from Gregory or Lord Falmouth that would allow him to return home. Sadly, no encouraging words came, and, as they all felt some concern that the British government might request extradition from the French, William continued to move around France. Almost all letters to William from this time were sent poste restante or to a hotel.

Still insisting on control of his homes, William then faced the painful task of deciding which of the staff at both Old Palace Yard and Kingston Lacy to let go. Initially, as he sought to cope with his situation while keeping as many details from the staff as possible, William let his London staff believe that he was at Kingston Lacy while letting the Dorset staff think he was in town. But soon most of the Old Palace Yard staff were given the bad news, an action that really hurt because he cared about those who had served him well—and because the firings forced him to accept that no one would be living in either home on a regular basis.

While William remained in the north of France, the Earl of Falmouth continued to use his influence on his brother-in-law's behalf. He wrote to Gregory that "there does appear to be an undercurrent of persecution which may frustrate all our efforts" to send the problem into "the depths of oblivion." But he hoped that the source he was working would be able to check "such cruel immoral and impolitic proceedings." By the end of September, however, he had given up hope of effecting any change, telling Gregory that he had failed to "counteract the zeal of mischief of hostile partisans in the Home Office."[12] Gregory was shocked to learn that if William returned he would face trial and, if found guilty, the full force of punishment in homophobic England. However, once the government realized that William had flown and that his estate had been turned over to others, they did nothing more with the case.

Through the fall and winter of his first year in exile, William traveled extensively in France, spending the winter in the south. He visited the Roman arena in Arles and examined the two Corinthian columns remaining from the Roman theater. He compared Arles's arena with the larger, oval-shaped one in nearby Nîmes, marveled there at the superb condition of the city's fourth-century Roman temple (called the Maison Carée today), and studied the remains of the Temple of Diana (probably a library, not a temple), an excellent example of Roman stonework.

He rode to the Pont du Gard to gaze at Nîmes's water source, a 30-mile-long Roman aqueduct. Still exploring in Provence, he rode to Avignon to see the Papal Palace, the large Gothic home of popes in the fourteenth century, and then on to the windswept rocky spar of Les Baux to explore its ruined castle and ramparts. Everywhere he stopped to admire Romanesque churches and medieval villages perched above the Mediterranean as he made his way to the sunny squares of fishing villages and the narrow streets of Toulouse.

As usual when he traveled, William kept a notebook of sketches with comments on visited sites. Just as typically, he did not keep a diary of his thoughts or write a memoir, as Byron did. If he had been more the writer than student of art and architecture, what would he have written? His travel in France from the fall of 1841 through the summer of 1842 was, in fact, a journey without end. In spite of his not rushing home from his first long exploration of the lands of the Mediterranean, he knew—all along—that he would eventually return to England. This time there is no home he can return to. William now knew how Byron felt—knew as Hobhouse or Moore or Byron's publisher John Murray would never grasp—the mix of anger and despair, the constant struggle to enjoy new places and make new friends without letting loneliness overtake the spirit and spiral into depression. Would his heart crack?

LAST—AND LASTING— GIFTS TO THE FUTURE

40. Venice's Grand Canal approaching St. Mark's Square. The Palazzo Giustiniani (later the Europa Hotel) is on the left.

Wiliam's fluency in Italian and his love of Italian art and architecture led him to select Italy, not France, as his adopted country, and to make his base in Venice, the beautiful, decaying city on water that had been Byron's refuge as well. But actually all of Italy was his new home; he repeatedly traveled around the country from 1843 to 1851, spending time in Florence and Rome as well as in the northern cities of Padua, Verona, and Milan. Although in 1851 he chose to see something of Germany and Austria, visiting Cologne Cathedral and Heidelberg University, and enjoying the music and coffeehouses of Vienna, he was back in Venice before the onset of winter.

Venice, home to Giorgione, Titian, and Veronese, to Vivaldi and opera and a yearly masked party. An improbable city, built on water, a shipbuilding, commercial, and political success from the eighth century until Napoleon conquered it early in the nineteenth century. When William returned to Venice in 1842, the city's Gothic palazzos were about to twinkle in gaslight. Could its new gaslights, installed by 1843, and the new hotels disguise the city's cold and damp—and decay? For William, Venice was less cold and damp most of the time than his home country. For many romantics the answer remains a resounding yes.

William loved Florence, too, the city of Dante and Machiavelli. Michelangelo grew up here; Leonardo lived here, and Brunelleschi centered the harmonious city with his exquisite Duomo dome. This city's sturdy medieval buildings sheltered the Medicis and supported the nascent Renaissance. Perhaps a lonely, sometimes grieving William found solace gazing at the city's magnificent *David*.

William often rented an apartment in Venice, probably furnished as there is no discussion in letters to George or Anne of major purchases for a home there. If he rented the *piano nobile* (the second, main floor) of a palazzo, his suite of rooms was never as magnificent as Byron's and most likely not on the Grand Canal. He assured his brother George that he lived simply, even frugally, in Venice, perhaps with one manservant and an

arrangement for cleaning and cooking as part of his rent. He may well have vacated a current apartment when launching a long trip and then returned to Venice to rent other rooms, settling first in a hotel and then choosing a new home from what was available.

Splendid hotels were increasingly available in major cities. When the English traveled to France and Italy in the eighteenth century, they stayed in coaching inns, *pensione*, or the homes of friends or the British consul, depending on their connections. And they were all men, many preferring the inn—and the chance to meet the innkeeper's dark-eyed daughter. But with the end of the Napoleonic Wars, more wives began traveling abroad with their husbands, as William's sister Maria did in 1820. Fashionable hotels in safe parts of cities sprang up to serve the new tourists. William took advantage of this change, staying, for example, at the Hotel Due Torri when he traveled to Verona, just as tourists do today. When the Austrian siege of Venice (1848–49) was at its height and food became scarce, William did not flee, but he wisely moved into the Hotel Europa for greater comfort and safety.

The Hotel Europa (or L'Europe) opened for business in 1819 in what was originally the Palazzo Giustiniani. A Gothic-styled building—that William loved—it is not far from St. Mark's Square and looks across the Grand Canal to the Church of Santa Maria della Salute. The British artist J. M. William Turner stayed here as well and completed some lovely water-colors of La Salute and St. Mark's Basin. Later, early in the twentieth century, Monet would be a guest at the same enchanting hotel. William probably also sketched one of the most beautiful views in Venice.

By choosing to live simply in Venice, William was also choosing not to seek admittance into Venetian society. The oldest families who still had the money to live in their grand palazzos rarely opened their doors to British visitors. And in spite of the city's reputation for tolerance, it did not embrace Byron and probably would not have sought to include William. The choice, though, seems to have been William's. He had had enough of "society" and its demands. William also avoided other British visitors. In a letter to Anne

from Padua in 1844, he explains that he has fled Venice because the city is hosting a large conference. But before leaving, he attended a production in Vicenza of Sophocles's *Oedipus the King*, turned into an opera in Italian by Pacini and performed in a re-creation of an ancient theater built by the famous sixteenth-century architect Andrea Palladio. The acting was not great, but it was still a wonderful event, William concludes.[1] Trips to Padua, Verona, even Milan, were now easy journeys by train. When first taking advantage of this new convenience in Italy, William may have ruefully recalled the celebratory train ride in England with the Duke of Wellington and his friends the Arbuthnots.

Even though he did not seek out the British, William must have run into the Ruskins. John Ruskin and his wife Effie stayed at the Danieli Hotel (just on the other side of St. Mark's Square from the Europa) for many of the years that William moved in and out of Venice. To prepare to write his *Stones of Venice*, Ruskin spent countless hours climbing on scaffolds to study and sketch details of the art and architecture in palazzi and churches. Even though neither man ever mentions the other, it is hard to believe that two people with the same interest in the close study of art and architecture would not have bumped into each other in one church or another.

William probably also knew the scholar and sometime art dealer Rawdon Brown, a friend of John Murray's. Brown might have been useful in ferreting out artwork for sale, although William's knowledge of Italian art and his pleasure in making his own searches could have kept him from needing Brown's help. Nonetheless, the two shared a common interest that presumably would have brought them together in a small city with relatively few British residents. (There were plenty of British tourists each year but still only a handful of British expats.)

Brown knew the Ruskins and spent some time looking at art with Effie, John's young, pretty wife. Effie had to amuse herself most days while John studied Venice's art and architecture. At least once Brown accompanied Effie to the grand apartment in Palazzo Soranzo belonging to the British art collector Edward Cheney. Cheney, visiting Venice yearly during the 1840s

and '50s, put together an extensive collection of paintings and sculpture, including works by Venetian painter Giovanni Tiepolo. Surely William knew Cheney, meeting him through Brown or on his own as they both searched for art to purchase.

William must also have known Alexander Malcolm, a British businessman and vice consul in Venice. William would have needed passports for travel, and it was Malcolm who reported his death and helped sort out his effects for William's brother George. Good evidence that Malcolm knew William can be found in a letter to George after William's death. Malcolm writes in frustration several months after the event that he cannot possibly supervise all of William's unfinished works. A commissioned but still unfinished bedstead should be canceled, Malcolm advises, because he is sure that William knew it was a "mistake in design and taste."[2]

This is a short—and not even a certain—list of possible British associates. But William's fluency in Italian would have allowed him not only to converse with the craftsmen he would commission but also to initiate conversations with locals as they sat at nearby tables in Florian's, enjoying a morning coffee. The Italians would all be at Florian's, not at Quadri's across St. Mark's Square, for Quadri's was the café frequented by the Austrian military in control of Venice before—and after—the failed revolution of 1848–49. (The Austrians kept a close watch over the Venetian population—reading mail and employing spies—but apparently never harassed William.) William was also happy to converse with impoverished Russian counts and exiled French dukes, anyone with interesting stories to tell. Surely he made some friends over the years, but they do not get mentioned in letters home to George or Anne. On the other hand, William gave George directions to keep all of his letters referring to purchases for Kingston Lacy so that provenance records would be available to future Bankes owners. It may be that letters mostly about dinners or excursions with friends were not kept.

William's initial travels through France and his journey to Venice were, apparently, solitary. If he found companionship in the south of France, presumably it was not lasting. When he first settled in Venice in 1842,

his heart was still hurting from the sudden, unexpected death of Edward, Earl of Falmouth, at the end of December in 1841. How it must have stung not to be able to return for his best friend's funeral and to comfort his now widowed sister Anne. How bleak the future felt as he could no longer console himself with the prospect of visits with Edward and Anne in France or Italy. At 55 now, he might have given up—and been forgiven for the despair brought about by his cruel punishment of banishment. Instead, William continued to manage the family estate (he sent weekly instructions to the house steward Robeson until Robeson died in 1843), and he found consolation in art. He pursued what he most enjoyed: travel—sketchbook in hand—to study, learn, and purchase art for Kingston Lacy. As a result, one of William's gifts to the future was an estate that is, throughout, a work of art.

William did not start buying immediately. First, he walked every inch of Venice, studying and sketching details—a wrought-iron gate, ceiling moldings, even door handles. Comfortably dressed in a collarless shirt and loose jacket, pockets stuffed with sketching paper and pencils, he explored all of the art in the city of Titian and Tintoretto and Giorgione, paying particular attention to the palazzos' exquisite ceilings and to what might be for sale.

In a wide-brimmed hat protecting his eyes and his thinning gray hair, he walked all of Florence too, examining the shift from medieval to Renaissance design in its buildings, studying and sketching the decorative work of Florence's famous sculptor Donatello. He visited Rome again, unmatched in its presentation of art history—from ancient to medieval to Renaissance to baroque. Though growing—and providing more accommodations for the endless flow of tourists—Rome in the mid-nineteenth century was still a small city, its gardens and orchards, large villas and farms visible to the north in the undeveloped Via Veneto area.

Then the floodgates opened. William started purchasing and commissioning works by the hundreds. From Verona in the spring of 1846 William wrote to Anne about items he had commissioned. He declared that the chisel did not move without his direction. Viola Bankes, in her family history *A Dorset Heritage*, writes that George was distraught over his brother's "unbounded expenditure" and tried to curb it. However, he "might as easily have dammed the First Cataract, from beyond the mighty waters of which, a quarter of a century ago, William John had brought home his obelisk."[3]

He bombarded first George and then the new steward Osborne with demands, appreciative of Osborne's commitment but sometimes unhappy with his measurements. William needed clear and accurate drawings of rooms and stairways and doors in order to commission such works as the twelve door panels for the Spanish Room (see color plate C26). Just the upper staircase area alone shows how busy William was filling Kingston Lacy with art (see color plate C29). The copy of a Roman candelabrum in marble on the way up the stairs was carved in Verona in 1848; the two on the upper balustrade were carved around 1854 from a sketch of William's. Under the Snyders painting is a relief of dancing putti carved by Pietro Lorandini in a two-toned piece of marble that is naturally white on the surface and red-orange underneath.

William directed the carving based on works by Italian Renaissance artists Luca Della Robbia and Donatello. The reclining bronze figures, resting on a special green marble, are smaller versions of Michelangelo's *Times of Day* found in the Medici Chapel in Florence. William purchased the special marble, commissioned the sculpture, and commissioned the preparation of the marble plinths to place the bronze figures to dramatic effect at the top of the stairs.[4] It is almost impossible to estimate the final cost of the artwork in just this one area of the house.

In one long letter home, William announced that he was sending sixteen boxes of materials for Kingston Lacy. He described every item in detail—where each is to be placed, how each should be erected, and how each should be cared for. He gave each box a letter label, starting with A, and then listed the boxes' contents according to his lettering system. William is

no casual tourist, occasionally sending home a knickknack or two. Relying on his famous memory, he can picture every corner of Kingston Lacy, even his new half-loggia and grand staircase.

Eventually William hired a craftsman from London, Seymour, to provide measurements and put pieces together or mount as directed, once the works arrived, by ship, often many months after leaving Venice. More than once, Seymour had to write that the pieces did not fit and was then sent on a search to find what he needed to make it right. "It is for you to understand what an error the men has [*sic*] made in Italy in back jointing the consoles,"[5] he wrote anxiously to William.

George surely thought his brother a fool, but William knew the value of art. More than once he engaged in arguments over price, at times insisting that the agreed-upon price should include shipping as well. He wisely trekked to the waiting ship to be certain that his works were properly crated and stowed. Then Osborne would be instructed to watch for boxes from London or from the port at Poole along England's southern coast—and always admonished to handle everything with great care.

In an 1850 letter from Florence, William replied to Anne that he is delighted that she loves the changes in the house, especially the ceiling painting, which William purchased in 1849 from the Palazzo Grimani in Venice—at a price that the siege of Venice made doable. At the time he believed it to be a collaboration of Giorgione and John of Udine, but now it is attributed entirely to Udine. The central octagon is in the dome at the top of the marble stairway (see color plate C29). As he did many years before in Spain, William took advantage of Venice's crushing financial problems to purchase art at prices guaranteed to make George as unhappy as their father was in 1815, but which William knew to be great bargains. William also wrote of his distress to learn that Osborne was ill, as he had been a faithful servant. For his remaining years of work on Kingston Lacy, William will rely on Seymour to complete his plans.

Unwisely, William expected George to make regular inspections of the ongoing projects at Kingston Lacy and to act as his supervisor there—while

at the same time he complained to Anne and to Falmouth's son Edward that George had no taste and was really not competent to appreciate William's purchases for the house. Annoyed that George was most like their frugal father, William might have reminded himself that George was also a barrister, an MP for many years, then mayor of Corfe Castle, and father to a huge family. George and Georgiana lived near Richmond Park on the edge of London and at Studland Bay, on the south coast of Dorset County, in a house they continually enlarged until George's death in 1856. In 1844, perhaps to be more in town but possibly also for greater economy, George moved his family into Old Palace Yard and rented the Richmond Park house. He had neither the time nor the interest in supervising William's endless projects at Kingston Lacy.

Exactly what happened between the two brothers in 1844 is not clear, but William's reaction is: "I am not a man of complaints and you have therefore never heard of this before," he wrote to his nephew Edward, an opening that can only announce forthcoming complaints. He observed that Edward's mother, William's dear sister Anne, was well aware of the problem and complained that there are "limits to endurance" and that "capricious behaviour cannot be tolerated." The crisis has to be about money—about George's attempt to control what he correctly anticipated as a steady flow of purchases by his brother. Apparently, as an outlaw William was denied ownership of his lands and homes, but he could draw money regularly from his stock funds. It may be that George wanted to put William on a limited allowance to control his spending on Kingston Lacy.

In his letter, William insisted to Edward that the purchases were not an extravagance but necessary to complete his vision of Kingston Lacy. Apologizing to Edward for involving him in this conflict, William requested that Edward show the letter to George—who should take the blame for "the crisis that he had knowingly produced." William concluded that his "spirit has been too much broken" for him to harbor resentments but not so broken that he will "endure to be trampled upon." Should George apologize, William will seek to forgive and forget.[6]

William was so upset that he also wrote to his solicitor Gregory about the matter and even threatened to return to England and go to jail rather than be "trampled on by those I have constantly benefited." He begged Gregory to set his mind at ease by the next post if he has misunderstood George's behavior and overreacted to the presumed threat to his control of funds to purchase art for the house. Eventually satisfied that George will not "trample" on him, William offered an apology by explaining that he does not understand the law as George and Gregory do but is content now that the situation has been fully explained to him.[7]

William offered further apology by asserting that when one lives so much alone one becomes susceptible to brooding over what may be false impressions. He wanted the family to understand how painful his exile and isolation are, however much he may try to remain upbeat in his letters home, and this worked with George, at least for a while, as a kindhearted letter from him makes William feel much better.

William's spending is not George's only concern. George was also trying to guard against the possible loss of Old Palace Yard to the government at William's death, a concern that Charles Barry apparently raised. In preparation for a government seizure, George asked William for an inventory. William was able to produce, from memory, a room-by-room inventory complete with the value of furniture and artwork. Was George too busy to walk through the house and make a list? He understood that even from Venice William would do a more complete inventory and better valuation than he could. William was able to walk from room to room in his mind's eye and not overlook one painting or decorative clock. George eventually inherited the house at Old Palace Yard and willed it to his wife Georgiana. She lived there after his death with her second husband.

William was too exacting in his demands to avoid all future conflict with George—or frustration over his brother's failure to follow directions or consult him when necessary—so the remaining years of exile were not without angry letters. He wanted George to initiate and supervise various improvements to both the Dorset and Wales estates—draining land and

repairing roads—in addition to checking that a new ceiling is properly installed. William is correct, of course, that their estates will increase in value if they are carefully maintained and improved. Even so, George cannot possibly follow through on all of William's instructions. And so he is scolded for allowing doorknobs to be placed where they would never appear on an Italian door, and William expresses his discontent by sending two Gobelins tapestries to Soughton Hall—now home to his youngest brother Edward—rather than to Kingston Lacy. At least there was space to hang the tapestries at Soughton Hall. In Dorset, every wall is already covered with paintings.

William was gentler with his sister Anne. In spite of pressure from him to live at Kingston Lacy, Anne preferred to live in her London home and to stay at the Dorset estate only for short visits. William wrote to her in May 1854 that he regrets she has not been able to get out and enjoy spring at Kingston Lacy. In this tender letter he writes that he is continually thinking of her and that one of his desires is to make her comfortable when she is in residence in Dorset. And so he has decided to forgo the installation of the library ceiling. The pieces can be stored around the estate, and when they are both gone, others can complete the installation if they so desire.[8]

What his siblings may have failed to recognize is that William has become an expert not only in Italian painting but in Italian decorative arts as well. Just as he had taught himself about ancient Egyptian temple design and decoration, and about the design of Roman towns throughout the Empire, William has now taught himself how to design and decorate an Italian villa. It's all in the details, from ceiling molding to oak doorknobs to the proportions and placement of decorative sculptures—details that he spent hours studying and sketching as a basis for commissioning the artwork sent home to Dorset. The decorative elements on display at the top of his marble staircase provide a glimpse of just one exquisitely finished corner of Kingston Lacy. William went directly to the marble quarries outside Verona and Florence to select just the color and grain he needed to give the desired effect. He took his sketches to the craftsmen and said, "How much alabaster do I need to purchase for you to carve a balustrade that is this long by this

high?" And, "Can you carve this decorative relief so that the orange marble shows as a backdrop to the white putti?"

He must have watched with delight as sculptors carved the slabs of marble he had purchased. And he surely paced impatiently in the studio of the Venetian artist selected to render his drawings for the Spanish Room door panels. Some of the craftsmen groaned when they saw him coming, but they all knew that his orders kept them busy. And while William was proud to own a Titian and a Giorgione, he also sought out young painters and sculptors in Venice and Verona. He became something of a fixture in the area, the solitary but "liberal" Englishman entering the workroom, sketches in hand, his face alight as he could see vines emerging from the marble slab. William had not lost either his generosity of spirit or of purse. The local Verona paper summed him up as one who "trains, encourages, and commissions rising artists."[9]

Letters from William about purchases and bills for purchases that were kept run into the hundreds. Unwilling to sit still long enough to sort through and pay all the bills and keep track of commissions—even at 64—William, in 1851, left Italy for some months of travel in Germany and Austria. But in December, when he turned 65, he was back in Venice—and tired from this journey to new places. Although there is still much to do to complete his image of Kingston Lacy, his step is a bit slower as he revisits studios and workrooms.

Focused more strongly on the family legacy, he pressed forward with the life-sized bronze statues of his ancestors for the loggia, negotiated by letter with Marochetti and aided by his brother Edward's oldest son (see color plate C28).

Then news came in the summer of 1852 that Anne's only son, a brilliant scholar and musician, had died suddenly, unmarried, at 40. When Anne asked for suggestions for a memorial window in St. Michael Penkevil, the Cornish church where he was buried, William eagerly turned his attention to her request. The sketch he sent, showing eight angels, each playing an instrument, turned out not to be the chosen design. What, if any, role

William had in the final design is unknown. It may be that Anne wanted something simpler than William would create; it may be that she was too distraught at that time to make any decisions.

The longing to come home seems to have intensified in William by 1853. He worried about money, writing to George that he will need more to cover the commissioned bronzes as well as additional money for the more expensive France where he expected to spend some time. He even wrote to Gregory to ascertain if the arresting policeman were still alive, as he again raises the issue of his return to England—and learned that the man is not only alive but still on the force. Gregory advises that William's only hope would be to argue that, for some reason of fact or law, the charge of outlawry would not apply in his case. If there were a trial, conviction would follow, in Gregory's judgment. Finally, William decided that he will at least sneak home for a visit to Kingston Lacy. The law forbade outlaws from setting foot in England—except on Sundays, a law retained from Roman Catholic days and the need for confession and the Mass.

William sailed across the Channel from Cherbourg to Studland Bay at least once, certainly in the summer of 1854. (There is one letter from Calais on July 15, another after his return to Paris in late July.) Someone, possibly George but more likely Seymour, rowed out in a dinghy from George's boathouse to William's hired boat, brought him ashore, and hustled him to Kingston Lacy. William had much to examine: the work already done throughout the house, the projects still underway, and the crates of marble as yet unpacked. He no doubt broke the law by staying more than just one Sunday.

His particular concern was the completion of the marble niches in the saloon, designed by Charles Barry in 1840 based on sketches of shell niches William had seen in Montpellier and Narbonne. The niches were carved in Verona in 1847 by Montresor, using yellow Torre, Biancone, and *fleur de pêcher* marble.

Writing to Seymour after his visit, he explained that the green and white marble is not available and instructed Seymour to open "the two great cases (*which you showed me*) [italics mine] containing blocks of purple and white

marble and see whether slices shaved off from them" will work for the backs of the niches. William warned Seymour that this marble is very rare and expensive and must be used "with the least possible waste" so that there will be some left for work in the dining room. He requested Seymour to see to this at once and let him know, before he leaves France, if the strategy will work.[10]

In a letter received by Seymour in December 1854, William, having just turned 68, expressed considerable unhappiness with some of the work in the saloon—providing further proof that he had been at Kingston Lacy:

> There has been the gross folly also of passing oil paint over that finely carved oak capping which was not only primed for gilding but which was actually gilt and required nothing but retouching here and there . . . but what is worse than all . . . *it appeared to my eye* [italics mine] that the plaster cornice around the saloon (which was never intended to be painted but to remain pure white and gold) had been picked out with the same abominable colour. . . . Let this be examined and . . . , if *my eye has not been misled* [italics mine], see if it be possible to scrape the ground white again.[11]

Was William prepared to come again in the summer of 1855 to see if the saloon was finally competed to his satisfaction? In one letter to Anne he listed a prescription for cough medicine; in other letters there are discussions of medications. Did William know that he had a serious medical problem, or were these exchanges merely typical of two correspondents facing the problems of aging? We do not know. In his last letter home, to Anne on March 22, 1855, he is filled with joy over the bronze relief of the burning of Corfe Castle, seen in a photograph she has sent. On the back of this letter, Anne wrote: "This was the last letter written to me by my very dear kind brother—taken ill April 2nd—he died on the 15th . . . quite conscious to the very last moment."[12]

British vice consul Alexander Malcolm, who came to the apartment to confirm William's death, had been informed by Edward Williams, about whom nothing else is known. There is no mention of the cause of death, although Malcolm would have been told something by the attending phy-

sician and would have shared that information with the family. Possibly William contracted cholera, succumbing to a recent outbreak of the disease in Venice. It is also possible that he—like Byron—had contracted malaria on his early journeys and came down with another high fever, common to those who have suffered from this disease. His serious illness in Syria in 1818 and his fever while at Abu Simbel suggest this possibility. Much older now, he could not survive this bout with the high fever. But, of course it is also possible that he more simply died of "old age," the collapse of one or more vital organs.

William's request to George, expressed soon after his exile, was to be "closed up in lead and buried with our forefathers in the vault at Wimborne." William's body was returned to England, and his funeral held, in secret, at a chapel in Wimborne Minster. Edward, the youngest brother and a canon in the church, probably arranged the funeral and obtained permission for William's burial request to be met, for new laws prohibited multiple burials in one crypt. A brass plaque placed on the outside of the vault at Wimborne Minster in 1856 states that the vault is now closed forever.

William lives on through his archaeological work in both Egypt and Syria. Of special value to Egyptologists are his drawings and notes on temples south of Aswan, since many of these temples were lost under the sand or the Nile waters. His discovery of the Abydos King List and his copies of hieroglyphs contributed to the decoding of Egypt's sacred language. Our knowledge of his role has also helped to give greater recognition to the work of Thomas Young, reminding us once again that most important discoveries develop from the contributions of many scholars, not just one.

William also survives in every room at Kingston Lacy. George's descendants did not always take great care of their inheritance, but when the estate was given to the National Trust in 1982, the home on which William lavished so much of his time and creative imagination was given renewed life.

Significant conservation efforts by the National Trust—cleaning, painting, repairing, restoring—were necessary before the house could be opened to the public. One decision was to remove the library ceiling (eventually installed after William's death) because it was sagging heavily and in need of restoration. After many years, restoration of Guido Reni's painting *The Separation of Night and Day* (c. 1600) was undertaken. This involved the removal of dirt, overpaint, and varnish and then the retouching of places where there was a loss of paint. In January 2006, Reni's work was returned to Kingston Lacy, carried in through the library window, and installed. The beauty of Reni's original work once again gives pleasure from the library ceiling—where William wanted it to be.

A CHRONOLOGY OF ANCIENT EGYPTIAN KINGDOMS AND DYNASTIES

Egyptologists organize the history of ancient Egypt into three major kingdoms separated by intermediate periods. The intermediate periods are times of conflict with outside forces that lacked a unifying government led by a pharaoh. The history of ancient Egypt ends with a Late Period and then the Ptolemaic Period, which includes the reign of Cleopatra. Some of the most famous kings, including those mentioned in the text, have been listed within their dynasties. Early dates are approximate only and still under debate, and scholars disagree over the spelling of some kings' names.

Predynastic 3500–3100 BCE *(All Dates Below Are BCE.)*

Early Dynastic Period
Dynasty "0" 3100–3000
 King Narmer ends this dynasty.
First Dynasty 3000–2800
Second Dynasty 2800–2649
Third Dynasty 2649–2575

Old Kingdom
Fourth Dynasty 2575–2450
 Sneferu (First pyramids built at Saqqara)
 Khufu (Cheops), builder of the Great Pyramid at Giza

> *Khafre (Chephren), builder of the second pyramid at Giza*
> *Menkaure, builder of the third pyramid at Giza*

Fifth Dynasty 2450–2325

Sixth Dynasty 2325–2175

Seventh and Eighth Dynasties 2175–2125

First Intermediate Period

Ninth and Tenth Dynasties 2125–1975

Eleventh Dynasty (Thebes only) 2125–2055

Middle Kingdom

Eleventh Dynasty (all of Egypt) 2055–1985

> *Mentuhotep II, reunited Egypt.*

Twelfth Dynasty 1985–1795

> *Senusret (Senwotris) I 1918–1875*

Thirteenth Dynasty 1755– after 1630

Second Intermediate Period

Fourteenth Dynasty 1750–1630

Fifteenth Dynasty 1630–1520

> *Hyksos rule.*

Sixteenth Dynasty

> *Continued rule by Hyksos.*

Seventeenth Dynasty 1630–1550

> *Kamose rises to power in Thebes.*

New Kingdom

Eighteenth Dynasty 1520–1292

> *Ahmose, successfully fights the Hyksos.*
> *Amenhotep I*
> *Thutmose (Tuthmosis) I*
> *Thutmose (Tuthmosis) II*
> *Thutmose (Tuthmosis) III*
> *Hatshepsut 1473–1458*

Amenhotep II

Thutmose (Tuthmosis) IV

Amenhotep III

Amenhotep IV (Changed his name to Akhenaten) 1352–1336

Smenkhare 1336–1333

Tutankhamun 1333–1323

Ay 1323–1319

Horemheb 1319–1292

Nineteenth Dynasty 1292–1190

Ramesses I 1292–1290

Sety (Sethos) I 1290–1279

Ramesses II 1279–1213

Twentieth Dynasty 1190–1070

Ramesses III through Ramesses XI

Third Intermediate Period

(Various rulers operating from different power bases throughout the Third Intermediate Period: 1070–664.)

Twenty-First Dynasty

Twenty-Second Dynasty

Twenty-Third Dynasty

Twenty-Fourth Dynasty

Late Period

(Twenty-Fifth through Thirtieth Dynasties, including two Persian Periods of control: 664–332.)

Ptolemaic Period

Macedonian Dynasty 332–309

Ptolemaic

Ptolemy I Soter I 304–282

Ptolemy II Philadelphus 282–246

Ptolemy III Euergetes I 246–221

Ptolemy IV Philopator 221–204
Ptolemy V Epiphanes 204–180
Ptolemy VI Philometor 180–164
Ptolemy VIII Euergetes II 170–164 (2nd reign)
Ptolemy IX 116–107
Ptolemy X Alexander I 107–88 (2nd reign)
Ptolemy IX Soter II 88–80 (3rd reign)
Ptolemy X 80
Ptolemy XII 80–51
Cleopatra VII 51–30

Roman Emperors, beginning with Augustus, 30 BCE–CE 14

NOTES

PRIMARY SOURCES AND ABBREVIATIONS USED

Bankes Albums Two MS volumes of Egyptian travel notes, given to the British Museum (1923) by G. Nugent Bankes.

WJB letters of Bankes.

Byron *Byron's Letters and Journals*, 13 vols., ed. Leslie A. Marchand, London: John Murray, 1973–94.

DHC Dorset (England) History Centre, formerly the Dorset Record Office, location of the Bankes family papers and William John Bankes's drawings and paintings.

Finati *Narrative of the Life and Adventures of Giovanni Finati*, 2 vols., ed. William John Bankes, London: John Murray, 1830.

JMA Archive of letters held by John Murray Publishers, London.

KL/AM Anthony Mitchell, *Kingston Lacy*, London: National Trust, 1994, rev. ed., 1998. (All information about Bankes's family home and the history of the Bankes family, unless otherwise noted, comes from this source, a guidebook to the home and family prepared by Mitchell for the National Trust, now owner of Kingston Lacy.)

PROLOGUE

1. **Finati**, pp. 312–17. All details of Bankes's journeys in the prologue are from this source unless otherwise noted.

2. Quoted in Anne Sebba, *The Exiled Collector*, London: John Murray, 2004, from the MS. journal of John Hyde, p. 91.

3. **Byron**, to John Murray, Aug. 7, 1820.

4. William Turner, *Journal of a Tour in the Levant*, London: John Murray, 1820, footnote.

1. THE SECOND SON

1. **DHC**, Frances Bankes Notebook.

2. **DHC**, Frances Bankes to son Henry Bankes, 1785.

3. **KL/AM**, for family history and details of the Pratt House presented in this chapter.

4. **DHC**, Henry Bankes to Margaret Bankes, Nov. 2, 1779, and Henry Bankes to Margaret Bankes, Sept. 23, 1779.

5. Frances Bankes to Margaret Bankes, letter quoted in full by Antony Cleminson, "Christmas at Kingston Lacy: Frances Bankes's Ball of 1791," *Apollo*, Dec. 1991, pp. 405–409.

6. **Byron**, to John Murray, Oct. 19, 1820.

2. COLLEGE CONNECTIONS: A BRAVE NEW WORLD!

1. **DHC**, William Bankes to Margaret Bankes, Nov. 1, 1803.

2. **DHC**, William Wynne to William Bankes, Nov. 12, 1804.

3. Quoted of the Rev. Mr. Rouse by Thomas Moore, *Journal of Thomas Moore*, ed. Wilfred S. Dowden, Associated University Presses, 1983–91, IV: 1540.

4. Fiona MacCarthy, *Byron: Life and Legend*, New York: Farrar, 2002, p. 58.

5. **Byron**, to John Hanson, Oct. 26, 1805.

6. See T. A. J. Burnett, *The Rise and Fall of a Regency Dandy*, Oxford: Oxford University Press, 1981.

7. **Byron**, Oct. 15, 1821.

8. John Hanson to Catherine Gordon Byron, Mar. 13, 1799.

9. Byron, "To George, Earl Delawarr," first published in *Hours of Idleness*, 1807.

10. Hobhouse diaries, January 15, 1829, British Library.

11. Hobhouse, in a letter quoted by D. R. Fisher from an unpublished biography of William John Bankes for *History of Parliament*.

12. **Byron**, to John Murray, Oct. 19, 1820.

13. **Byron**, to Hobhouse, Aug. 30, 1811.

14. **Byron**, to John Murray, 1820.

15. **Byron**, to Charles Matthews, June 22, 1809.

16. **JMA**, from Matthews to Byron, June 30, 1809.

17. **Byron**, from Bankes to Byron, Jan. 2, 1822.

18. **Byron**, to John Murray, Oct. 19, 1820.

19. **JMA**, from Bankes to Byron, Mar. 18, 1807.

20. Hobhouse to Byron, 1808, quoted by Viola Bankes in *A Dorset Heritage*, 2nd ed., London: Anthony Mott, 1986, p. 128.

21. **JMA**, from Bankes to Byron, Mar. 10, 1807.

22. **Byron**, to Edward Long, Feb. 23, 1807.

23. **Byron**, to Bankes, Mar. 6, 1807.

24. Ibid.

25. Ibid.

26. Letter to Laurence and Elizabeth Sulivan in *Letters of the Third Viscount Palmerston to Laurence and Elizabeth Sulivan 1804–1863*, ed. Kenneth Bourne, London, 1979.

27. **DHC**, from Sir William Wynne to Bankes, Mar. 9, 1807.

28. Viola Bankes, p. 126.

3. LONDON: POLITICS AND PARTIES

1. **Byron**, to Bankes, Mar. 1809.

2. Income estimates from Anne Sebba, *The Exiled Collector*, pp. 37–38.

3. Quoted in *The History of Parliament: House of Commons 1790–1820*, III, Members A-F, ed. R. G. Thorne, London: Secker & Warburg, 1986, p. 132.

4. William Hague, *William Wilberforce*, New York: Harcourt, 2007. Details of Wilberforce's life from this source unless otherwise noted.

5. Ibid., pp. 240–41.

6. Ibid., p. 249.

7. Ibid., p. 53.

8. *Gentleman's Magazine*, 1835, p. 323.

9. Quoted in *The History of Parliament*, p. 133.

10. **DHC**, William Wynne to Bankes, Dec. 26, 1810.

11. Anne Sebba, in *The Exiled Collector*, also notes that the Old Palace Yard home reflects Henry's love of Parliament.

12. **Byron**, to Augusta, Mar. 26, 1813.

13. **Byron**, to John Hanson, Apr. 16, 1808.

14. **Byron**, to John Hanson, Nov. 12, 1809.

15. **DHC**, from Bankes to Byron, Apr. 20, 1812.

16. **Byron**, to Bankes, Apr. 20, 1812.

17. **Byron**, to Bankes, Apr. 1812.

4. TIME TO GET AWAY

1. **DHC**, Bankes to Sir William Wynne, Aug. 9, 1809.

2. **DHC**, Bankes to Margaret Bankes, Dec. 23, 1811.

3. **DHC**, Sir William Wynne to Bankes, Oct. 24, 1810.

4. **DRO**, Bankes to Byron, Aug. 25, 1811.

5. Ibid.

6. **Byron**, to Hobhouse, Aug. 30, 1811.

7. **DHC**, Bankes to Byron, Sept. 24, 1812.

8. **Byron**, to Bankes, Sept. 28, 1812.

9. **Byron**, to Lady Caroline Lamb, May 1, 1812.

10. **Byron**, to Annabella Milbanke, Aug. 31, 1813.

11. Viola Bankes, p. 134.

12. **JMA**, Bankes to Byron, Dec. 21, 1812.

13. **Byron**, to Bankes, Dec. 26, 1812.

14. **DHC**, Sir William Wynne to Bankes, June 10, 1814.

15. **JMA**, Bankes to Byron, Jan. 20, 1813.

16. **DRO**, Bankes to Byron, Mar. 16, 1813.

17. **DRO**, Bankes to Frances Bankes, (n.d.) 1813.

18. Quoted in *Adventures in Egypt and Nubia*, Patricia Usick, London: British Museum, 2002, pp. 9–10, from *The Heber Letters, 1783–1832*, ed. R. H. Cholmondeley, London: Batchworth, 1950.

19. Letter of November 22, 1822, in *Private Letters of Princess Lieven to Prince Metternich 1820–1826*, ed. Peter Quennell, London: John Murray, 1937, p. 155.

20. Viola Bankes, p. 139.

21. **DHC**, William Bankes to Henry Bankes, 1814.

22. **DHC**, William Bankes to Henry Bankes, Sept. 3, 1815.

23. Anabella Milbanke to Byron, quoted in *A Dorset Heritage*, p. 138.

5. EGYPT: A GIFT OF THE NILE

1. **DHC**, from Bankes's 25-page journal started with his arrival in Alexandria in 1815. Details of his 1815 travels are drawn from this journal.

2. Johan L. Burckhardt, *Travels in Nubia*, London, 1822.

3. Quoted in *Adventures in Egypt and Nubia*, Patricia Usick, London: British Museum, 2002, p. 27, from letter to E. D. Clarke, June 28, 1816.

4. From a footnote added to *Journal of a Tour in the Levant* by William Turner, 3 vols., London, 1820, vol. 2.

5. **DRO**, William Bankes to Henry Bankes, Cairo, Sept. 3, 1815.

6. **Bankes Albums.**

7. Ibid.

8. Ibid.

9. Alan Gardiner, *The Egyptians: An Introduction*, London: Oxford University Press, 1961, 27.

10. **Finati**, p. 80.

6. THE FIRST EGYPTOLOGIST

1. **Bankes Albums.**

2. **Finati**, p. 86. All information and quoted material from this source throughout the chapter unless otherwise noted.

7. DARING AND PERSEVERANCE: FROM THE HOLY LAND TO JERASH

1. **Finati**, pp. 109–10. All information and quoted material from this source throughout the chapter unless otherwise noted.

2. **Byron**, letter to Hobhouse, Oct. 4, 1810.

3. Stanhope to Bruce, March 21, 1816, quoted in *The Nun of Lebanon* by Ian Bruce, London: Collins, 1951.

4. **DHC**, Bankes to Stanhope, June 17, 1816.

5. **DHC**, Bankes to Stanhope, June 21, 1816.

6. **DHC**, Burckhardt to Bankes, July 1816.

7. **DHC**, Bankes to Burckhardt, Cyprus, Oct. 15, 1817.

8. PACKED FOR PETRA: PAINT BOXES AND GUNS

1. **Finati**, p. 224. All information and quoted material are from this source throughout the chapter unless otherwise noted.

2. **DHC**, Bankes to Burckhardt, Oct. 15, 1817.

3. Charles L. Irby and John Mangles, *Travels in Egypt and Nubia, Syria and Asia Minor*, London: John Murray, 1823. All quoted descriptions of Petra are from this work.

4. Ibid., pp. 152–53.

9. ARTISTS SET SAIL: WILLIAM BEGINS HIS GREAT SECOND JOURNEY UP THE NILE

1. **Finati**, pp. 295–97. All information and quoted material are from this source throughout the chapter unless otherwise noted.

2. **DHC**, William Bankes to Henry Bankes.

3. Giuseppe Belzoni, *Narrative*, London, 1822, II, pp. 105–106.

4. Salt letter, quoted in John J. Halls, *The Life and Correspondence of Henry Salt*, London, 1834, II, pp. 133–35.

5. **DHC**, William Bankes to Henry Bankes, c. 1818.

10. WILLIAM MEETS RAMESSES II: EXCAVATIONS IN NUBIA

1. **Finati**, pp. 310–12. All information and quoted material are from this source throughout the chapter unless otherwise noted.

2. Ibid., pp. 312–17.

3. Ibid., pp. 317–40.

11. OBELISKS AND KING LISTS: WILLIAM'S DISCOVERIES AT PHILAE AND ABYDOS

1. **Finati**, pp. 340–41.

2. Ibid., p. 341.

3. Ibid., pp. 309–10.

4. Ibid., p. 342.

5. John Fuller, *Narrative of a Tour through Some Parts of the Turkish Empire*, London, 1829, p. 230.

6. **Finati**, p. 343.

7. **Bankes Albums**, letter from Thomas Young, attached to the Albums, II, p. 3.

8. Robert Richardson, *Travels along the Mediterranean, and Part Adjacent, in Company with the Earl of Belmore, During the Years 1816–17–18*, I, pp. 27–28.

9. George Peacock, *Memoirs of Dr. Thomas Young*, Vol. I of *Thomas Young's Life and Works*, 4 Vols., ed. John Leitch, London: John Murray, I, p. 264. (Young to Mr. Gurney, 1814.)

10. Ibid., pp. 266–67. (Sylvestre de Sacy to Young, 1815.)

11. Ibid., p. 163. (Thomas Young, *Supplement to the Encyclopedia Britannica*, 1819.)

12. Ibid., p. 93. (From the *Quarterly Review*, No. 31.)

13. John Leitch, ed., *Thomas Young's Life and Works*, III, p. 86. (Footnote to Young's 1819 *Supplement to the Encyclopedia Britannica.)*

14. Thomas Young, letter to the *Edinburgh Review*, 1822.

15. Leitch, *Works*, III, p. 293. (Footnote.)

16. Leitch, *Works*, III, p. 371. (Young to Gell, 1823.)

17. William John Bankes, "To the Right Hon. Charles Yorke" (dedication), in Henry Salt, *Essay on Dr. Young's and M. Champollion's Phonetic System of Hieroglyphics*. London: Longman, 1825, vi–vii.

18. Andrew Robinson, *Cracking the Egyptian Code*, Oxford: Oxford University Press, 2012, p. 254.

19. Ibid., pp. 133–37.

20. **Finati**, p. 347.

12. THE EXPLORER RETURNS

1. Fiona MacCarthy, *Byron: Life and Legend*, New York: Farrar, 2002, pp. 371–72.

2. Ibid.

3. **Byron**, to Bankes, Nov. 20, 1819.

4. MacCarthy, p. 336.

5. Ibid., p. 382.

6. Ibid., p. 379.

7. **Byron**, to Richard Hoppner, Jan. 31, 1820.

8. **Byron**, to Bankes, Feb. 26, 1820.

9. **DHC**, from the diary of Frances Bankes, 1820.

10. **Byron**, to Bankes, Feb. 19, 1820.

11. Ibid.

12. **Byron**, to John Murray, Oct. 8, 1820.

13. **DHC**, from the diary of Frances Bankes, 1820.

14. Ibid.

15. Francis Bamford and the Duke of Wellington, eds., *The Journal of Mrs. Arbuthnot*, London: Macmillan, 1950, pp. 17–18.

16. Ibid., p. 103.

17. Quoted in *Life of Stratford Canning* by Stanley Lane-Poole, London: Longman, 1888, I, pp. 292–93.

18. Quoted in *A Dorset Heritage* by Viola Bankes, p. 170.

19. Bamford, p. 57.

20. **JMA**, to Byron, Jan. 2, 1822.

21. Bamford, I, p. 113.

22. **JMA**, to Byron, Jan. 2, 1822.

23. **Finati**, pp. 426–27.

24. **DHC**, William to Frances Bankes, n.d.

25. Bamford, I, pp. 170–71.

26. **DHC**, Young letter, with William Bankes's papers.

27. **DHC**, William to Henry Bankes, 1821.

28. **KL/AM**, William to Byron, 1822, quoted by Mitchell, p. 25.

13. FATHERS AND SONS

1. **JMA**, letter to John Murray, Nov. 12, 1822.

2. Kenneth Bourne, *Palmerston: The Early Years: 1784–1841*, London: Allen Lane, 1982, pp. 242–43.

3. John Clark and Thomas Hughes, eds., *Life and Letters of the Reverend Adam Sedgwick*, Cambridge: Cambridge University Press, 1890.

4. **DHC**, from Henry Bankes to Georgiana Bankes, Aug. 2, 1829.

5. James S. Buckingham, *Verbatim Report of the Action for Libel in the Case of Buckingham Versus Bankes*, London, 1826, p. 7.

6. **Finati**, pp. 424–29.

7. Buckingham, pp. 22–23.

8. **JMA**, Bankes to John Murray, Dec. 9, 1829; second letter, 1830.

9. Bamford, p. 327.

10. Viola Bankes, p. 165.

11. From John Cam Hobhouse to William Bankes, at Kingston Lacy, n.d., but with an 1824 watermark.

12. **DHC**, Bankes to Byron, Jan. 2, 1822.

13. *The* [London] *Times*, Dec. 3, 1833. (Details of the trial are from this source.)

14. John Brooke and Julia Gandy, eds., *The Prime Ministers' Papers, Wellington, Political Correspondence, I, 1833–Nov. 1834*, London: 1975.

14. FINAL JOURNEYS

1. **KL/AM**, pp. 6–8. Details throughout the chapter regarding changes to Kingston Lacy are from this source.)

2. **DHC**, Bankes to Wellington, Sept. 27, 1840.

3. **DHC**, Bankes to Anne Falmouth, July 1, 1853.

4. Bankes to Lady Burghersh, quoted in Viola Bankes, *A Dorset Heritage*, pp. 173–74.

5. **DHC**, Bankes to Anne Falmouth, Mar. 22, 1853.

6. Broughton, *Reflections of a Long Life*.

7. **DHC**, *Queen v. Bankes*.

8. **DHC**, All letters regarding the foreigner and possible meetings are in the Bankes archives.

9. **DHC**, Gregory to Bankes, Oct. 5, 1841.

10. Viola Bankes, p. 138.

11. **DHC**, Bankes to Gregory, dates of letters as indicated in the text.

12. **DHC**, Lord Falmouth to Gregory; all letters are from the fall of 1841.

15. LAST—AND LASTING—GIFTS TO THE FUTURE

1. **DHC**, Bankes to Anne Falmouth, Padua, 1844.

2. **DHC**, Malcolm to George Bankes, Aug. 26, 1855.

3. Viola Bankes, p. 177.

4. **KL/AM**, pp. 72–73.

5. **DHC**, Seymour to Bankes.

6. **DHC**, Bankes to Edward Falmouth, undated but the fall of 1844.

7. **DHC**, Bankes to Gregory, Sept. 21, 1844.

8. **DHC**, Bankes to Anne Falmouth, Venice, May 5, 1854.

9. **DHC**, *Foglie de Verona*, no. 34, 1846, and no. 228, 1849.

10. **DHC**, Bankes to Seymour, Aug. 25, 1854.

11. **DHC**, Bankes to Seymour, noted "read" Dec. 30, 1854.

12. **DHC**, Bankes to Anne Falmouth, Mar. 29, 1855.

BIBLIOGRAPHY

The life and work of William John Bankes is best understood through a study of what scholars call primary sources: all of the family letters, his portfolio of drawings and notes, his journals, even the stacks of bills saved over the years. But, beyond these key sources—that appear so frequently in the chapter notes—there are many books and articles that relate to William and his times and explorations. The following list of sources that I have studied is a useful, but not exhaustive, list of works on ancient Egypt, on hieroglyphs and obelisks, on the British Parliament, on English country houses, on changes to Kingston Lacy, on other early nineteenth-century travelers to Egypt and the Middle East.

Abt, Jeffrey. *American Egyptologist: The Life of James Henry Breasted and the Creation of His Oriental Institute*. Chicago: University of Chicago Press, 2011.

Adkins, Leslie and Roy. *The Keys of Egypt: The Race to Crack the Hieroglyph Code*. New York: HarperCollins, 2000.

Anderson, Robert, and Ibrahim Fawzy. *Egypt in 1800*. London: Barrie & Jenkins, 1988.

Baines, John, and Jaromir Malek. *Cultural Atlas of Ancient Egypt*, rev. ed. Oxford: Facts on File, 2000.

Bamford, Francis, and the Duke of Wellington, eds. *The Journal of Mrs. Arbuthnot, Vol. 1 and 2*. London: Macmillan, 1950.

Bankes, George. *The Story of Corfe Castle*. London: John Murray, 1853.

Bankes, Viola. *A Dorset Heritage*, 2nd ed. London: Anthony Mott, 1986.

Bankes, William John. *Geometrical Elevation of an Obelisk . . . from the Island of Philae, together with the pedestal . . . First Discovered There by W. J. B*. London: John Murray, 1821.

Barbet, Alix, Pierre-Louis Gatier, and Norman N. Lewis. "Un Tombeau Peint Inscrit de Sidon." *Syria* 74 (1997): 141–60.

Barry, Alfred. *The Life and Works of Sir Charles Barry*. London: John Murray, 1867.

Belzoni, Giuseppe. *Narrative of the Operations and Recent Discoveries within the Pyramids, Temples, Tombs and Excavations in Egypt and Nubia, Vol. 1 and 2*. London: John Murray, 1822.

Bierbrier, Morris L., ed. *Who Was Who in Egyptology*, 3rd rev. ed. London: Egyptian Exploration Society, 1995.

Bosworth, C. E. "Henry Salt, Consul in Egypt 1816–1827 and Pioneer Egyptologist." *Bulletin of the John Rylands University Library of Manchester* 57 (1974): 69–91.

Bourne, Kenneth, ed. *Palmerston, Henry John Temple, Viscount: The Letters of the Third Viscount Palmerston to Lawrence and Elizabeth Sullivan, 1804–1863*. London: Royal Historical Society, 1979.

———. *Palmerston: The Early Years: 1784–1841*. London: Allen Lane, 1982.

Bowsher, J. M. C. "An Early Nineteenth Century Account of Jerash and the Decapolis: The Records of William John Bankes." *Levant* 29 (1997): 227–46.

Brier, Bob. *Egyptomania: Our Three Thousand Year Obsession with the Land of the Pharaohs*. New York: St. Martins/Palgrave Macmillan, 2013.

Brooke, John, and Julia Gandy, eds. *The Prime Ministers' Papers, Wellington Political Correspondence, I, 1833–Nov. 1834*. London: Her Majesty's Stationery Office, 1975.

Broughton, Lord (John Cam Hobhouse). *Recollections of a Long Life, Vol. 1–6*. Ed. Lady Dorchester. London: John Murray, 1909–1911.

Bruce, Ian, ed. *The Nun of Lebanon: The Love Affair of Lady Hester Stanhope and Michael Bruce*. London: Collins, 1951.

Buckingham, James S. *Autobiography of James Silk Buckingham, Vol. 1 and 2*. London Longman, 1858.

———. *Travels among the Arab Tribes Inhabiting the Countries East of Syria and Palestine . . . etc., with an Appendix Containing a Refutation of Certain Unfounded Calumnies Industriously Circulated against the Author of this Work by Lewis Burckhardt, Mr. William John Bankes, and the Quarterly Review*. London: Longman, 1825.

———. *Verbatim Report of the Action for Libel in the Case of Buckingham versus Bankes. etc.* London: Longman, 1826.

Burnett, T. A. J. *The Rise and Fall of a Regency Dandy: The Life and Times of Scrope Berdmore Davies*. London: John Murray, 1981.

Cerny, Jaroslav. *Egyptian Stelae in the Bankes Collection*. Oxford: Oxford University Press, 1958.

Clark, John W., and Thomas McKenny Hughes. *The Life and Letters of the Reverend Adam Sedgwick, Vol. 1 and 2*. Cambridge: Cambridge University Press, 1890.

Clayton, Peter A. *The Rediscovery of Ancient Egypt: Artists and Travelers in the 19th Century*. London: Thames & Hudson, 1982.

Cleminson, Antony. "Christmas at Kingston Lacy." *Apollo* (December 1991): 405.

———. "The Transition from Kingston Hall to Kingston Lacy." *Architectural History (Journal of the Society of Architectural Historians of Great Britain)* 31 (1988): 120–35.

Collier, Mark, and Bill Manley. *How to Read Egyptian Hieroglyphs*, rev. ed. London: British Museum Press, 1998.

Colvin, Sir Sidney, and Lionel Cust. *History of the Society of Dilettanti*. London: Macmillan, 1898.

Crompton, Louis. *Byron and Greek Love: Homophobia in 19th Century England*. Berkeley: University of California Press, 1985.

d'Athanasi, Giovanni. *A Brief Account of the Researches and Discoveries in Upper Egypt Made under the Direction of Henry Salt, Esq.* London: J. Hearne, 1836.

Davies, Nina M. *Egyptian Tomb Paintings, from Originals Mainly of the Eighteenth Dynasty in the British Museum and Bankes Collection*. London: Faber, 1958.

Denon, Vivant. *Travels in Upper and Lower Egypt, Vol. 1 and 2*. New York: Arno, 1973.

Edwards, I. E. S. "The Bankes Papyri I and II." *JEA* 68 (1982): 126–33.

Fagan, Brian M. *The Rape of the Nile: Tomb Robbers, Tourists, and Archaeologists in Egypt*. New York: Scribner's, 1975.

Finati, Giovanni. *Narrative of the Life and Adventures of Giovanni Finati, Translated and Edited by William John Bankes, Vol. 1 and 2*. London: John Murray, 1830.

Fox, Margaret. *The Riddle of the Labyrinth: The Quest to Crack an Ancient Code*. New York: HarperCollins, 2013.

Fuller, John. *Narrative of a Tour through Some Parts of the Turkish Empire*. London: R. Taylor, 1829.

Habachi, Labib. *The Obelisks of Egypt*. New York: Littlehampton, 1977.

Halls, John J. *The Life and Correspondence of Henry Salt, Vol. 1 and 2*. London: R. Bentley, 1834.

Hamilton, William R. *Remarks on Several Parts of Turkey, Part One. Aegyptiaca or Some Account of the Ancient and Modern State of Egypt, as Obtained in the Years 1801, 1802*. London: T. Payne, 1809.

Harris, Enriqueta. "*Las Meninas* at Kingston Lacy." *Burlington Magazine* (February 1990): 125–30.

Hermann, Frank. *The English as Collectors*. London: John Murray, 1999.

Herodotus. *Histories. Books II, III, and IV*.

Hibbert, Christopher. *Wellington: A Personal History*. Reading: Perseus Books, 1997.

Hume, Ivor Noel. *Belzoni: The Giant Archaeologists Love to Hate*. Charlottesville: University of Virginia Press, 2010.

Hutchins, Rev. John. *The History and Antiquities of the County of Dorset*, 3rd ed. Westminster: J. B. Nichols, 1861–1870.

Irby, Charles L., and James Mangles. *Travels in Egypt and Nubia, Syria, and Asia Minor During 1817 and 1818*. Privately published, 1823.

James, T. G. H. "Egyptian Antiquities at Kingston Lacy, Dorset." *Apollo* (May 1994): pp. 29–33.

———. *Egypt Revealed: Artist-Travellers in an Antique Land*. London: Folio Society, 1997.

Jolliffe, T. R. *Letters from Palestine; to the Second Edition of Which Was Added Letters from Egypt*. London: Partridge, 1820.

Lane, Edward. *Description of Egypt*. Ed. Jason Thompson. Cairo: American University in Cairo Press, 2000.

Lane-Poole, Stanley. *Life of Stratford Canning*. London: Longman, 1888.

Lees-Milne, James. *People and Places: Country House Donors and the National Trust*. London: John Murray, 1991.

Leitch, John, ed. *Thomas Young's Life and Works, Vols. 1–3*. London: John Murray, 1855.

Lewis, Norman N., Annie Sartre-Fauriat, and Maurice Sartre. "William John Bankes: Travaux en Syrie d'un Voyageur Oublie." *Syria* 73 (1996): 1–4.

Light, Sir Henry. *Travels in Egypt, Nubia, Holy Land, Mount Lebanon, and Cyprus in the Year 1814*. London: Rodwell and Martin, 1818.

Macadam. M. F. Laming. "Gleanings from the Bankes MSS." *JEA* 32 (1946): 57–64.

MacCarthy, Fiona. *Byron: Life and Legend*. New York: Farrar, 2002.

Maclarnon, Cathleen. William Bankes and His Collection of Spanish Paintings at Kingston Lacy." *Burlington Magazine* (February 1990): 114–25.

———. "W. J. Bankes in Egypt." *Apollo* (August 1986).

Manley, Bill. *The Penguin Historical Atlas of Ancient Egypt*. London: Penguin, 1996.

Manley, Deborah, and Peta Rée. *Henry Salt: Artist, Traveller, Diplomat, Egyptologist*. London: Ars Libri, 2001.

Marchand, Leslie A., ed. *Byron's Letters and Journals, Vols. 1–11*. Cambridge, MA: Harvard University Press, 1973.

Mitchell, Anthony. *Kingston Lacy*. London: National Trust, 1986.

Moore, Thomas. *Letters and Journals of Lord Byron: With Notices of His Life, Vol. 1 and 2*. London: John Murray; New York: Harper, 1831.

National Trust. "Guido Reni Conservation." November 18, 2009. www.nationaltrust.org.uk.

Norwich, John Julius. *Paradise of Cities: Venice and Its Nineteenth-Century Visitors*. New York: Viking, 2003.

Ollard, Richard. *Dorset*. Wimborne: Dovecote Press, 1999.

Peacock, George. *Memoir of Dr. Thomas Young*. London: John Murray, 1855.

Pearce, Nathaniel. *The Life and Adventures of Nathaniel Pearce, Written by Himself, Vols. 1 and 2*. Ed. John J. Halls. London: Colburn and Bentley, 1831.

Porter, B., and Rosalind Moss. *Topographical Bibliography of Ancient Egyptian Hieroglyphic Texts, Reliefs, and Paintings, Vol. 7*. Oxford: Oxford University Press, 1951.

Quennell, Peter, ed. *Private Letters of Princess Lieven to Prince Metternich 1820–1826*. London: John Murray, 1937.

Quirke, S. "The Bankes Papyri." *British Museum Magazine* 24 (1996).

Parkinson, Richard. *Cracking Codes: The Rosetta Stone and Decipherment*. Berkeley: University of California Press, 1999.

Richardson, Robert. *Travels Along the Mediterranean, and Parts Adjacent; in Company with the Earl of Belmore, during the Years 1816–17–18, Vol. 1 and 2*. London, 1822.

Ridley, Ronald T. *Napoleon's Proconsul in Egypt: The Life and Times of Bernardino Drovetti*. London: Rubicon, 1998.

Robinson, Andrew. *Cracking the Egyptian Code: The Revolutionary Life of Jean-Francois Champollion*. London: Oxford, 2012.

———. *The Last Man Who Knew Everything: Thomas Young, the Anonymous Genius Who Proved Newton Wrong and Deciphered the Rosetta Stone, Among Other Surprising Feats*. London: Penguin, 2007.

Rouse, A. L. "Bryon's Friend Bankes: A Portrait." *Encounter* (March 1975).

———. *Homosexuals in History: A Study of Ambivalence in Society, Literature, and the Arts*. London: Weidenfeld and Nicolson, 1977.

Salt, Henry. "Antiquities of Egypt." *Quarterly Review* 10 (1817): 391.

———. "Belzoni's Operations and Discoveries in Egypt." *Quarterly Review* 24 (1821): 140.

———. *Essay on Dr. Young's and M. Champollion's Phonetic System of Hieroglyphics: with Some Additional Discoveries, etc.* London: Longman, 1825.

Sebba, Anne. *The Exiled Collector: William John Bankes and the Making of an English Country House*. London: John Murray, 2004.

Sim, Katherine. *Desert Traveller: The Life of Jean Louis Burckhardt*. London: Gollancz, 1969.

Starkey, Paul, and Janet Starkey, eds. *Travelers in Egypt*. London and New York: IB Taurus, 1998.

Taylor, John H. *Egypt and Nubia*. Cambridge, MA: Harvard University Press, 1991.

Thorne, R. G., ed. *The History of Parliament: The House of Commons 1790–1820, Vol. 3*. London: Secker & Warburg, 1986.

Tyldesley, Joyce. *Egypt: How a Lost Civilization Was Rediscovered*. Berkeley: University of California Press, 2005.

Uglow, Jenny. *The Pinecone: The Story of Sarah Losh, Forgotten Romantic Heroine—Antiquarian, Architect, and Visionary*. New York: Farrar, 2012.

Usick, Patricia. *Adventures in Egypt and Nubia: The Travels of William John Bankes (1786–1855)*. London: British Museum Press, 2002.

———. "The Egyptian Drawings of Allessandro Ricci in Florence." *Gottinger Miszellen* 162 (1998): 73–92.

———. "Excavating the Bankes Manuscripts and Drawings." *Sudan Archaeological Research Society Newsletter* 10 (1996): 31–6.

———. "The First Excavation of Wadi Halfa (Buhen) in *Studies on Ancient Egypt in Honour of H. S. Smith.* Eds. L. Leachy and J. Tait. London: Egyptian Exploration Society, 1999.

———. "Not the Travel Journal of Allessandro Ricci." In *Studies in Egyptian Antiquities, A Tribute to T. G. H. James.* Ed. W. V. Davies. London: British Museum Occasional Paper 123 (1999): pp. 115–21.

Vercoutter, Jean. *The Search for Ancient Egypt.* New York: Abrams, 1992.

Wilkerson, Richard H. *The Complete Gods and Goddesses of Ancient Egypt.* New York: Thames & Hudson, 2003.

———. *The Complete Temples of Ancient Egypt.* New York: Thames & Hudson, 2000.

Wilkinson, Toby. *The Rise and Fall of Ancient Egypt.* New York: Random House, 2010.

Williams Wynn, Frances. *Diaries of a Lady of Quality from 1797 to 1844.* Ed. A. Hayward. London: Longman, 1864.

Wilson, Richard, and Alan Mackley, eds. *Creating Paradise: The Building of the English Country House 1660–1880.* London: Hambledon and London, 2000.

Wood, Alexander. *Thomas Young, Natural Philosopher, 1773–1829.* (Completed by Frank Oldham.) Cambridge: Cambridge University Press, 1954.

Young, Thomas. *An Account of Some Recent Discoveries in Hieroglyphical Literature and Egyptian Antiquities, Including the Author's Original Alphabet as Extended by M. Champollion.* London: John Murray, 1823.

———. *Rudiments of an Egyptian Dictionary.* London: J. & A. Arch, 1831.

PICTURE CREDITS

The illustrations listed below with the label NT/BKL have been reproduced with the permission of the National Trust and have been provided by the staff at the Dorset History Centre, Dorchester, England, where they reside as a part of the Bankes archive. The photographs are reproduced with the permission of Ruth Seyler.

BLACK AND WHITE IMAGES

1. Photograph/© Ruth Seyler
2. NT/BKL
3. NT/BKL
4. National Trust/Architecture Image
5. Courtesy of the National Trust
6. Photograph/© Ruth Seyler
7. Photograph/© Ruth Seyler
8. Photograph/© Ruth Seyler
9. Thomas Malton/watercolor; permission from the British Museum
10. N. Whittock/lithograph; National Trust/Simon Harris
11. Robert Gray/photograph; NT/BKL
12. Photograph/© Ruth Seyler
13. Map from W. J. Bankes, ed., *Narrative of the Life and Adventures of Giovanni Finati*, London, 1830
14. NT/BKL
15. NT/BKL
16. NT/BKL
17. Photograph/© Ruth Seyler
18. Photograph/© Ruth Seyler

19. Map from W. J. Bankes, ed., *Narrative of the Life and Adventures of Giovanni Finati*, London, 1830
20. NT/BKL
21. NT/BKL
22. NT/BKL
23. Photograph/© Ruth Seyler
24. NT/BKL
25. NT/BKL
26. NT/BKL
27. Artifact at the Cairo Museum
28. NT/BKL
29. NT/BKL
30. NT/BKL
31. NT/BKL
32. Photograph/© Ruth Seyler
33. Photograph/© Ruth Seyler
34. From Henry Salt, *Essay on Dr. Young's and M. Champollion's Phonetic System of Hieroglyphics*, London, 1825
35. Lines from the Rosetta Stone/John Leitch, ed., *Thomas Young's Life and Works*, 3 vols., London, Murray, 1855
36. NT/BKL
37. Photograph/© Ruth Seyler
38. Photograph/© Ruth Seyler
39. Courtesy of the National Trust
40. Photograph/© Ruth Seyler

COLOR IMAGES

C1. © National Trust Images/Christopher Hurst
C2. © National Trust Images/Christopher Hurst
C3. © National Trust Images/Derrick E. Witty
C4. © National Trust Images/Derrick E. Witty
C5. Courtesy of the John Murray Archive
C6. © National Trust Images Federico Pérez
C7. NT/BKL

C8. © National Trust Images/Derrick E. Witty

C9. NT/BKL

C10. Photograph/© Ruth Seyler

C11. NT/BKL

C12. NT/BKL

C13. NT/BKL

C14. NT/BKL

C15. NT/BKL

C16. NT/BKL

C17. NT/BKL

C18. NT/BKL

C19. Photograph/© Ruth Seyler

C20. Photograph/© Ruth Seyler

C21. © National Trust Images/Derrick E. Witty

C22. Photograph/© Ruth Seyler

C23. Photograph/© Ruth Seyler

C24. © National Trust Images/Angelo Hornak

C25. © National Trust Images/Angelo Hornak

C26. © National Trust Images/John Hammond

C27. © National Trust Images/Richard Pink

C28. © National Trust Images/James Dobson

C29. © National Trust Images/James Mortimer

INDEX

Italicized numbers refer to interior black-and-white images
Italicized numbers preceded by "C" refer to color plate insert